⎯STUDIES IN⎯
IMPERIALISM

Established in the belief that imperialism as a cultural
phenomenon had as significant an effect on the dominant
as on the subordinate societies, Studies in Imperialism
seeks to develop the new socio-cultural approach which
has emerged through cross-disciplinary work on popular
culture, media studies, art history, the study of education
and religion, sports history and children's literature.
The cultural emphasis embraces studies of migration and
race, while the older political, and constitutional,
economic and military concerns will never be far away.
It will incorporate comparative work on European and
American empire-building, with the chronological focus
primarily, though not exclusively, on the nineteenth and
twentieth centuries, when these cultural exchanges were
most powerfully at work.

‾‾STUDIES IN‾‾
IMPERIALISM

general editor John M. MacKenzie

PROPAGANDA AND EMPIRE
THE MANIPULATION OF BRITISH PUBLIC OPINION, 1880–1960
John M. MacKenzie

IMPERIALISM AND POPULAR CULTURE
ed. John M. MacKenzie

EPHEMERAL VISTAS
THE EXPOSITIONS UNIVERSELLES, GREAT EXHIBITIONS AND WORLD'S FAIRS, 1851–1939
Paul Greenhalgh

'AT DUTY'S CALL'
A STUDY IN OBSOLETE PATRIOTISM
W. J. Reader

IMAGES OF THE ARMY
THE MILITARY IN BRITISH ART, 1815–1914
J. W. M. Hichberger

THE EMPIRE OF NATURE
HUNTING, CONSERVATION AND BRITISH IMPERIALISM
John M. MacKenzie

'BENEFITS BESTOWED'
EDUCATION AND BRITISH IMPERIALISM
ed. J. A. Mangan

Images
of the army

THE MILITARY IN BRITISH ART,
1815-1914

J. W. M. Hichberger

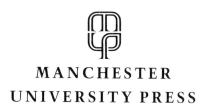

**MANCHESTER
UNIVERSITY PRESS**

Distributed exclusively in the USA and Canada
by ST. MARTIN'S PRESS, New York

Published by **MANCHESTER UNIVERSITY PRESS**
OXFORD ROAD, MANCHESTER M13 9PL
Distributed exclusively in the USA and Canada by
ST. MARTIN'S PRESS, INC.
ROOM 400, 175 FIFTH AVENUE, NEW YORK, NY 10010, USA

British Library cataloguing in publication data
Hichberger, J. W. M.
 Images of the army: the military in British Art, 1815-1914.— (Studies in imperialism).
 1. Painting, British. 2. Painting, Modern —Great Britain 3. Armed Forces in art
 I. Title II. Series
 758′.9355′00941 N8260

Library of Congress cataloging in publication data applied for

ISBN 0-7190-2575-3

Typeset in Trump Mediaeval by
Koinonia Limited, Manchester

Printed in Great Britain
by Bell and Bain Ltd., Glasgow

CONTENTS

LIST OF ILLUSTRATIONS

The illustrations follow p. 119, between Parts one and two

GENERAL EDITOR'S FOREWORD

Imperialism was more than a set of economic, political, and military phenomena. It was a habit of mind, a dominant idea in the era of European world supremacy which had widespread intellectual, cultural, and technical expressions. The 'Studies in Imperialism' series is designed to explore, primarily but not exclusively, these relatively neglected areas. Volumes are planned on the scientific aspects of imperialism, on education, disease, the theatre, literature, art, design, and many more. But in redressing the balance in favour of these multi-disciplinary and cross-cultural studies, it is not intended that the economic, political, and military dimensions should be ignored. The series will also contain books in these fields and will seek to examine colonial and imperial developments in a variety of periods and in diverse geographical contexts. It is hoped that individually and collectively these works will illumine one of the more potent characteristics of modern world history.

There were few more effective vehicles for the conveyance of the ideological complex made up of nationalism and imperialism than nineteenth-century art. In an age when engraving and photography were making artistic images available to a much wider public, a period in which art was seen as an inseparable element in commerce, civic pride, and national aspirations, artists were able to influence public attitudes more powerfully than ever before. It is no accident that a growing proportion of artists' income came from royalties on reproductions. As their public expanded they were concerned less to flatter patrons and customers who might hang their paintings than to mirror an entire national culture. In doing so they received, adapted, and mediated a growing corpus of dominant ideas. Nowhere was this more true than in nineteenth-century battle painting and images of the army. Dr Hichberger examines this extensive genre in its wider cultural setting, in its many variations as the British experience of and attitudes towards the army developed during the century.

John M. MacKenzie

ACKNOWLEDGEMENTS

This book is a reworking of some of the material from my doctoral thesis, submitted to the University of London in 1985. My thanks are due to individuals and institutions who assisted and encouraged both projects: Catherine Gordon, Sir Oliver Millar, the Squire de Lisle, Robin Hamlyn, David Brown, Joe Darracott, Jenny Elkan, the Institute of Directors, Jenny Spencer-Smith of the National Army Museum, Colonel Kelly of the Royal Military Hospital, Chelsea, the officers of the Royal Artillery Regiment, and Edmund Morris. I particularly wish to thank friends who assisted by reading the manuscript and in other practical ways; Michael Sliney, Sarah Hyde, Nick Warren, John House, Neil McWilliam, William Vaughan, Tom Gretton, Sylvia Wright, Julia Willock and Paul Crossley. Lastly I wish to thank Marcia Pointon, to whom the book is affectionately dedicated.

INTRODUCTION

'Of all the phases of Art, there is none so barren as the Military, and none in which English painters have found themselves so peculiarly abroad.'[1] William Michael Rossetti's comment summarises two related contemporary mythologies; that military art was a 'barren' area of activity and that British artists were unwilling and unable to work on the subject. These two beliefs were interwoven with the pervasive myth of British anti-militarism. Almost all nineteenth-century writers on the army and the State, prior to the Boer War at least, agreed that Britain was not a military nation. The belief was reiterated even in the face of the phenomenon of 'jingoism'. The term was coined in 1878, but the reality was discernible much earlier, before the Crimean campaign in 1854. The feverish desire for war was attributed by such politicians as the Tory Disraeli to healthy national pride and the wish to use military strength in a just cause. Popular song from which 'jingoism' took its name stressed that 'we don't *want* to fight,' implying that war had to be forced upon a pacific people. The British were prone to contrast themselves favourably with nations such as France and Prussia, where a distinct military caste held considerable political influence and military men were highly respected. In England, it was pointed out, the army was officered by gentlemen, acting upon a spirit of public duty and responsibility. Alan Skelley has shown in his book *The Victorian Army and Society* the extent to which the pre-Crimean officer class was composed of the landed gentry and aristocracy, in effect the power-holding groups.[2]

It is simplistic, then, to argue that because there was no military lobby the army was divorced from the power structure. Indeed, it will be contended here that although the army was attacked by some members of Parliament who felt that its role must be limited to preserving 'Liberty and the Constitution', prior to 1854 its position remained intact and was even strengthened. All governments, Whig or Tory, continued to pay lip service to the mythology of the national anti-militarism, and used the 'no standing army' rhetoric whilst continuing to employ it as an instrument of state control for the suppression of social or political unrest. In spite of these political attempts to show that the army was controlled and marginalised for the preservation of constitutional freedoms, it is clear that those who held power in the early nineteenth century saw the army's interests as indistinguishable

from their own. Indeed, it was partly because the army was so closely linked with the aristocracy and landed gentry that it was the target of attack, both from working-class radicals and from the emergent political force of the urban bourgeoisie. The struggle for control of the army has been described by some historians as a process of 'democratisation' and rationalisation of an institution run down by incompetent aristocrats. It will be taken here that the invocation of terms like 'democratisation' was one of the ways in which the middle classes articulated their own right to infiltrate the social and political bases of power. In the Cardwell reforms of the early 1870s this process reached its fullest development and major changes were instituted, aimed at opening the officer class to gentlemen from the middle classes, and making the army a desirable career for 'decent' working-class men.

It will be argued that the relationship of the army to the state, and the ideologies underpinning and surrounding it, may be shown to have had a significant relation with works of art on military themes exhibited at the Royal Academy. The nature of this link is by no means a straightforward one in which the picture unproblematically reflects the ideologies of the ruling class. The pictures themselves work ideology in a specifically pictorial way and play a role in negotiating ideas about the military in Britain.

In the post-Waterloo period there was intense debate as to whether the genre should exist in Britain. The pervasive myth of anti-militarism made it impossible for the state to endorse the patronage of overtly propagandistic battle paintings in the High Art manner favoured by the Napoleonic regime in France. Such patronage as there was was sporadic and administered by sub-groups or individuals from the ruling class. At the same time the lack of battle painting compared with France was noted and the conclusion drawn that it was a 'reflection' of the anti-military character of the nation. So, although the army was involved in constant wars throughout the century, the activity was constructed not as resulting from a warlike spirit but as the exercise of a God-given role as arbiter of international justice, and in the empire as the taking up of the 'white man's burden'. In the High Victorian and Edwardian eras the mythology of anti-militarism was retained in the form of a ritual shunning of military professionalism, but was in fierce competition with a need to assert national superiority.

This book examines oil paintings on military subjects exhibited at public metropolitan venues in the century 1815-1916. The discussion is confined to oils because that was the form in which most *public* art was presented, and it is with the creation of works for public rather than private consumption that the book is primarily concerned. The

problem of circumscribing an already rich subject dictated the omission of drawings and water colours, as also of prints and public sculpture.

Arguments about the nebulous phenomena of 'increasing popularity' and 'higher numbers' are supported by statistical data on exhibits of the Royal Academy.[3] The selection of this institution may seem like blind acceptance of its own evaluation of itself as the forum for all 'important' art in England. Although the drawbacks of focusing on a single exhibiting body are acknowledged, the RA offers two major advantages. It has uniquely continuous documentation – the annual exhibitions, which occurred without interruption throughout the period, were always accompanied by a catalogue which detailed the artist, his/her location and the title of the picture. Secondly, the RA, for almost the whole period, was regarded as the foremost venue for the exhibition of paintings, and thus occupied an important place in the social life of the metropolis. It is essential to be able to gauge, even in outline, the audience for the paintings.

In the early years of the century the RA exhibition formed part of the London season. It was a fashionable venue at which members of the aristocracy and upper middle classes gathered. This social group consisted of a large proportion of government ministers, members of the judiciary, members of both Houses of Parliament and high-ranking officers of the services. In the pre-Crimean period the Academy could count the most influential and wealthy of the land among its audience. That audience did not remain static over a long and changeful period. From the 1820s members of the bourgeoisie were observed to be increasingly patronising contemporary artists. To quote Lady Eastlake's comment on the participation of the industrial bourgeoisie in the art market after about 1830 has become almost a cliché.[4] Of course this class had long bought paintings, from local artists and metropolitan artists of lesser status. But their intervention in the exalted circles of Academic art may be seen as further evidence of their growing wealth and social aspiration. It was in this period that they began to demand greater participation in the processes of government. The broadening of the RA audience after about 1830 did not mean that its constituency was any less powerful or influential. In the mid-1850s the summer exhibition was still a requisite part of the social curriculum.

> Some slight acquaintance with the pictures is, however, essential for anyone who aspires to the high aim of making himself agreeable in society. Of all the stereotyped commonplaces of conversation, the Royal Academy Exhibition is the most fruitful and convenient.[5]

[3]

In the 1870s the primacy of the RA was under attack from sections of the 'art world' who deplored its encouragement of 'old-fashioned' forms of painting and its exclusion of 'avant-garde' artists. Rival exhibition galleries had, of course, existed throughout the century, but even such organisations as the British Institution did not disrupt the received notions of the Academy about what constituted 'good' or 'important' art.

The Grosvenor Gallery, and its successors, espoused forms of re-presentation which promoted 'aesthetic' values over didacticism or narrative, and thus established an alternative kind of exhibition. Despite the split in the 'art world' it is hard to see that the position of the academy in relation to the political power-holding groups had really changed. The RA banquet continued to be patronised by the monarchy and members of the forces and government. It was only in terms of a limited elite within the elite – critics and a few patrons – that the Royal Academy lost its supremacy.

This issue of audience is crucial in establishing that the pictures shown at the RA at the very least could not have been directly antithetical to the ideologies of those who held the reins of power. It should be noted that the term 'ruling class' as used here does not denote a homogenous group of people with unified aims, but is rather the association of interest groups and classes who may be perceived to have dominated the processes of power at a given time. It is not the function of this book to try to prove which group dominated or why and when. It will be seen that the works of art on military themes exhibited at the RA may be significantly related to the contending ideologies of different sections of the ruling classes.

An important function of the book will be to examine works of art on military themes in relation to ruling-class ideologies about the army, war and the empire. The first part of the book, chapters one to eight, is devoted to a chronological survey of battle painting, integrated with a study of contemporary military and political history. The chapters will link the debate over the status and importance of battle painting to contemporary debates over the role of the army and its function at home and abroad. The second part of the book will also discuss the intersection of ideologies about the army and military art, but is concerned with an examination of genre representations of soldiers.

Another important theme which runs through the book is the relation of English to French military art. During the first eighty years of the period under review France was the cynosure of military artists, the school against which British critics measured their own, and the

place from which innovations were imported and modified. In every generation after Waterloo battle painters visited France and often trained there. It is not as a study of Anglo-French artistic relations that this acount has been written, although this is clearly a vital element in the British military art in the period. Questions of artistic 'influence' have been passed over in favour of discussion of the ways in which the pictures were understood and received in Britain. The existence of a French tradition of battle painting was simultaneously admired, despised and condemned. France's role as economic, military and polit-ical rival was scarcely disrupted by the few occasions on which the two nations were military allies. It will be shown that military art, or the 'absence' of it, was one of the ways in which nationalist commen-tators articulated Britain's moral superiority.

The final theme which underlies much of the book is the shifts which took place in the perception of heroes and hero-worship. Of course, in the nineteenth century hero-worship was considered deeply important to the national spirit. It was claimed by Carlyle to be 'the basis of all possible good, religious or social, for mankind'. The evils of the age, mammon-worship and lack of enthusiasm, could be banished if people would study and venerate the example of heroes. Samuel Smiles's *Self-help* (1859) was a catalogue of hard-working, imaginative, industrous heroes to inspire all walks of life. 'Heroic' qualities were defined broadly, since the term was applied to such diverse characters as Michelangelo, Homer, Shakespeare, Nelson, Napoleon and Luther. Clearly heroic status depended not on moral example but rather on the hero's impact upon history. The concept of the great man whose enormous insight could transform the world, was a legacy of Romantic thought. In the mid-nineteenth century the man of poetic insight was replaced by the man of action as hero of the age. The ideal military man should manifest courage and compassion but above all patriotism. In the post-Napoleonic era generals such as Sir John Moore and Sir Charles Napier were represented by artists and writers as heroes because their courage was inspired by devotion to country rather than any abstract notions of right. Love of country was the common cause in which Englishmen should bury their individual selfishness, and by extention their political differences. The soldier-hero was especially sacred because he fought in the cause of country, and could be an inspiration to civilians as well as to other soldiers. The increasing identification of civilians with the military was reflected in the widespread veneration of such men as Havelock and Gordon. They were compared to the Christian knights of medieval Europe who were believed to have combined Christian ethics, personal

integrity and physical strength. The contradiction between Christianity and violence was seldom mentioned, since it was believed that Britons would fight reluctantly and then only in a noble cause. The soldiers who were represented as heroes were not always the most successful but were those who could be interpreted as displaying chivalric qualities: reckless exposure to danger; cool reaction to imminent death; taking on enormous odds – the 'forlorn hope'; sacrifice for one's comrades or for the honour of the regiment; above all, for one's country. It will be perceived that with the development of even longer-range weapons the chance to display this kind of heroism grew less and could occur only on the event of a breakdown in military procedure. In the late nineteenth century the era of Waterloo, with its hand-to-hand fighting, was perceived as a 'golden age'.

The processes by which particular soldiers came to be selected by artists for representation as heroes are complex. A hero might emerge (on canvas) as a result of patronage by an interested person or group wishing to further the soldier's reputation. An artist might have a personal admiration for a hero or, more realistically, might respond to public demand for images. In the nineteenth century the impact of newspapers, journals, cheap book printing, ballad sheets and prints was vital in the process of manufacturing an heroic image. The eighteenth-century American painters, Benjamin West and John Singleton Copely, established a tradition for the depiction of the contemporary military hero which was adapted and modified by British painters in the following century. West's influential picture *The Death of General Wolfe* created a genre for heroic death which combined classical compositional formulae with modern dress. This example was particularly absorbed by David in revolutionary France. Soldier heroes in the nineteenth century were no longer required to have a godlike image but were made to portray important 'admirable' qualities for a didactic purpose. The reputation of a hero was established in the press and in literature, which also laid emphasis on his home life and personal qualities. The meaning of the hero picture at the RA was amplified by the viewer's presumed prior knowledge of the subject.

Analysis of the characters of famous historical figures had begun with the historians of the Enlightenment such as Voltaire and Hume. From their examination of motives and ideas developed a literary genre of biographies of heroes written in a popular style. Small details and incidents of the hero's youth and later life were recorded to 'throw light' on his personality and subsequent conduct. This fashion for exploring the private lives of military heroes stimulated developments in the genre of hero painting. Artists, assisted by biographers, embarked

upon elaborate research to gather details for anecdotal scenes of the subject's private life. These new types of hero picture were often meticulously researched and were taken as 'true' accounts of historical facts.

> The traditional figures with their correct postures, attributes and didactic values were gone. Heroes were interesting as individuals, visualised rather than analysed, recognisable rather than significant. New settings, new characteristics were in demand. New homeliness as well – the range of human emotions was to be studied in the mysterious and the horrific but also in the every day.[6]

During the period 1815-1914 considerable shifts took place in the representation of the military hero; from the idealised and generalised to the familiar, almost domesticated figure. Similarly the depiction of battles moved from the distant panorama to the 'close-up' incident in an engagement. The army, the officers, the ranks and the women associated with it, were transformed in the art of the middle and upper classes. An organisation whose relation to the civilian state had always been equivocal was domesticated and incorporated into the belief system of the ruling classes before 1914. This book attempts to chart the process of transformation in the images of the army and its soldiers from Waterloo to the eve of the Great War.

Notes

1 W. M. Rossetti. *Fine Art, Chiefly Contemporary*, 1867, p. 13.
2 Allan Ramsey Skelley, *The Victorian Army at Home*, 1977.
3 J. W. M. Hichberger, 'Military Themes in British Painting, 1815-1914', unpub. doctoral thesis, University of London, 1985.
4 Lady Eastlake, *Memoir of Sir Charles Eastlake*, 1870, p. 147.
5 *Fraser's Magazine*, June 1855, p. 707.
6 T. S. R. Boase, *English Art, 1800-1870*, 1959, p. 1.

The face
of battle

CHAPTER ONE

After Waterloo

In the spring of 1815 Napoleon escaped from Elba, returned to France and reassembled his army. After the Hundred Days he was conclusively defeated by an allied army of Belgian, Prussian and British troops under the command of the Duke of Wellington. It might have been expected that the peace celebrations of the summer of 1814 would have stimulated the patronage and production of pictures celebrating Wellington's victories in the Peninsula. In that year, however, there were no state projects for commemorative battle pictures, nor was there an increase in the number of battle pictures exhibited at the Royal Academy. In fact the exhibition contained only two battle pictures, only one of which was by a British artist.[1] This surprising dearth of military pictures can be explained in terms of two separate but related issues. The first is the status of battle painting within the hierarchy of academic art; the second is the lack of patronage, either from the state or from individuals. The status of battle painting as a genre was, as we shall see, the subject of some confusion. In France the patronage and encouragement of the emperor Napoleon had elevated battle painting to the exalted level of history painting. Lalumia's account of the history of battle painting points out that there was no indigenous battle painting in Britain prior to the nineteenth century and that in preceding centuries such works as were produced were by artists brought over from the Low Countries or France.[2] It will be contended here that owing to the absence of a thriving tradition of High Art battle painting, the genre was associated with a lower-ranking genre, topographical painting. Topographical painting of battles had its origin in map-making and sketches of troop formations and was regarded as a 'documentary' account of the facts of engagements.[3]

One High Art form of military painting which had flourished in England in the late eighteenth century was the *exemplum virtutis* painting such as West's *Death of General Wolfe* or Copely's *Death of Major Peirson.* These works showed military heroes expiring in poses based

on Renaissance images of the dead Christ. The innovations of this genre, presenting a contemporary hero in modern dress, but in terms of the traditions of High Art, were not absorbed in Britain as they were in France by David and his followers. Although such works were occasionally produced to depict the death of Nelson or Moore, no such pictures were commissioned as part of the peace celebrations. They cannot be seen as 'battle' pictures, since the military event depicted was of comparatively little significance except as a context for the sacrifice of the hero.

The supreme hero at the end of the French wars was the Duke of Wellington, who was constructed in the national mythology as the saviour of Europe, achiever of a near miracle by defeating Napoleon. As commander-in-chief of the allied army he was regarded, at least by the British government, as the sole victor of Waterloo, and it was believed that he played a dominant role in 'redrawing the map of Europe' at the Congress of Vienna.[4] Much of the peace celebrations went to honouring the national hero. The Prussian commander, Prince Blücher, was also fêted. Personally a popular figure, he was symbolic of the alliance of nations which had defeated Napoleon. The Prince of Wales, Regent for the latter years of the war during his father's insanity, was eager to associate himself and his dynasty with the victories, despite the fact that the monarchy had had less, in administrative and personal terms, to do with the war than ever before.

It will be shown that the Regent's desire to appropriate the Peninsular, Trafalgar and Waterloo victories, resulted in patronage for a genre of battle painting not legitimised by the tenets of academic theory. In the immediate aftermath of the war, however, the Regent patronised or supported a range of projects which excluded battle painting. The schemes were designed to celebrate Napoleon's defeat and emphasise Britain's leading role in restoring the Bourbon monarchy and beating back the forces of anarchy and revolution.[5]

The painter Benjamin Haydon noted bitterly in his diary that History painting had not benefited from the expenditure of money stimulated by the peace celebration. 'It is a most extraordinary thing. . . that in all these monuments and pillars, neither mayor, minister nor prince has said a word about painting.'[6] Haydon was incorrect: a number of schemes had been mooted which might have led to the commissioning of History paintings. Lord Castlereagh, the Prime Minister, had obtained a vote from Parliament to devote £500,000 'for the erection of a Waterloo monument, in which painting, sculpture and architecture were to have been united'.[7] This grandiose project was never executed, owing to the inability of the committee to resolve upon a plan

which met with the approval of the Royal Academy. The reluctance of the Academicians to connect their institution with the project suggests misgivings about the way Academic painting would be utilised to celebrate the victory.

In 1814, after the first defeat of Napoleon, the Regent had proposed to commission a series of painting for Windsor Castle on the theme of the restoration of the Bourbon dynasty to the throne of France.

> It was first proposed that the Restoration of the Bourbons should be com-
> memorated in two historical compositions on a large scale, 'not inferior
> to that of West lately finished'. . . But the project was again cancelled
> and the Prince commissioned the portrait painter Lawrence to produce
> a series of 'full and three-quarter length portraits of the Monarchs, States-
> men and General Officers who contributed most conspicuously to bring
> the Revolutionary war to its happy and glorious conclusion.[8]

The Regent's motives for abandoning the project for commemorating the victory in two Historical paintings are not documented, but nevertheless require some speculation. Certainly, he met Lawrence for the first time in this period and was favourably impressed by his talents. Moreover, the new scheme allowed for the Regent's portrait to be included among the heroes who had brought about the victory. The decision to eschew historical compositions was part of a broader trend so frequently bewailed by Haydon and other enthusiasts who believed that the genre was the indicator of the strength of the 'National School'. The reference to the recent compositions lately finished by West was not to his famous and highly successful *Death of General Wolfe* but to his commission from George III for thirty-five paintings expounding the theme of the History of Revealed Religion. The elaborate scheme had foundered for a complex set of political, religious and practical reasons. John Dillinger has attributed part of West's unpopularity with the royal family to his known admiration of Napoleon and sympathy with republican France. West had forcefully expressed the opinion that the lack of state support for his work con- trasted unfavourably with the flowering of history painting in France, especially in the art of David.[9] It seems admissible to argue that during the war, the genre of military history painting had come to be particu- larly associated with Napoleon and thus with pro-Napoleonic senti- ment.[10] The victorious British wished to dissociate themselves from French militarism, which had led to the commissioning of overtly propagandistic battle paintings. As will be seen, a critic appraising Ward's allegory of Wellington's victories found it to be too full of 'ex- travagance' and 'flights of fancy' to suit the sober temperament of the British nation. The argument about the form that military art might

take in Britain was thus complicated by the feeling that military history painting was the domain of the French and reflected their militaristic and blood-thirsty national character. It will be argued below that this association underpinned many of the objections to history painting schemes which were planned in the immediate post war period.

In France the genre of military painting had been raised to the level of History painting as a result of a calculated programme of patronage on the part of Vivant Denon, Napoleon's virtual Minister of the Arts. Since the emperor's reputation was founded on his prowess as a general and his reputation for invincibility, it was obvious that the art of his regime should express those aspects in the most portentous and glamorous manner.[11] The process of raising the status of military painting as a genre commenced by Napoleon was further assisted by the restored Bourbon monarchy. Louis XVIII embarked on 'a generous programme of official support designed to make up for the lack of private patronage and at the same time to raise the level of French painting by encouraging artists to attempt works of the noblest and most strenuous kind'.[12] The French government wished to demonstrate that the highest branch of art flourished under the Bourbon regime, and they were willing to cultivate that branch with generous commissions. This policy acknowledged that large-scale paintings on historical and 'national' themes were not the province of the private patron.

In England the artistic importance of History painting was also acknowledged. West's conviction that the production of History paintings was the truest indication of a flourishing national school formed part of a wider discourse on the relation of art to the state of the nation, and in particular to the notion of a distinctively English national school. The arguments around these issues have been ably expounded elsewhere and need only be summarised here.[13] The theoretical basis for the academic hierarchy of genres had been formulated by Sir Joshua Reynolds in his *Discourses*, delivered before the Royal Academy between 1769 and 1780. Reynolds had not explicitly located battle painting in his post-Albertian construction of a table of artistic importance. The definition of History painting in England had not broadened as it had in France to absorb 'national themes', including the representation of contemporary battles in modern dress.

If military themes did not have a thriving existence within the parameters of High Art in Britain, it is clear that there was a market for the representation of military subjects. The *Printsellers' List* shows that there were numerous battle sketches and costume studies available at the cheaper end of the art market. This type of production was

outside Academic practice although inevitably patronised, in part, by the same audience. The art form had evolved from topographical sketches, and combined the portraits of certain military figures with carefully delineated troop dispositions. The link with the lowly esteemed genres of topograpical landscape and portraiture undoubtedly located this type of battle painting, even when executed in oils and on an 'important' scale, as an academically negligible practice. Because this type of battle painting eschewed the conventions of Baroque or Renaissance battle painting, it was thought to be without conventions and thus to be purely documentary. The work of artists like Jones was frequently discussed in terms of 'illustration' and this language employed to establish the work's closeness to perfect accuracy. It was assumed that 'topographical' battle paintings were documentary, and that military pictures could be read on two levels, in terms of 'truth' and in terms of 'art'. Implicit in this distinction was the belief that any battle painting which aspired to the status of 'art' must necessarily have abandoned any relation to the historical event and, conversely, that any work which was outside the High Art tradition must be read as a neutral transcription of the event: '. . . who ever saw a battle-piece that was a work of art except in Greek sculpture, or from the hands of M. Angelo or Leonardo?'[14] There is some evidence that those persons committed to the encouragement of a national school, and in particular to fostering history painting, were concerned to integrate battle painting into the highest echelons of art on the model of France.

The British Institution competition

The British Institution for Promoting the Fine Arts in the United Kingdom, had been formed in May 1805 by important members of the Royal Academy and members of the aristocracy who were patrons and amateurs of art. The BI was thus constituted of some of the most influential connoisseurs of the age, who were members of the ruling classes. The interests of the BI were inevitably different from those of the Royal Academy, which was only indirectly controlled by the establishment. The BI was overtly committed to the elevation of the national character through the influence exerted by great art. Its catalogue for 1811 declared that the exhibitions organised by the Institution were: '. . . calculated to raise the standard of morality and patriotism; to attract the homage and respect of the foreign nations, and to produce those feelings, which are perpetually alive to the welfare and glory of the country'.[15]

In 1815 the directors announced that instead of the usual premiums

for the best pictures in a range of genres, there would be a special pre-mium for pictures 'illustrative of our recent successes' in the war.[16] The reviews of the exhibition which resulted from the competition were deeply disapproving of the whole project, holding that battle paintings were vainglorious and incompatible with the anti-militarism of the British character. It will be perceived that the desire of the directors to have pictorial celebrations of the military victories over-rode both the resistance to battle painting as a genre and this supposed reluctance to commemorate national military achievements.

This competition, as the only major patronage for battle painting in the post-war period, must occupy a central position in any discussion of the development of the genre prior to the Crimean war. One aspect of the exhibition frequently discussed in the press was the 'low quality' of the artists who took part. By this it was meant that very few well known Academic artists participated. The committee had offered a handsome prize of a thousand guineas for the best sketch, in addition to the opportunity to work it up into an oil painting to hang at the Royal Military Hospital at Chelsea. Despite these temptations none of the leading historical painters of the day, such as Henry Howard or William Hilton, competed. The absence of any member of the Royal Academy, except for James Ward, might in part be attributable to the bitter rivalry between the two institutions at that date.[17] It might also be argued that the history painters did not feel that the production of sketches 'illustrative' or connected with 'recent military' events was proper material for their genre.

The competitors included two established battle painters, J. A. Atkinson and the Prince Regent's 'Military Painter', Denis Dighton. There were two foreign competitors, J. T. Masquerier and A. I. Sauer-weid. The remaining competitors were Samuel Drummond, William Brooke, William Findlater, Douglas Guest, F. P. Stephanoff, James Howe and Thomas Mullichap. The four premium winners were Luke Clennell, James Ward, George Jones and Abraham Cooper. All but one of the fifteen entrants chose to illustrate some aspect of the Waterloo campaign, in preference to the Peninsular wars which had culminated in the first peace in 1814. The subjects chosen throw interesting light on what the painters considered appropriate for such a prestigious pub-lic competition. Jones, Clennell, Howe, Dighton and four others, all sent in paintings described merely as *The Battle of Waterloo*. It is prob-able that most of these pictures depicted a panoramic view of the battlefield at a crucial moment or focused on an especially significant incident. Findlater selected the charge of the Scots Greys, which some authorities saw as the turning point of the battle. Masquerier painted

one of the earliest versions of the meeting between Wellington and Blücher at La Belle Alliance. Abraham Cooper selected the battle of Ligny, which had occurred two days before Waterloo, and Stephanoff also painted Blücher in desperate danger in this battle. The only departure from the Waterloo campaign was by Thomas Mullichap, who reverted to the retreat across Spain of Sir John Moore's army.

The British Institution competition received slight attention from the press, and of that very little was favourable. Much of the criticism was levelled at the concept of the competition:

> The British Gallery was yesterday opened for private inspection. . . We certainly are not disposed to undervalue the taste or talents of our fellow-countrymen; but we must say, that we never witnessed an exhibition less calculated to give an idea of British genius. There are unquestionably a few good pictures, but the collection on average betrays equal poverty of intellect and imagination in our native artists.[18]

The critic was evidently aware that the competition provided a forum in which British productions would be compared to those of the Continent. It should also be noted that the invocation of the qualities of 'intellect and imagination' suggests that the critic is placing battle painting in the domain of History painting. An unattributed paragraph from a contemporary newspaper or journal suggests that this location for the genre was not undisputed:

> We have heretofore insisted on the total inadequacy of battle subjects in eliciting the higher powers of the artist. We have likewise adverted to the folly of that species of patronage which affects to encourage art, not from an impression of its own intrinsic importance but collaterally as a medium for the celebration of our military exploits. . .[19]

The reviewer was clearly resistant to battle painting as a genre, since he/she considered it did not require the exertion of imagination and intellect which were the hallmarks of history painting. He/she is also disapproving of patronage for such blatantly celebratory subjects. The competition, by its very terms, demanded pictures 'illustrative of our successes', cutting across the mythology that Britain did not glory in war and only fought out of duty, with a painful recognition of the horrors of war.

A number of the entrants are now known only by name and have been impossible to trace. It seems likely that the competition attracted a few amateur artists or perhaps battle artists who worked in the provinces and did not exhibit in London. The artists whose histories can be reclaimed suggest that there were two basic routes into battle painting, via sporting art or History painting. The study of these painters' career patterns reveals that it was almost impossible to sustain a

specialist practice as a battle painter without the support of a generous patron.

Apart from Denis Dighton, who as 'Military Painter to H.R.H. the Prince Regent,' is considered below, the most experienced military painter to enter the competition was John Augustus Atkinson. Atkinson's early life had been spent at the court of Catherine the Great at St Petersburg, and it was there that he first practised as a battle painter.[20] It is noteworthy that three artists who produced battle paintings in late Georgian Britain had received their experience in the genre in Russia. William Allan when a young inexperienced painter spent some time in the Scottish community in St Petersburg. It was through this connection that he received a number of commissions from the court to produce battle pieces. Sauerweid, another competitor in the BI competition, was a Russian national who had also had his first experience of battle painting at the Russian court. Although little work has been done on this topic, it seems safe to state that the Russian court provided a valuable training ground for artists wishing to work in the genre and may be compared to Louis-Phillipe's Versailles project which initiated so many English battle painters of the next generation.

Atkinson returned from Russia about 1801 and established a practice as a designer and engraver of prints. From 1803 he exhibited regularly at the RA, showing military scenes from British history as well as more recent episodes such as *The Battle of Lasswaree gained by General Lake over the Mahratta forces, 1 November 1803* (RA 1805). Farington states that Boydell's partner, Harrison, commissioned Atkinson and a portrait painter called Devis to go to Belgium two months after Waterloo, 'to collect portraits and matter for forming a picture of the Battle of Waterloo from which a print had been advertised to be made'.[21] Atkinson had probably been at the war front at some time during the Peninsular campaigns, gathering material for an earlier project, *The Battle of Salamanca* (RA, 1813). The expense involved in sending two artists to Brussels suggests that Harrison believed that the cost was of less importance than getting the project executed in a very short time. Farington's remarks suggest that the artists were to take responsibility for different aspects of the commission, a not uncommon practice when a work was complex and time of great importance. The collaboration was successful and the picture was finished in time to send to the Royal Academy in 1817. John Burnet engraved it and the engraving was published on Waterloo day in 1819.

Atkinson seems to have used his practice as a painter of genre and costume scenes to finance his battle pictures. There is no documentary evidence about the sale of the latter, but there are no examples in public

collections in Britain, suggesting that they were not greatly valued. His entry in the BI contest was based on the battle of Vittoria, a subject that he had probably executed or researched earlier, since he had been in Brussels during 1815.

The four winners of the competition, Clennell, Ward, Cooper and Jones, all merit examination. Their careers exhibit the variety of routes into the genre of battle painting, the financial difficulties in sustaining a practice in the genre, and the continuing uncertainty over its academic status. The most famous and academically successful of the winners was George Jones. His career, which spanned the period from after Waterloo to the Indian Mutiny, shows the impact of state patronage on battle painting and that the genre did not enjoy widespread popularity in the commercial market.

Jones (1786-1869), as one of the most prolific battle painters of the first half of the period, will figure prominently in this book. He came from a family of artists; his father was Engraver Extraordinary to the Prince of Wales. The decision to be a painter must have been formed early, since he entered the Royal Academy schools in 1801, aged fifteen. His first exhibits at the RA in 1803 suggest ambitions to be a painter of historical subjects: *A Design for the first Volume of Telemachus* and *Christ and the Woman of Samaria*. [22] In 1808 he joined the army, finally gaining a captaincy in the South Devon Militia. His company formed part of the allied army of occupation in Paris in 1815. Jones returned to his civilian career in 1815, coinciding with the announcement of the BI competition. During his military service he had continued to send exhibits to the RA and the BI and had compiled many books of sketches of foreign cities, uniforms and ideas for battle paintings. [23]

Jones was obviously determined that his contribution would have maximum impact at the British Institution competion, since he alone submitted two sketches. They depicted moments at the battle of Waterloo. In the accompanying catalogue, he claimed that his work was documentary. 'The information relative to the sketch. . . was obtained at the Headquarters of the British Army in France and the local Representatives drawn on the spot.' [24] This strategy located him within the tradition of topographical artists who accompanied troops. Jones wished his work to be received as an authentic document.

The approach was successful: he was awarded a premium of £500, a special prize, given in addition to the 1,000 guineas won by Ward. The existence of a 'second prize' was announced as an afterthought some weeks after Ward's, and it is interesting to speculate upon the reasons for this change in plan. Jones's art occupied the opposite end

of the spectrum from Ward's. It may have been that the directors felt that by rewarding both extremes they were being even-handed. In effect, by choosing to give Ward the first prize they were giving History painting precedence over the topographical tradition and thus endorsing traditional values.

Jones worked up his premium-winning sketch into an oil painting 16ft x 20ft (457.2 x 335.2 cm) which was presented to the Royal Military Hospital at Chelsea. The picture was completed in 1820, a remarkable achievement for an artist working without studio assistants. His knowledge of the Waterloo campaign was encyclopaedic. In 1817 he published a book entitled *The Battle of Waterloo, with those of Ligny and Quatre Bras, described by Eye-witnesses and by the Series of official Accounts, published by authority*, a compilation informed by a sense of reverence for the achievements of the army and the Duke of Wellington in particular.

In terms of composition Jones's work was innovatory, achieving a synthesis between the Baroque battle scenes of Van der Meulen, in which the viewer is on a higher level than the field, and the panoramic battlefield view. This enabled him to set out troop formations without the sense of crowding usually created by telescoping the action. He retained the traditional Baroque device of wounded figures in the foreground but diminished their impact with the wider background. In the finished painting at Chelsea (the sketch is lost), he corrected the sense of space by creating an enormous area of sky which occupied over half the canvas. The most original aspect of his work was the very high standard of his landscape painting, and his strong sense of design removed the picture away from the stiff formula of the topographical sketch. Jones depicted the closing stages of the battle, focusing on the Duke of Wellington making the crucial signal to persue the fleeing French troops. The duke is shown on a horse at the top of a small hillock, set a little apart from his Staff. His figure is the cynosure and all the action devolves from it. Jones showed Wellington making the gesture, a well documented wave of his hat, a device which economically explains the narrative and links the halves of the canvas. It also served to make a non-fighting commander into a dynamic hero.

Jones's picture went unnoticed by reviewers of the BI exhibition, while Ward's essay in the grand manner received a great deal of praise. It seems clear that Jones's work did not meet the reviewers' conception of 'art' and was deemed unworthy of consideration. His paintings appealed to a different constituency; shortly after the Chelsea painting he was commissioned to produce another version for the United Service Club – surely a critical and expert audience who admired his atten-

tion to details and his hero-worship of Wellington.[25] Jones continued to think of himself as a military man who also painted. His contemporaries were amused at the way he modelled his dress and appearance on the duke.[26] He retained strong links with the military, attaching himself particularly to the Napier and Moore cliques. He produced many battle paintings designed to make a point for a military audience.

James Ward, the winner of the thousand-guineas premium, was the oldest and most experienced of the four winning artists and the only one who was already a member of the Royal Academy. He had received his first training in the studio of the engraver John Raphael Smith. Ward's early paintings had been closely based upon the rural genre scenes of his brother-in-law, George Moreland. He had made his reputation, however, as an animal painter, specialising in portraits of prize farms for the Agricultural Society. He also achieved success with mezzotints of horses and landscapes and was appointed painter and engraver of mezzotints to the Prince of Wales.[27]

After 1805, probably in an attempt to gain election to the Academy, he introduced religious and mythological themes into his repertoire. He also experimented with Romantic, dramatic pieces after the manner of Stubbs. Ward's *Fighting Bulls at St Donat's Castle* was inspired by Rubens's *View of the Château de Stein, Autumn*, which had been acquired in 1803 by Sir George Beaumont.[28] Ward's huge canvas of *Gordale Scar* [29] (1811) was an essay in Sublime landscape. The work combined careful topographical research with subtle manipulation of scale to achieve a monumental landscape. At the bottom of the towering cliffs were a range of domestic and wild animals, including a huge white bull, symbolic of the British nation, and a wild goat to recall a poem by Gray. Ward's essays in the 'higher' genres were very successful. He was elected ARA in 1807 and made a full Academician three years later. He acquired an enormous reputation. In the estimation of some contemporaries he was a genius whose powers could justly be compared to those of Rubens. It was in this spirit of self-confidence that Ward entered the British Institution contest. In his unpublished autobiography he described his decision to paint an allegorical celebration of the victory.

> As an observer of the signs of the times, and considering the battle to be the crowning act of Great Britain's greatness, I conceived the allegory, determined to be the poet as well as the painter of the subject. My success exceeded my expectation, for the praise bestowed on the work was unbounded, and it was pronounced the first premium sketch. This annoyed many and among the rest, Northcote, who told me 'There was nothing but rubbish in it.'[30]

The directors' decision indicates that they believed that allegory was the appropriate form for the celebration of a nineteenth-century victory. This taste was undoubtedly the product of the reverence for high art and classical culture which formed part of the education of the aristocacy at the time. As Fullerton has shown, the directorate of the BI was dominated by a group of landowning aristocratic connoisseurs, such as the Duke of Bedford, the Earl of Aberdeen, Richard Payne Knight and Sir George Beaumont. The prestige and influence of the Institution was naturally extended by the personal power of the directors. Unwins, an Academy man, saw them as 'the contemptible aristocracy' who 'know, that by combining within their own body all the rank and opulence of the kingdom, they have it within their power to kill and make alive; they know that artists are needy men and that sooner or later they must submit'.[31] The directors saw their duty as the promotion of higher forms of art, believing that they would influence taste and production. Their notions of artistic greatness were modelled upon the Continental old masters. Allegory, as a form practised by the greatest of the latter, had all the right hallmarks of cultural quality; it demanded intellectual invention on the part of the artist and the intellectual participation of the audience in decoding its meanings; further, it demanded a cerebral rather than a sensuous response. In the late Georgian era both these standards and the right of the aristocracy to impose them were being challenged.

The complex genesis of Ward's allegory is recounted by Fussell as 'The Waterloo Allegory Fiasco'. Its full title was *The Genius of Wellington on the Car of War supported by Britannia, attended by the Seven Cardinal Virtues, commanding away the Demons Anarchy, Rebellion and Discord with the Horrors of War.* [32] The view of Waterloo Ward's allegory presented was calculated to appeal to the Tory supporters of the Duke of Wellington, among whom were the Dukes of Bedford and Northumberland and the other BI directors. Ward implied that the victory was the result of Wellington's efforts alone, and moreover that the spirit of Britannia and all the cardinal virtues attended him. Waterloo was more than a battle between European powers – it was a victory for aristocratic and monarchist stability over the republican forces of 'Anarchy, Rebellion and Discord'. As the war receded these views were increasingly attacked by liberals and radicals.[33] Criticism of Ward's creation was directed against the form rather than the content:

> The notification of this picture in the catalogue is accompanied by a prolix narration descriptive of the various parts of which it is composed. This necessity to fly from canvas to paper for explanation is in itself a defect, but one necessarily arising out of the uncontrolled use of allegory.[34]

Despite the widespread reservations about the propriety of allegory for the national school, and the criticisms of Ward's work in particular, it is probable that Ward's picture would eventually have hung at Chelsea beside Jones's, since the directors had no reason to be deterred by adverse reviews. After receiving the commission, however, Ward's ambitions for it grew:

> The first plan was for a painting 14' x 12', but Ward found that his complex conception would be cramped on this relatively small scale. It was accordingly agreed that the canvas should be 20' x 14' but even this would not allow life-size figures so the size was eventually made 35' x 21'.[35]

One critic had foreseen that the composition would not well work up into a large-scale work:

> The subordinate parts have much important actions assigned to them and are withal so numerous, that they create confusion; a fault that we have observed likely enough to occur in subjects of this kind, even the most limited ones, but which the exhuberance of the artist's fancy has here carried to excess.[36]

The length of time he took to complete the project worked against Ward. It was finished in 1821, a year after Jones's picture was in place. It was exhibited at the Egyptian Hall, Piccadilly, where it had a very poor reception: 'critics came to mock and the public to jeer'. The purpose of exhibiting it was to earn money from admission tickets and to attract subscribers to a proposed engraving. So few subscribers were forthcoming that the notion had to be abandoned. The failure of the picture to please or impress 'the public', i.e. the predominantly bourgeois clientele of the Egyptian Hall, was attributable to two causes: resistance to allegory as an alien form and, more important, the current unpopularity of the Duke of Wellington. Many reviewers were annoyed that the picture could be understood only by recourse to a printed pamphlet which explained the fifty or so figures. The reviewer of the *Literary Gazette* was willing to concede that 'the design is unquestionably one which could only have emanated from great genius; but whether in this instance misdirected, or happily called forth, will, in our opinion, be the source of much controversy'. He/she reiterated the belief that allegory was antipathetic to the national character:

> The English character is perhaps rather cold, resting too much on calculation, on precedent, on judging by sober rules. With the mass, the flights of fancy are extravagance, the bolder concepts of art, folly, the ideal, unnatural; and the imaginative absurd.[37]

This quotation is interesting, sounding as it does like an elitist attack

on the taste of the 'mass' public, who would not like the work because it conformed to the tenets of history, which they would be unable to understand.

When the painting was taken to Chelsea it was found impossible to hang it without cutting or folding it. Ward suggested that Soane's newly built gallery should be pulled down and rebuilt to accommodate it. The directors refused but paid for the allegory, which was housed at Chelsea in a truncated form. It was eventually given back to Ward's descendants and is now lost.

The episode is extremely suggestive of the changing climate of the art market in the immediate post-war period. The aristocratic connoisseurs of the BI showed themselves out of sympathy with the majority of urban middle-class art consumers. Although most reviewers, presumably also educated with reverence for the grand manner, were careful not to demolish Ward's effort entirely, the prevailing mood was one of impatience with an inaccessible and grandiose work.

Ward's ill-fated picture was not the only allegory among the British Institution entries. Douglas Guest, a painter and writer on art, submitted an interesting sketch. His aims were so comprehensive that it is difficult to imagine how they could be fitted on to a canvas less than four feet square. His meaning was also amplified by a lengthy text. Unlike Ward, who was committed to the 'pure' allegory, Guest attempted to combine allegory and historical incident:

> The object aimed at has been to unite, on one complete work, the most interesting events of that memorable Battle and to illustrate by Allegory or poetical allusions its importance and principal facts; to record the names of those who have so bravely fallen, and by a beautiful combination recall the most vivid images and recollections.[38]

After setting out this programme Guest described what sounds like carefully researched battle incidents, chosen for their exciting or 'telling' quality. Evidently they were placed close together on the canvas and shown occurring simultaneously, with no concern for the conventions of time or place:

> The machinery or poetry used in the illustration are thus introduced in the upper part of the picture. Victory with wings, places over the point of the upraised sword of her Hero [Wellington] a wreath of laurel, in her left hand she bears the lily, the emblem of the House of Bourbon, accompanied by the Palm Branch, the type of Peace – also History recording in golden letters the names of the fallen with Fame and Eternity, etc.[39]

Guest received no critical notice whatever.

The third recipient of a premium was Luke Clennell (1782-1840). Like Ward and Cooper he came to battle painting only after establish-

ing a practice as an animal painter. In Clennell's case the BI competition was the culmination of a decade's effort to 'elevate' himself from engraver to history painter.[40] He was the son of a Northumbrian farmer, and served an apprenticeship with the local engraver and designer Thomas Bewick before moving to London in 1804. It seems to have been soon after that he began to pursue his ambitions to achieve fame as an artist. In the words of T. H. Ward, '. . . being ambitious, he resolved to be a painter'.[41]

The position of the engraver in the late Georgian art world as inferior to painters was under attack from such men as John Landseer, who lobbied for them to be given equal status with painters in the RA. Despite this it remained true that, in the collaboration between artist and engraver, it was the artist who received recognition. Whatever the final impetus, Clenell began to branch out into the practice of painting. After 1810 he exhibited water colours at the London exhibitions, where his subject matter was mostly landscape and sporting scenes.

His first military subject was exhibited at the Academy in 1816. *The Baggage Waggon* was an essay in the Sublime, showing a group of soldiers and camp followers lashed by a fearful storm. The timing of its exhibition suggests a desire to win public approval by presenting a military scene at a time of military fervour. *The Baggage Waggon* is not a battle painting but a generalised genre scene with no attempt to define the historical location or the locale. Clennell had already established strong links with the directors of the BI. He had developed his capacity as a painter in oils through studying at the annual display of old masters in the winter exhibition. He had received a commission from a highly influential director, Francis Egremont, Earl of Bridgewater. This was for a large-scale representation of the banquet, given at the Guildhall on 18 June 1814, for the Allied sovereigns who had defeated Napoleon during the Peninsular war. The painting included portraits of over 400 guests, an enormous task for a comparatively inexperienced artist.[42]

Clennell painted his *Overthrow of the French Allied Army at Waterloo – sauve qui peut* while he was working on the Bridgewater commission. This sketch, which was awarded a premium of 150 guineas, is lost and known only by an engraving. The reviewer in the *New Monthly Magazine and Universal Register* admired it as 'a very spirited charge of cavalry, which from want of identity, might be called any battle in which the Life Guards were engaged'.[43] The remarks about the lack of identity implies that it was judged according to the criteria for topographical battle painting and fell short of them. Clennell's painting departs from that genre by showing only foregound activity.

Jones's had laid out the battle in almost cartographic form, displaying
the other regiments and their relative position. The uniforms in Clen-
nell's work were carefully rendered but the faces and gestures of the
soldiers themselves were stylised and repetitious. His horses indicate
a debt to Rubens and probably to the eighteenth-century Dutch and
French battle paintings derived from the Baroque tradition. One admir-
ing contemporary suggested more recent influences:

> The overthrow of the French Army at Waterloo, painted by Mr Clennell,
> is a striking proof of the vigour and versatility of that gentleman's
> powers. It detracts something from its praise of originality, by having its
> general grouping and some of its figures imitated from Mr West's noble
> picture of 'Death on the Pale Horse'. The men sounding the trumpet of
> retreat, the tumultuous mixture of men, horses, ammunition etc. of the
> flying French and the onward attack of the conquerors, with the judicious
> mass of shade thrown over the defeated group and the bursting of shells
> in the distance, all feed in the mind the fuel of ideal war and describe to
> us an enemy driven before the victors as 'chaff before the wind'.[44]

It may be seen that, to a large extent, the critic's enthusiasm was aimed
at Clennell's representation of an 'ideal war' – which the British won
effortlessly. Clennell's work occupies a different category to that of
the topographical tradition of history painting. It derived from the
essentially decorative and non-descriptive battle pieces of Salvator
Rosa, whose influence is discernible in the *meleé* of horses, fallen men,
flying hoofs and swords. The figures are heaped upon one another with
no attempt at logic. The cavalrymen are charging neatly in serried
rows, their sabres and helmets precisely parallel.

Sauve qui peut was Clennell's final work. In 1817 he lapsed into
insanity at the age of thirty-six. He was supported by the Artists'
Benevolent Fund, some members of which arranged for William Brom-
ley to engrave the BI picture, 'the proceeds being used for the support
of his children'.[45]

The fourth winner of a premium, Abraham Cooper, was the most
successful practitioner of battle painting in the long term. A consider-
able mythology exists around him, all his nineteenth century bio-
graphers describing him as 'self-taught'.[46] In view of the evidence about
his training which survives it is difficult to escape the conclusion that
they regarded non-academic art training as of negligible value and the
artist who struggled to eminence without it as virtually 'self-taught'.
In fact Cooper's experience and education must have been closer to
that of the majority of artists in the late Georgian period than, for exam-
ple, Jones's. He did not come from a family of artists; his father was a
tobacconist in Holborn. After leaving school at thirteen, Cooper

B

worked with his uncle at Astley's Amphitheatre, a place of popular entertainment specialising in equestrian spectacles.[47] Astley's staged reconstructions of battles with hundreds of horses and riders. Cooper was at first self-taught, and is said to have learnt by sketching the horses at Astley's. He may have received several commissions for horse portraits before placing himself under the guidance of a famous painter of sporting and animal subjects, Henry Marshall. The precise duration and nature of Cooper's apprenticeship are not known, partly because his admirers were anxious to stress the informal nature of his training. An obituary in the *Athenaeum* states that he 'made the first picture so late in life as twenty-two years of age (1808) the subject being a favourite horse belonging to Sir H. Meaux, the likeness of which he took for love.'[48] This view, which again constructs the painter as a talented amateur, seems over romantic. Cooper began exhibiting at the RA and the BI in 1812, only three years later. His progress was rapid: by March 1816 he had been elected chairman of the Artists' Benevolent Society. The post had previously been held by the already eminent Mulready. Cooper had attained a certain status in London art circles, although not within the Academy.[49]

His exhibits at the BI and RA were mostly animal portraits and sporting subjects. He also experimented with literary subjects which had some equine elements. In 1813 he exhibited *Tam o'Shanter*, illustrating the poem by Burns: a dramatic, supernatural tale. The literary subject gave Cooper the opportunity to attempt a 'higher' genre while working on a form for which he was celebrated. A reviewer praised it as 'a cabinet picture, so estimable for its spirited drawing, and lightness and freedom of pencilling, [which] considerably increased the well-earned reputation of its painter'.[50]

Like all the other premium winners, Cooper's entry was his first documented essay in battle painting. It is in the context of a battle painter attempting to break free of the academically less highly regarded genres that his entry should be considered. His chosen subject was *The Battle of Ligny,* when most competitors had opted for Waterloo, the more significant event. Ligny had been fought two days before Waterloo. Cooper selected the moment when Blücher was in danger of being killed. In the catalogue Cooper appended the following paragraph:

> The dangerous situation and narrow escape of Prince Blucher when his horse was killed by a musket shot and the French cuirassiers were, on repassing him, driven back by the Prussian cavalry; an Adjutant General alone remained with him and resolved to share his fate.[51]

These words seem to have been taken, with a few minor changes, from

a book published in 1815, *The Life and Campaigns of Field-Marshal Prince Blucher of Wahlstatt* by J. E. Marston, in part a translation from a German biography but with considerable additions. The book makes it clear why Ligny was recognised as a suitable subject by the British Institution judges:

> The battle of Ligny was marked by the peculiar fury and hatred with which the Prussians fought the French. The mutual animosity was beyond comprehension. The slaughter made by the Prussians was immense; they refused to take quarter, as much as the French refused to give it; and it may be easily supposed that there never was such havoc made as here, for, where men fight with equal desperation, the loss on both sides is always terrible.[52]

Ligny gave the artist an opportunity to depict a savage battle without offending his audience by representing the British killed or killing.

Blücher was a popular figure in the post-Waterloo period. His portrait appeared in the Waterloo gallery at the command of the Prince Regent. He was symbolic of the alliance which had overthrown Napoleon. The most popular subject for the celebration of this theme was 'the meeting of Wellington and Blücher at La Belle Alliance after the battle of Waterloo'. One of several versions was commissioned from Maclise to decorate the House of Lords in the reign of Victoria under the aegis of a German consort.

Ligny received an enthusiastic review in the *Examiner*, whose critic devoted over a hundred words to its praise, the longest review received by any BI picture:

> The Battle of Ligny by Mr Cooper, strikes us as the most originally felt and best executed battle-piece in the rooms. The grouping is compact without being crowded and the flash and sparkle of firing with the local general spread of colour and light are impressive and true. Advance, retreat, attack, defence and death, are in unison with the particular nature of the event. Nature had been closely copied in the stiffened and cowed action of the wounded horse and in the horse which is standing with downward look on Blucher, whom a soldier is most naturally relieving from weight of an animal under which he has fallen. Among its other beauties is particularly noticeable the unobtrusiveness of the stiff military modern dress and that off-hand neatness of execution which is always found in Nature, but so little in the battle-pieces in the exhibition.[53]

The painting was sold to the fifth Duke of Marlborough, a friend and an admirer of the Duke of Wellington, who as part of the refurbishment of Blenheim Palace adorned a room in 'Waterloo blue' as a tribute. Presumably Cooper's painting adorned this room, as a compliment to Wellington and a reminder of his favourite ally.[54]

Cooper maintained an enormous output, showing about 300 pictures at the RA between 1812 and 1888. Approximately fifty were battle pieces. His most frequent subject was the Civil War, and his diploma picture for the Royal Academy was *Marston Moor*. The most striking thing about Cooper's battle paintings by comparison with Jones's is the difference in scale. Jones's 'Battle of Waterloo' canvases were approximately 15ft by 20ft. The British Institution catalogues, prior to 1853, include dimensions and these show nearly all Cooper's battle pictures to be cabinet size, about two or three feet square. The function of such pictures was clearly very different from those of Jones. Jones's picture for the United Service Club was hung at the head of a fine staircase, where it would be seen by everyone on the way to the library. Cooper's battle pieces were meant to be admired from close quarters and to be hung at eye level.

This examination of the artists who took part in the British Institutions competition reveals how unresolved the form and practice of battle painting was in the post-Waterloo period. The first prize winner was an Academician working in a tradition related to the ideals of High Art, but Jones's picture was in a genre new to British art and of low status. The scale and technique used by Cooper and Clennell were also outside the parameters of High Art, but the patronage they received from the directors suggests that the 'elevation' of the national school was secondary to the desire to obtain pictures which celebrated the nation's military achievements.

The catalogues of the Royal Academy exhibitions in the immediate post-war years reveal very few battle pictures that had not been executed for the BI competition. It must be supposed that the works which did not sell were sent to the RA in the hope of finding a buyer. One genre which emerged briefly was the landscape painting featuring a contemporary military event. Military landscape paintings do not generally fall within our scope, since they are often, like Clennell's *The Baggage Waggon*, not historically located. Turner's *The Field of Waterloo* (RA, 1818) must be considered a different genre, since it was specifically located, in the manner of a historical subject. The large scale of the painting, 58in. x 94in., further implies that it was to be read in the category of historical landscape.

Within months of the victory Waterloo had become part of the European tour for gentlemen of sensibility. A contemporary guide book explained, 'Waterloo has become a kind of pilgrimage and there is scarcely an interval of ground between that place and Brussels which is not consecrated by some event or circumstance... to interest the feelings of an observer.'[55] The process was assisted by writers and poets.

Southey in his *Pilgrimage to Waterloo*, (1816) and Scott, in his *Field of Waterloo*, (1815) supplied a wealth of historical details with which to imaginatively reconstruct the battle.[56] More significantly, the writers imbued the place and the battle with a wealth of symbolic meanings: as a place where democracy and order triumphed over the demagogue and chaos, and as a place where Britain gained the ascendancy over France.

When Turner visited Waterloo in 1817 he took with him Campbell's *Travellers' Guide*. The author suggested that the tourist should follow a certain route, reading passages of prose and poetry as he progressed, which would bring to life episodes from the battle, or arouse suitable emotions. The emphasis of the guide book was on the sensibility of the traveller. Turner chose to depict the night after the battle; drawing upon Byron's *Childe Harold* for inspiration, he appended a quotation to the catalogue entry at the picture's exhibition in 1818. Byron's lines are not purely patriotic, rather they question the morality of war and the cruel losses sustained in the course of winning the victory.[57] Campbell also described the field after the fighting had ceased. Camp followers swarmed on to the field to search for their men among the wounded, dead and dying. Local peasants also came, with Sisters of Mercy, to succour the fallen. After nightfall a more sinister group of people came to pick over the bodies looking for valuables:

> During the night, tribes of unfeeling wretches had assembled for the purpose of plunder, the soldier while breathing his last, was inhumanly stripped and his agonies were terminated by the chill of the night, or if he resisted, he perished by the hand of a brutal depredator and the moon beam, that flittered on the polished cuirass 'served only to discover sights of woe'.[58]

Turner chose an anti-heroic aspect of the battle, showing soldiers not as glamourous warriors but as vulnerable pawns. These aspects of mankind, helplessness and the evil which emerges in moments of extremity, were of particular interest to Romantic artists. *The Field of Waterloo* represents humans as small and insignificant beneath the immensity of the night sky. A sense of evil is created by the ambiguity of the lighting. A burst of light from a flare illuminates a small group of struggling bodies and small torch flames fall on other figures in the gloom. Robbers, kind villagers and searching relatives are indistinguishable from one another in the darkness. Turner's work is close to the sentiment of Byron's poem. It should not, however, be read as anti-establishment, since the disinclination to war, for moral reasons, was a convention in the national mythology. Turner was reinforcing rather than disrupting that mythology by dwelling on the human sacrifice of

the battle.

In relation to this genre of military landscape it is important to notice that they also were often read as *topographical,* in the sense of being true delineations of fact rather than historical landscapes, as Turner's classical landscapes were. Of Clarkson Stanfield's *The Battle of Roveredo* (RA, 1851) a critic wrote praising the treatment of the snow-capped Alps, 'which look down from the serene and inaccessible heights on the strife and bloodshed below', then launched into some very technical criticism of the way the painter represented the battle, with admonitions about the real nature of the conflict:

> We are thus particular in the examination of this picture, because, when *military subjects are selected by artists and designated by names, dates and places, they are bound to something like historical fidelity* and a battle which is accurately described in every narrative of the campaign. . . cannot be treated as a pure work of fiction.[59]

It is admissable to bring a criticism from 1851 to bear on Turner's much earlier work because of the relative immobility of the genre from Waterloo to the beginning of the Crimean war. The genre was deemed lowly by adherents of Academic principles, and connected with 'inartistic' representations such as panoramas, dioramas and topographical sketching. Such works as did emerge in this period were a result of sporadic royal and state intervention, motivated by propaganda rather than the desire to foster a neglected genre.

The patronage of the Prince Regent

The Prince Regent's decision to display Lawrence's portraits rather than his battle paintings for his Waterloo gallery has already been noted. He was alive, however, to the propagandist functions of the genre and employed Denis Dighton as 'Military Painter to H.R.H. the Prince Regent'. Dighton was an unsuccessful competitor in the British Institution competition.

His special relationship with the Prince Regent antedated his career as a painter. His royal patron who had been a close friend of Dighton's mother, had bought him a commission in the army when he was only seventeen. Dighton's military career was short-lived, for two years later, in 1812, he had returned to civilian life and was exhibiting genre paintings at the Royal Academy.[60] By 1814 he was exhibiting as 'Military Painter to the Prince Regent' (the exact meaning of the term is not clear). His Academy picture of 1816, entitled, as was his BI competition entry, *The Battle of Waterloo,* was appended 'painted from sketches made on the ground a few days after the action: and from information

from the Duke of Wellington and the Marquis of Anglesea's staffs, Royal Engineers Department etc.'. The Regent sent Dighton to Belgium shortly before the end of hostilities and evidently ensured that he had every facility for gathering information.[61] The Regent seems to have owned all the paintings Dighton exhibited, and may have used them to reward especially favoured subjects. A larger copy of Dighton's BI picture was presented to the Marquess of Anglesey. It represented the marquess leading the final charge against the French cavalry on the evening of Waterloo. It was at this point that his leg had been blown off. Presumably a representation of this celebrated scene was felt to be an appropriate gift from a grateful monarch.

Dighton's technique in this painting suggests that he had very little experience of oils, and was uncertain in his use of colour. His use of light and shade is also curious and disturbing. The horizon line is lit a vivid yellow by the setting sun, and the zones are articulated by strands of white cannon smoke. The foreground figures, instead of being conventionally spotlighted, are half submerged by shadow. The major figure is the marquess, isolated by a shaft of sunlight and by a swirl of smoke behind him. The general's pose is dynamic; he has reined-in his horse and leans far back in the saddle to address one of his aides. All around are groups of skirmishing cavalry, indicating the general's heroic indifference to danger. The treatment of uniform shows the greatest attention to detail, and Dighton has used differences in colour to simplify the otherwise chaotic mass of figures. In the right foreground a line of red-coats bayonet French soldiers, dressed in white with brass helmets. Beyond, a French square can be seen, crumbling before the onslaught of the British cavalry. In the centre distance is a curiously out-of-scale figure on a white horse, clearly meant to be taken as Napoleon, who at this point realised that the battle was lost and fled. The event was of such significance that no reviewer remarked the erratic perspective.

Dighton's title as battle painter to the Regent suggests a more elevated status than perhaps may have been the case. Since his patron bought all his works, he never established a broader clientele and was thus entirely dependent on his good graces. The prices he could command were low. The unsuccessful British Institution picture earned him only £50.[62] In his *Patronage of British Art* John Pye recounts how this situation brought about Dighton's downfall:

> He displayed considerable talent, and his pictures, exhibited from year to year in the Royal Academy, having attracted marked attention and admiration, he became buoyed up with the hope of becoming a member of that body. . . He was, however, yet young when Sir Benjamin Bloom-

field, through whom his works had been placed before the Prince, was removed from the position he had held in the royal household. . . but few of Mr. Dighton's drawings were shown to his royal highness after this change took place.[63]

It seems likely that the fall from royal favour prevented him finding new patrons. He is reported to have fled to France to avoid his creditors, and he died insane two years later, in 1827.[64] Whatever the relations between Dighton and his patron, it is clear that the Regent felt the need to have at his disposal, at least in the immediate post-war years, an artist who could delineate the army's victories in the lasting medium of oil. Dighton's lack of technical experience and Academic training suggest that the Regent regarded the accurate depiction of a battle as a higher priority than the cachet attached to the patronage of an established Academic artist.

The Regent's scheme for the redecoration of St James's Palace is an example of battle paintings being used for purposes of state propaganda. He bought or commissioned paintings of the principal military and naval battles of the reigns of his father and grandfather. The visitor to court would pass first in the George II ante-chamber, adorned with naval battles by De Loutherbourg, then through the George III room, hung with Turner's version of the battle of Trafalgar. The actual and psychological climax was the throne room, the George IV room, with two battle paintings by George Jones, *Vittoria* and *Waterloo,* hung either side of Lawrence's portrait of the monarch in his coronation robes.[65] The king's plan successfully appropriated these victories for his own reign, although at the time he had been regent rather than monarch.

The king's decision to inaugurate such an important scheme caused difficulties within the Royal Academy. One of the artists chosen, Turner, was already a prominent member. As a practitioner of historical landscape, he was a staunch adherent of the Academic tradition. Jones, on the other hand, was a young man, working the genre of military painting in an undesirable 'low art' manner. Yet, there were powerful arguments for admitting an artist so greatly honoured by the king. Jones received the commission in 1822, was elected an Associate that year and was made a full Academician in 1824. The St James's Palace scheme was bitterly criticised on very divergent grounds. Turner's *Battle of Trafalgar,* as Finberg relates at length, was attacked by naval experts at court, who repeatedly asked him to alter technical details. Jones, as an 'expert' himself, does not seem to have had to cope with any such technical quibbling.[66] No references to the rival aesthetic merits of the pictures are to be found. Mrs Arbuthnot, the friend of

Wellington, noted that Jones's pictures were the 'least awful' part of the arrangement at the palace, but the nature of their slight superiority was not indicated.[67] It seems reasonable to surmise that the king had chosen Jones as an artist who could execute a 'truthful' representation of a battle, on a large scale, in an intelligible manner that would please military experts. Jones was clearly the chosen artist of the establishment. In the 1830s he received another prestigious commission, to paint a naval battle for the Greenwich Hospital.[68] His later career was blighted by inability to secure more commissions for battle pictures or to sell those he produced speculatively.

The status of battle painting, in the first three decades after Waterloo was ambiguous. The Royal Academy did not exhibit more than one such picture in five years during the period, implying that artists were not active in the genre and that patrons were unwilling to purchase works of that nature. Conversely, George Jones benefited from a succession of commissions from sections of the ruling class allied to the monarchy and the forces. His admission to the Academy was undoubtedly accelerated, if not secured, by his success in obtaining such commissions. All his works in these commissions were large-scale representations of battle in the detailed, 'documentary' manner of his BI picture, and all were hung prominently. Clearly, his pictures were purchased as 'proof' – as accurate representations of national victories. Yet his work was not overtly propagandistic in the manner of Gros's celebrations of Napoleon; their use of the techniques of topography gave them the illusion of being historically truthful.

The status of battle painting was still very much an open issue in the 1830s. The only works to appear regularly were in the manner of Cooper's 'skirmish' scenes, which were on a small scale in the manner of Salvator's 'bandit' scenes and did not have to be read as either history or 'document'. In the following decade the status of the genre, and whether it was compatible with the national 'character', were debated in connection with the schemes for redecorating the Palace of Westminster. The importance of the palace ensured that the questions whether and how the military heritage was to be depicted were given a public airing. Reviews of the 1847 exhibition provide valuable evidence of the continuing debate about the status of the genre and what constituted a 'good' essay in it. It will be seen that the terms of the debate had shifted from those of the 1820s and had become more rigorously tied to issues of 'truth' and 'art'.

Notes

1 Dighton, see below, and Manskirch.
2 Lalumia, pp. 14-18.
3 *Ibid.* Lalumia, p. 6, links with panorama painting, a 'low brow' medium of entertainment.
4 Arthur Bryant, *The Great Duke,* 1971, pp. 400-1.
5 T. S. R. Boase, *English Art, 1800-70,* p. 300.
6 F. W. Haydon, *Benjamin Robert Haydon: Correspondences and Table-Talk,* 1876, I, p. 285.
7 *Ibid,* p. 92.
8 Oliver Millar, *The Queen's Pictures,* 1977, p. 88.
9 John Dillinger, *Benjamin West; the Context of his Life's Work,* 1977, p. 88.
10 *Loc. cit.*
11 R. Rosenblum and J. W. Janson, p. 69.
12 Lorenz Eitner, *Gericault's 'Raft of the Medusa',* 1977, p. 3.
13 I am indebted to William Vaughan for allowing me to read an unpublished paper on the 'English school', see also Boase, 1959.
14 *Critic,* 7 April 1860, p. 437.
15 Catalogue of the Works of British Artists placed in the Gallery of the British Institution, 1811, pp. 11-12.
16 Minutes of the British Institution (Victorian and Albert Museum), 1815.
17 Peter Fullerton, 'Patronage and pedagogy: the British Institution in the early nineteenth century', *Art History,* Vol. 5, No. 1, pp. 66-7.
18 *Times,* 3 February, 1816, p. 3.
19 London, V & A, *Cuttings from English Newspapers,* pp. 1194.
20 Samuel Redgrave, *A Dictionary of Artists of the English School,* 1878, p. 15.
21 *The Farington Diary,* ed. James Greig, 1928, Vol. 8, 1822, p. 30.
22 T. Smith, *Recollections of the British Institution,* 1860, p. 80.
23 *DNB,* 1892, Vol. 30, pp. 198-9.
24 British Institution catalogue, 1816.
25 L. C. Jackson, *The United Service Club and its Founder,* 1931, *passim.*
26 G. A. Storey, *Sketches from Memory,* 1899, p. 64.
27 G. E. Fussell, *James Ward, RA,* 1974, p. 47.
28 *Ibid,* p. 95.
29 Edward J. Nygren, *James Ward's 'Gordale Scar'* (Tate Gallery), 1982, p. 47.
30 *Art Journal,* 1849, p. 181, published fragments of Ward's unpublished autobiography.
31 S. Uwins, *A Memoir of T. Uwins, R.A.,* 1858, I, p. 38.
32 J. Frankau, *William Ward and James Ward, R.A.,* 1904, p. 39.
33 Elizabeth Pakenham, *Wellington: Pillar of State,* 1972, p. 40.
34 *Repository of the Fine Arts,* 1 March 1816, p. 155.
35 Fussell, p. 119.
36 *Repository of the Fine Arts,* 1 March 1816, p. 155.
37 *Literary Gazette and Journal of the Belles Lettres,* No. 251, 3 March 1821, p. 139.
38 British Institution catalogue, 1816.
39 *Loc cit.*
40 M. Postle, 'Luke Clennell' unpub. M.A. thesis, Courtauld Institute, University of London, 1981.
41 T. H. Ward, *Men of the Queen's reign,* 1885, p. 188.
42 Tyne and Wear County Council Museums, *Luke Clennell, 1781-1849,* 1981, p. 2.
43 *New Monthly Magazine and Universal Register,* V, March 1816, p. 154.
44 *The Examiner,* No. 426, 25 February 1816, pp. 124-4.
45 John Pye, *The Patronage of British Art,* 1845, p. 386.
46 Clement and Hutton, I, p. 153.
47 J. Maas, *Victorian Painters,* 1969, p. 74.
48 *Athenaeum,* 2 January 1869, p. 23.
49 Pye, p. 386.

50 Unattributed cutting in the artist's file, Witt Library.
51 British Institution catalogue, 1816.
52 Marston, 1815, p. 410.
53 *Examiner*, 25 February 1816, pp. 124-5.
54 A. L. Rowse, *The Later Churchills*, 1958, p. 97.
55 Charles Campbell, *The Traveller's Complete Guide through Belgium, Holland and Germany*, 1817, p. 62.
56 A. G. H. Bachrach, 'The field of Waterloo and beyond', *Turner Studies*, I, No. 2, p. 8.
57 Royal Academy catalogue, p. 62.
58 Campbell, p. 62.
59 *Times*, 6 May, 1851, p. 6.
60 *D. N. B.* 1888, 'Dighton', XV, p. 74.
61 W. Y. Carmen, ''The battle of Waterloo' by Denis Dighton', *Journal of the Society for Army Historical Research*, 1965, p. 55.
62 Oliver Millar, *Later Georgian Pictures in the Collection of H. M. the Queen*, 1972, p. 32.
63 Pye, p. 387.
64 Carmen, p. 55.
65 *Examiner*, I, January 1824, p. 8.
66 J. Hichberger, 'Captain Jones of the Royal Academy', *Turner Studies*, Vol. 3, No. 1, p. 17.
67 *The Journal of Mrs Arbuthnot*, ed. the Duke of Wellington and Francis Salford, 1950, p. 313.
68 Redgrave, p. 242.

CHAPTER TWO

The Westminster Palace competitions

In 1834 the ancient Palace of Westminster, home of the two Houses of Parliament, burned down. The process of rebuilding and decorating was perceived as an opportunity for large-scale public patronage of the arts. It would not only produce the best possible and therefore most fitting monument to the birthplace of democracy, it would provide 'encouragement' to painters and sculptors. Generous patronage would support the most ambitious artists to develop the genres which could not thrive on private, and therefore small-scale, commissions. This would add to the glory of the 'national school' of art.[1] It was perceived as the perfect occasion upon which 'desirable' forms of art could be called forth. Such enthusiasts as Benjamin Robert Haydon lobbied for the scheme to foster history painting.[2]

It is important to note the intense interest displayed by the Press, reflecting a new concern on the part of the urban bourgeoisie with the visual arts.[3] Closely connected with that concern was the desire for the nation to compete in the production of great art, and the growing myth that art could exercise a beneficial moral influence on the working classes. Both concerns lay behind the establishment of a Royal Commission to consider the interior decoration of the palace. The commission's terms of reference proclaim a broad programme for using the competitions to 'facilitate the Promotion of the Fine Arts in this Country'.[4] The commissioners were for the most part connoisseurs and collectors, 'art experts' and painters. Their chairman was the new Prince Consort, who was imbued with contemporary German theories on painting and art history.[5] The commission was less rigidly aristocratic than the directors of the British Institution had been twenty years before, the new elements being industrialists and scholars. The decisions made by the commission showed a predictable bias towards history painting as the most desirable and important branch of art.

In April 1842 the commission announced that a cartoon design competition was to be held, the subjects to be drawn either from British

history or from the most venerated national authors, Shakespeare, Milton and Spenser. The designs were to be executed in charcoal as a basis for wall paintings.[6] Analysis of the entries reveals a tendency to shy away from contemporary or even fairly recent history. Only one cartoon took its subject from a period later than 1500 and the majority were placed before the Norman conquest. This shunning of contemporary history reveals how apart the British and French schools were in the first half of the nineteenth century, and how completely the example of West and David, who had married the principles of history painting with recent times, had been ignored by British artists. It is probable that, on one level, contemporary themes were felt to be too colloquial for such a context. In his book on historical themes in Victorian art Roy Strong has shown that, far from being neutral figures, many historical figures were politically loaded and their characters used to exemplify meanings that were sometimes contradictory. A personality such as Cromwell, though, whose meanings were so explosively relevant was undoubtedly more contentious than a more distant figure such as William the Conqueror.[7]

No battle paintings or contemporary military subjects were submitted for the cartoon competition. The remarks of Hallam in his *Observations of Principles which may regulate the Selection of Paintings in the Palace of Westminster* (1844) suggests that the situation of battle painting within the category of history painting was by no means undisputed:

> Some indeed, have, perhaps a notion that nothing but parliamentary or at least civil history should be commemorated on these walls. But the majority would probably be willing to let Trafalgar or Waterloo find a place; . . . yet with this extension it may be suspected that really good subjects would not be found over numerous. Battles we have, of course, but I cannot reckon battle pieces the greatest style of historic art, and since the introduction of field artillery and scarlet coats, they are much less adapted to it than they were.[8]

Hallam plainly considered modern warfare undignified and the costumes glaringly coloured. It is difficult to decide what he would consider 'really good subjects', those which could be depicted without artillery or scarlet coats, or those which had pleasing historical associations. Hallam added a scathing reference: 'Versailles may show us what they are good for.'[9]

French battle painting was very much in the minds of British painters and critics during the period of the Westminster project. Louis-Philippe had commenced the rearrangment of the paintings commissioned by Napoleon for Versailles. He also commissioned artists to produce

enormous battle paintings to supplement those of David and Gros. His aim was to create a military museum celebrating French successes in the domain of war.[10] Surprisingly, no British artists refer to Versailles in diaries or letters, but interest in the museum was intense enough to warrant the printing of an English-language guide to the paintings, published in 1843.[11] It is likely then that Charles Barry, architect of the Parliament buildings, had Versailles in mind when he proposed that Westminster Hall should be made into a pantheon of naval and military heroes. In his paper before the select committee of 1841 Barry pointed out that such a plan fitted well with the hall's traditional function as a repository for war trophies.[12] He proposed the commissioning of twenty statues of statesmen and twenty-six of naval and military commanders. He proposed that above and between the statues there be hung twenty-eight large paintings (16ft by 10ft) whose subjects 'might relate to the most splendid warlike achievements connected with English history and these as well as the statues that are proposed to divide them may be arranged chronologically. . .'.[13]

Barry's scheme was decidedly similar to Louis-Philippe's arrangement at Versailles, where the paintings orchestrated a chronological tour through French history. It would have overtly linked military achievement with national glory. The equation would scarcely have been popular with those politicians who saw a standing army as an anti-democratic instrument of repression. In the early 1840s the army's popularity with the bourgeoisie was low. In 1840 the first of a number of attempts to reduce aristocratic influence over the army was launched in a move to abolish promotion by the purchase of commissions. In the early 1840s most military activity was either at a great distance or too close to home. The army was often brought in to quell unrest in provincial industrial towns, and was regarded by many sections of the middle and working classes as a government tool for enforcing repressive laws.[14] Barry's equation of Britain's greatness with her military tradition was likely to be badly received by elements of the bourgeoisie as well as the radical press, who were beginning to see the army as a locus for class struggle.

Barry's motives for proposing such a pro-military scheme may not only have been influenced by a desire to emulate France. His scheme had a decidedly Gothic Revivalist flavour:

> With reference to further effect in Westminster Hall if the proposed arrangements of painting and sculpture were adopted in connection with a display of armorial bearings and ancient armour on the sides and above the windows, trophies and banners etc suspended from the roof, ornamental glass and tesselated pavement and decorative painting, the whole

would have a peculiarly striking appearance and arouse old and interesting associations connected with our national history.[15]

Mark Girouard has shown that the Gothic Revival was instrumental in constructing the contemporary officer as an admirable figure. By stressing the essentially chivalric nature of such 'military virtues' as discipline, dedication and self-sacrifice it was possible, in terms of this ideology, to interpret colonial skirmishes as Christian crusades. These terms had been applied to Moore early in the 1820s but the language of chivalry was used, increasingly self-consciously, by elements within the army in the 1840s. William Napier, whose brother led a controversial campaign in Sind in this decade, was particularly fond of describing his imperialist forays in the terms of medieval knighthood.[16]

The only work depicting near-contemporary military history in the completed Houses of Parliament was Maclise's waterglass painting *The Meeting of Wellington and Blucher, etc.* Maclise was commissioned to paint this and *The Death of Nelson*. The pictures were conceived as part of an integral scheme for the Royal Gallery with the subjects to the 'military history and glory of the country'.[17] It is noteworthy that most of the subjects described by the phrase were not battle pictures. Of the eighteen scenes only three showed a battle in progress; the majority illustrated some aspect of the aftermath of war: *Edith finding the dead Body of Harold, Edward the Black Prince entering London at the side of King John of France* and *Lord Cornwallis receiving the Sons of Tippoo as Hostages.*[18] It will be seen from these titles that war was not perceived as glorious only when it led to military or political advantage for Britain. Four of the frescoes dealt with the death of military or naval heroes in battle – Harold, Nelson, Wolfe and Abercrombie. The preponderance of tragic heroic death scenes suggests a bias towards moral rather than practical victories, and is part of the discourse of anti-militarism.

The competition for portable oil paintings for the Houses of Parliament was important in defining the position of battle painting in the hierarchy of genres in the late 1840s. The competition was to have been judged in 1846 but a decision was postponed for a year, to allow the artists more time. This was doubtless because of the labour required to produce canvases of eighty square feet. A reviewer pointed out that the unsuccessful paintings were most unlikely to be sold since their dimensions would 'disqualify them for reception in ordinary-sized buildings and even those who have large mansions are generally indisposed to receive them'.[19]

There were 120 entries, sixty-nine of which depicted specific historical events. The remainder were described as 'ornamental or fancy',

suggesting that historical or didactic subjects were deemed most suitable for the competition. For the first time in the Westminster Hall competition there were representations of recent battles. The majority of the military paintings, though, were connected with the activities and especially deaths of individual heroes. There were two versions of 'the death of Nelson' and two of 'the death of Sir John Moore'.

Three battle paintings and the reviews they received are of particular interest. The criticisms of this exhibition reveal conflicting notions about the function of battle painting, about the desirability of the genre in general and of attitudes to foreign influences upon British battle painting. The three painters – Sir William Allan, Thomas Sidney Cooper and Edward Armitage – are considered individually, since their career patterns and choice of pictoral sources indicate the range of practitioners of the battle painting genre in the early 1840s. The reviews of their pictures suggest that the Westminster Hall competition should be considered in the context of the continuing dispute about the existence and nature of the 'English school'.

Thomas Sidney Cooper was an animal painter who had established a successful practice in sheep and cow subjects. He trained at the Royal Academy schools before moving, in 1827, to Brussels. There he came under the influence of a Belgian animal painter, Verboeken, and studied the Dutch masters of the seventeenth century. In 1831 he returned to London and began to exhibit his prolific output at the Suffolk Street galleries, the British Institution and the Royal Academy.[20] His biographer, Sidney Sartin, asserts that, of the 226 paintings exhibited at the RA between 1833 and 1902, only one, *Hunting Scene* (1902) was neither a cow nor a sheep picture.[21] During his time in Brussels he experimented with 'pure' landscape and portraiture, but his success in the genre of animal painting made it impossible for him to forsake it as a mature artist. This tendency for artists to become 'type-cast' is discussed below. The Westminster Hall battle painting represented, therefore, a dramatic departure for Cooper. In his entertaining autobiography the artist does not discuss his motives for entering the competition, but it must be concluded that like Ward, he hoped to demonstrate his facility in other genres. His status as a master of a lower-class genre made it unlikely that he would receive full Academic honours. He had been elected ARA in 1845, at the comparatively late age of forty two, and he may well have hoped that not only new commissions, but Academic acceptance would result from the competition.[22]

His entry, *The Defeat of Kellerman's Cuirassiers and Carabineers*, was an episode from the battle of Waterloo. It is known that he obtained

permission from Captain William Siborne to make sketches from his model of the battle. Siborne, a veteran of the battle, had constructed a relief map with wooden figures much like those now used for war games. The model was displayed at the Museum of the Royal United Service Institution in Whitehall.[23] Siborne was also the author of a *History of the War in France and Belgium, 1815,* which contained minute details of the battles of Quatre-Bras, Ligny, Wavre and Waterloo.[24] It was the standard source for battle painters as late as 1914 and was used by, among others, Elizabeth Butler. Cooper's profoundly practical, fact-seeking approach is reminiscent of Jones, but also of historical genre painters of this generation such as E. M. Ward. He is known to have scoured pawn-brokers' shops for authentic costumes and weapons. He also 'borrowed' a Life Guard from Albany barracks as a model, to ensure that he achieved a correctly military bearing in his figures.[25] Sartin has shown that Cooper drew extensively on contemporary and historical sources for the individual figures in the painting; 'the riderless horse in the foreground of his picture is derived from bronze reproductions of Guillaume Cousteas's *Chevaux de Marly.'* [26] Sartin cites similar debts to the sporting prints of Alken and Wolstenholme; the French Romantic painters, Gros, Delacroix and, in particular, Géricault. Cooper owned several examples of horse lithographs by the latter.

The finished painting is minutely detailed in style and far removed from any of the pictorial sources postulated by Sartin. The canvas, 8ft x 10ft, contains approximately 800 figures. The principal innovation is the absence of a central group from which the rest of the action could devolve. This can be traced to the artist's use of a map-like layout for his information. One of the most praised aspects of the painting, which can only be seen on close inspection, is the carefully studied action of the horses and riders.

Cooper's battle piece did not win a prize in the Westminster Hall competition, but its critical reception was very favourable. The *Art Union Journal* described it as 'among the best pictures of its kind that has ever been painted'.

> Mr Sidney Cooper's picture of 'The Defeat of Kellermann's Cuirassiers and Caribineers' (109) must be regarded as the best production from that artist's easel. It was trying ground for one hitherto occupied with the more peaceful animals to grapple with the striking and varied movement of cavalry. Mr Cooper has done his work well and if it may be objected that his men are not insufficiently accidental looking combinations, he cannot at least be charged with allowing his subject to degenerate into caricature or contortion – so common in battle treatments.[27]

A book reviewer in the *Literary Gazette & Journal of the Belles Lettres*

found the painting 'realistic'. Although ostensibly discussing a new memoir of Waterloo the reviewer broke off to eulogise Cooper's work.

> It seems as if artist had been present with the writer and had transferred in the most graphic and spirited manner to the canvas what he had committed with such particular effect to the paper. The chivalrous encounters, the almost single combats, the groups of cavalry slaughterings, the flight, the rally, the rush of riderless horses, the dying and the dead scattered among the trampled corn – all told the terrible tale of the last charge and effort of the French to retrieve the discomfiture of the day. . . It is indeed such a battlepiece, and upon the largest scale such as has never been produced before by English painter, if by the greatest foreign master in this style of art.[28]

The language of the review is extraordinarily enthusiastic: 'one may easily imagine he hears the cannon boom'.[29] Reviewers who were not pleased by Cooper's picture, such as the critic of the *Art Journal*, were willing to concede that it was a 'very faithful statement of the fact'.[30] The use of such terms as 'statement' and 'fact' seem to imply a belief that a painting could in some way 'record' the actuality of a battle. There can be little doubt that the antiquarian approach adopted by Cooper, and the clarity of each figure set in careful relation to the others, gave the illusion of authenticity. His painting demanded to be interpreted in this way because it manipulated the language of reportage. The work demanded to be 'read', each small group at a time. This can be related to Frith's technique in constructing huge, detailed scenes which were admired by contemporaries as depictions of modern life.

The second major contemporary battle painting in the 1847 competition was also of the battle of Waterloo. Its painter, William Allan, had been trained at the Trustees' Academy in Edinburgh at the same time as David Wilkie. Allan's route to battle painting was very similar to Atkinson's. He visited the Russian court in St Petersburg and, through the royal physician, Sir Alexander Crighton, received royal patronage.[31] Allan was still in Russia during the invasion of the Napoleonic army in 1812, and witnessed the horrors of the campaign and the winter retreat. On his return to Scotland he sold genre scenes of Russian peasant life. He was also working on several historical pictures commissioned by the Grand Duke Nicholas.[32] The most crucial influence on his career was his close friendship with Sir Walter Scott, formed around this time. Under the influence of the novelist, Allan turned to the depiction of Scotland's national history. 'He devoted his great energy and sense of romance to the history of his native land.[33] Allan became absorbed by stories of medieval chivalry, a current fashion with the English aristocracy. He attended and later painted the famous Eglinton

tournament, a mock chivalric joust attended by prominent members of London society. It seems likely in view of the close relationship betweem artist and novelist that the inspiration to depict Waterloo also came from Scott. Scott had devoted several works to the exploration of the personality cult of the emperor, *The Field of Waterloo* and *The Life of Napoleon Buonaparte.* [34]

Allan's first Waterloo picture, *The Battle of Waterloo, 18 June 1815, from the French Side*, was exhibited at the Royal Academy in 1843. It was favourably received:

> This picture contains a very correct notion of the battle. It is in the proper sense of the word 'graphic'; it is painted after the manner in which some of the battles of the campaigns of Marlborough and his contemporaries are represented. The divisions, battalions and regiments are all defined and the plan and circumstances of the battle may be traced with accuracy. As a work of pictorial art it also has high claims, it is full of life, the distances well preserved, the groups well arranged and the general composition combined.[35]

The critic clearly believed that in painting a battle an artist had two distinct functions; to inform and to please aesthetically. Allan's picture is considered successful in fulfilling its 'documentary' function and its merits as a 'work of art' are considered a secondary bonus. The distinction is crucial to understanding why, despite the popularity of their works with some critics, Allan and Cooper did not succeed in the Westminster competition. Their paintings failed to conform to the tenets of history painting. One of the basic lessons was that all figures should be idealised. In the *Third Discourse* Reynolds recommended continuous study of the great masters to the aspiring painter:

> By this means, he acquires a just idea of beautiful forms; he corrects nature by herself, her imperfect state by the more perfect. His eye being enabled to distinguish the accidental deficiences, excrescences and deformities of things, from their general figures, he makes out an abstract idea of their forms more perfect than any one original; and what may seem a paradox, he learns to design naturally by drawing his figures unlike to any one object. This idea of the perfect state of nature, which the artist calls the Ideal Beauty, is the great leading principle by which works of great genius are conducted.[36]

In the mid-nineteenth century, the Reynoldsian notions of the hierarchy of genres and the eighteenth-century definitions of what constituted history painting were being challenged. The Westminster competitions represent a late attempt to construct a British school of history painting in the Reynoldsian sense. The intended destination of the paintings and the national importance of the building seemed, to a generation of men whose ideas were based on academic theory, to

demand history painting. The reviews of the exhibition show a split between those critics who accepted Reynoldsian art theory and those whose criteria of 'good' art were based on notions of fidelity to nature and 'truth'. If High Art was based on the idealisation of natural forms mediated through a study of the great masters, then 'factual' battle paintings could not approach the status of High Art. Topographical battle painting was seen to be important for retelling the 'truth', for recording the particular. The critic of the *Athenaeum* believed that such paintings as Cooper's should occupy a category quite distinct from history:

> ... with excellencies of such a peculiar nature as this picture possesses, it was as injudicious to put it in the same category with historical works of natural and colossal proportions as it was to include in the same Sir William Allan's great work.[37]

Its merit rested on the 'truthfulness' of the painting:

> Without any question, of all the representations of the day or place – this is one of the most successful. We cannot attempt the praise of a work so full of details as this – every particular of which exhibits the almost exhaustless resources of the artist's invention. In the conduct of the groupings, while strict regard has been paid to such situations as the history of the event prescribes, Sir William has contrived to show how the incidents of military manoeuvre may be modified in line or perspective or by the inequalities of ground. The conventionalities to which we have been too commonly treated in these matters Sir William Allan has dispensed with; filling his picture with episodes at the bidding of his own imagination, that offer no contradiction to its severer facts.[38]

The only battle picture to win a premium in the Westminster Hall competition was perceived by many critics to belong to the tradition of history painting. Edward Armitage, its painter, had studied in the Paris studio of Paul Delaroche.[39] His time in France had coincided with a number of projects which had used paintings to celebrate national glory. Armitage had participated in the decoration of the hemicycle in the Ecole des Beaux Arts.[40] Delaroche, the son-in-law of Horace Vernet, was involved with the Versailles project. It will be seen that Armitage's training was very different from that of either Cooper or Allan. His aspirations to be a History painter were aided by his education in France. His absorption of the tenets of History painting had won him spectacular success in the earlier Palace of Westminster competitions. His cartoon *The Landing of Julius Caesar* had won him £300 and the commission for his two frescoes in charcoal, *The Spirit of Religion.*[41]

The subject of Armitage's entry was *The Battle of Meeanee*, the most decisive of Sir Charles Napier's encounters in the Sind campaign.

Napier's successes in Sind were perceived, at least initially, as restoring British prestige in the Indian subcontinent, after appalling defeats in Afghanistan and India.[42]. Armitage's choice of subject was shrewd, stressing as it did that Britain's military genius was continuous, not a thing of the past. *Meeanee* won him a further premium of £500. The committee expressed a desire to hang the painting at the palace but were forced to allow the Queen to buy it. The enthusiasm of the committee suggests that they accepted the picture as a 'History' painting of a battle. An adverse critic attacked it as merely fact, thus challenging its appropriation for the revered category:

> It is one of those huge battle pieces like Horace Vernet's in the galleries of Versailles. . . This though the record of an historical incident is not an historical picture in the true sense of the term. It has no elevation of abstractation but renders common circumstance with great imitative power.[43]

Armitage's picture is said not to be History because it 'records' 'common circumstance'. 'To have invented and filled so large a canvas with details is itself an art – but not of the high standard demanded by the commissioners for a first class prize.'[44] The critical response to the Palace of Westminster competition reveals the contemporary uncertainty as to what constituted a History painting. A further source of confusion was the assumption that the ability to produce History painting was the true test of the strength of a national school. Thus the critic of the *Athenaeum,* voicing anti-French views, was forced to argue that Vernet's art was not true history painting either. Marcia Pointon, writing on the Exposition Universelle, held in Paris only seven years later, has shown that French critics attacked the British on similar grounds. The English school was condemned as being concerned with genre, 'with material things, with the reproduction of fact'.[45]

The Armitage painting represented a problem for critics and connoisseurs who were anxious to encourage a British school, since it was obviously influenced by contemporary French art. Admitting the picture was tantamount to accepting France as perpetuator of the Great Tradition. Its success indicates that the judges of the competition were willing to accept it as a battle painting in the grand manner, tacitly endorsing the French school which had inspired it. In the next chapter we shall see that the new theories of painting popularised by Ruskin not only challenged the notion of the superiority of history painting but condemned the grand manner as insincere, inhuman and un-British.

A new type of criticism, to become increasingly familiar after the

Crimean war, emerged in relation to Armitage's controversial canvas. This was to attack a work on grounds connected with the event it depicted – a confusion between the work and the subject. In the following passage the artist is at fault first for selecting the subject and then for the events of the battle. It should be remembered that the Sind campaign was still so recent as to be a cause of controversy:

> In this picture, the choice of subject, instead of illustrating a glorious event, will hold up the British Army and Sir Charles Napier to the reprobation of mankind. We must protest against this misapplication of the Fine Arts. Nor do we think that the veteran Napier would allow the artist to escape his sarcastic sneer for this derogating from his discipline as a general and his moral rectitude. Was there nothing to deserve admiration in the battle of Meeanee? Nothing to select but 'single combats, where no quarter was given, none called for, none expected'? English soldiers, themselves in absolute disorder, bayoneting a fallen foe! Was there no generalship, no humanity, no 'true courage' on that day in Englishman's breasts to animate an artist's genius? [46]

Clarke objects to the picture because it focuses on chaos, violence and anger, not because he believes that such things did not occur at Meeanee but because their representation reflects badly upon Napier and the army. Other incidents from the battle might have been represented, incidents nore 'national' and 'characteristic'. Chivalrous action and magnanimous behaviour are more 'true' of the army than 'absolute disorder, bayoneting a fallen foe'. 'A few lines of Dibdin's illustration of that virtue in which he represents a brave soldier weeping over a wounded prisoner' is a truer depiction than Armitage's scene of 'butchery'.[47]

The issues raised here go beyond the mere preference for one means of representation over another, although the anti-history painting discourse is undoubtedly implicit. The writer is anxious to see a controlled presentation of the common soldier. Yet there is no evidence that his own 'truth' was based on anything more concrete than his own beliefs.

The Palace of Westminster competition was significant in the history of British battle painting for two reasons. It marked the last occasion on which High Art battle painting would triumph over the 'topographical' school, and the theoretical basis for the success of Armitage's picture was already being replaced by a more 'realistic' aesthetic. Also, and perhaps more importantly in terms of the social and political location of the army, the 'British soldier' was beginning to be thought of as an archetype, of deeper significance for his moral than for his fighting qualities. In the first three decades after Waterloo there were

a number of attempts to establish a British school, and battle painting was perceived to be related to it. Confusion reigned over the precise status of battle painting and, further, which genres of it were to be discouraged. Historical battle painting – in terms of accepted art theory, the most desirable form – had developed in France, and was thus inappropriate. Battle painting was then a site for ideological conflict between classes and interest groups. The nature of the debate shifted from whether battle paintings were art at all to which forms adequately described the British military character. In the post-Crimean period a new view of what the army meant to the nation strengthened this perception of battle painting as ideological.

The uncertain status of battle painting made it hard for artists to sustain a practice in the genre alone. The routes into it were, for the most part, from low-ranking genres, indicating that it represented a branch of High Art which could be best approached by artists skilled in the representation of horses. The only artists who consistently worked at battle painting in this era were Abraham Cooper and George Jones. Cooper produced small, lively scenes of combat, often exploiting the picturesque qualities of historical costume. It was to him that the principal commissions went, and he who most consistently produced 'important' large-scale pictures of contemporary subjects. Jones experienced considerable difficulties in sustaining his battle painting and had to resort to more commercial topographical views and genre scenes. The uncommerciality of battle painting was to contribute in the next generation to the emergence of new forms for the representation of aspects of war.

Notes

1 T. S. R. Boase, 'The Houses of Parliament', *Journal of the Warburg and Courtauld Institutes*, XVII, 1954, p. 319.
2 *Loc. cit.*
3 *Loc. cit.*
4 *Loc. cit.*
5 John Steegman, *Consort of Taste*, 1950, p. 130.
6 *Loc. cit.*
7 Roy Strong, *'And when did you last see your father?'* 1978
8 A. Hallam, *Observations on Principles which may Regulate the Selection of paintings in the Palace of Westminster*, 1844, p. 22.
9 *Loc. cit.*
10 Steegman, p. 129.
11 New Guide to the Palace Museum and Chateau of Versailles, etc. 1840
12 F. Knight Hunt, *Book of Cartoons, Frescoes, New Houses of Parliament*, 1846, p. 5.
13 *Loc. cit.*
14 Spiers, p. 82.
15 Report of the Select Committee, etc., 1841, Evidence of Charles Barry, Esq.

16 See the case of General Sir Charles Napier, J. Hichberger, *Turner Studies*.
17 Boase, 1978, p. 342.
18 *Loc. cit.*
19 *Athenaeum*, 3 July 1847, p. 246.
20 Stephen Sartin, *Thomas Sidney Cooper, CVO, RA*, 1976, pp. 59-78.
21 *Loc. cit.*
22 See, for example, James Ward and George Stubbs.
23 *Art Journal*, 1850, p. 246.
24 W. Siborne, *History of the War in France and Belgium, 1815*, 1844, 2 vols.
25 T. S. Cooper, *My Life*, 1890, I, p. 230.
26 Sartin, p. 34.
27 *Athenaeum*, 17 July 1847, p. 766.
28 *Literary Gazette and Journal of Belles Lettres*, 5 June 1847, p. 415.
29 *Loc. cit.*
30 *Art Journal*, 1862, p. 177.
31 William Allan, 'Sir William Allan', *Connoisseur*, June 1965, pp. 88-93.
32 *Ibid.*, p. 88.
33 *Loc. cit.*
34 The disapproval was always mixed with a feeling of fascination.
35 *Times*, 9 May 1843, p. 6.
36 Joshua Reynolds, *Fifteen Discourses upon Art, etc*, 1769-90.
37 *Athenaeum*, No. 1029, 17 July 1847, p. 766.
38 *Loc. cit.*
39 Norman D. Ziff, *Paul Delaroche: a Study in Nineteenth Century French History*, 1977, p. 168.
40 *Ibid.*, pp. 184-6.
41 Clement and Hutton, I, p. 23.
42 See below, chapter eight.
43 *Athenaeum*, 3 July 1847, p. 705.
44 *Loc. cit.*
45 Marcia Pointon, 'From the midst of warfare and its incidents to the peaceful scenes of home', *Journal of European Studies*, XI, 1981, p. 31.
46 H. G. Clarke, *A Critical Examination of the Pictures at Westminster Hall*, 1847, p. 31.
47 *Ibid.*, pp. 149-50.

CHAPTER THREE

The Crimean War

The Crimean war (1854-56) was a watershed in civil-military relations. In previous wars, events had been followed only at some considerable distance, with the majority of the population aware of hostilities only in so far as they meant increased taxation or higher prices. During the forty years since Waterloo communications had reached new levels of speed and efficiency. The railways, the penny post and, above all, cheap newspapers meant that the war overseas could be followed by a mass audience.[1] The press had achieved greater influence as a medium for the mobilisation of opinion, and was instrumental in fanning the flames of bourgeois and working class enthusiasm.

The aims of the war were ill defined. A confrontation between Russian and Turkish monks over the holy places in Constantinople had been the sparking point, and France and Britain intervened in support of Turkey. Their motives differed. In the case of France, the new emperor, Louis Napoleon, was eager to bolster his regime by military glory in emulation of his namesake. The British were motivated partly by the desire to frustrate Russian expansion in the eastern Mediterranean. The immense enthusiasm for the war suggests fervour which had little to do with the issues at stake. The figure of the Czar was the focus of much hatred as a despotic monarch, an Orthodox Catholic and a foreigner.

The anti-Peelite Tories called for an assertion of British power but also wanted to embarrass Peel's administration. Through a press campaign they demanded assertive action against Russia. Lord Aberdeen, the Prime Minister, was pressured by public opinion into declaring war. There were street demonstrations and opponents of the war were burnt in effigy.[2] There has been no adequate research to identify those involved but the upsurge of feeling seems to have affected all classes of society. One element may have been the wish to prevent France appropriating any glory that was to be won. Since the late 1840s the country had been rearming against fears of French invasion. This must

have contributed to a general feeling that forty years of peace was too long. In fact the army had been active during that time but in remote colonies such as Canada, New Zealand, Africa and India.[3] Many commentators welcomed an opportunity for Britain to assert her authority and reclaim the position as arbiter of Europe which had been won on the field of Waterloo.[4]

A number went further and urged war as a positive good, seeing it as a moral purgative: 'war, so long as it is righteous war, is a natural even beneficial experience.'[5] In his poem *Maude* Tennyson saw war as the embodiment of

> ... higher aims
> Of a land that has lost for a little her lust for gold,
> And love of a peace that was full of wrongs and shames,
> Horrible, hateful, monstrous, not to be told;
> And hail once more to the banner of battle unrolled![6]

Such sentiments seem to condemn the bourgeois proccupation with trade and commerce, yet Tennyson's audience consisted of sections of that class. It is clear that he was articulating a moral justification for nationalist aggression couched in terms of the chivalrous defence of a weaker nation. The mythology that Britain was not militarist, and did not seek war, made it necessary to adopt the position that the nation was roused to fight in defence of Turkey. Britain was the just arbiter of world affairs, entering the war from altruistic motives.[7]

The catastrophic events of the first winter are well known. The military encounters paled into insignificance against the revelations of indifference and incompetence among the commissariat and senior officers. News of the huge losses from cold, disease and starvation was relayed to the public at home by William Howard Russell, correspondent for *The Times*. His revelations came as an enormous shock, since speedy victory had been confidently expected. A commission of inquiry was demanded and the government forced to resign.[8]

A group of influential businessmen and some Liberal Members of Parliament, formed in May 1855, bemoaned the losses and 'waste' of the war calling for the army to be run on 'business principles'.[9] They claimed to be non-political, but the attack was directly aimed at the aristocracy who controlled the upper ranks of the army. They argued that incompetence of the kind manifested in the Crimea could be avoided if officers were selected by ability rather than by purchase. It has been argued that, far from being neutral recorders of military incompetence, Russell and the editor of *The Times* deliberately exaggerated conditions at the front for the benefit of anti-aristocratic elements among the middle classes.[10] It seems clear that the war was

the site of struggle between party and class interests, and this was to have a profound influence on dominant ideologies of the army. The war led to a sharp increase in the number of military paintings at the Royal Academy the following year. In a recent book on the period Matthew Lalumia asserts that:

> Victorian art dealing with the Crimean war abandoned the heroicizing modes of traditional battle art for depictions that were at once more realistic, in terms of graphic truth to nature, and more Realist, in terms of the subjects chosen and the manner in which they were treated. The resulting anti-heroic vision of the war stemmed from the current concern for the fate of the army in a daunting and unpopular war.[11]

As we saw in the previous chapter, the 'heroicizing modes of traditional battle art' were in the 1840s already dominated by representations of war that were read as 'factual' and 'realistic'. Only in such public, state-patronised spheres such as the Westminster Hall competition did battle art in the 'grand manner' meet with success. In no sense could topographical battle paintings be described as 'realistic', although it might be conceded that such works as Barker's *Charge of the Heavy Brigade,* in their obsessive concern with details, did reflect the current trend towards archeological exactitude. Genre representations *did* predominate numerically over battle paintings at the RA during the period of the Crimean war, but since the trend had started in 1830 it hardly seems sensible to attribute it to a new distaste for 'heroic' images.[12] While Academic battle painting continued to suffer from lack of patronage the new genre of battle painting pioneered on the post-Waterloo period received fresh impetus from the intervention of print sellers in the art market.

The disasters in the east did not diminish the public's interest and, as during the Waterloo campaign, there was a strong demand for 'documentary' images of the war. Agnew's, the Manchester publishers and print sellers, had been swift to perceive that photography could meet the demand much faster than topographical artists making prints. Roger Fenton, who had trained as a classical painter under Delaroche, was chosen to take photographs at the front. His brief was to take pictures of 'the people and scenes of historical interest'. Fenton embarked on the expedition under the special patronage of the Queen and Prince Albert and it may have been that the desire to please his royal patrons was responsible for the blandness of the finished results. Fenton directed his lens towards the agreeable aspects of the war: French and British soldiers amicably drinking beer; well fed soldiers cooking supper over a camp fire; commanding officers looking cool and competent in smart uniforms. It is said in defence that the limitations of his

[*51*]

medium precluded action shots but there can be no doubt that he eschewed chaos, disease and death. His orders from Agnew's were for photographs in the mode of 'art' representations of war – landscape, camp scenes, merry-making soldiers and generals in command. He also photographed 'local colour'; oriental troops from Tartar and Montenegro and transport camels.[13]

The Royal Academy exhibition of 1855, fourteen months into the war, displayed only five battle scenes of the Crimea. Unfortunately none can be located, but certain things can be deduced from the titles and the artists. George Jones exhibited *Balaclava – conflict at the Guns* and *The Battle of the Alma*; this latter picture was exhibited with an explanatory note in the catalogue, 'design for a large picture'. Since no larger version is known it must be assumed that Jones was unsuccessful in this speculation. The work was probably an oil sketch carefully delineating troop formation and topography. Abraham Cooper exhibited *Repulse of the Cossacks by the 93rd.* Since no critic mentioned the painting it may be concluded that it did not differ greatly from the small pictures of hand-to-hand conflict that he had been showing steadily since 1817. The third picture was by T. J. Barker, a representation of a troop horse standing beside its fallen master; it will be considered below.

The only new artist encouraged by the war to experiment with a new genre was Henry Selous (1811-90). Before 1854 he had practised in a number of genres particularly landscape and portraits. In 1843 he had won a £200 premium in the cartoon competition for the Palace of Westminster.[14] This, with his bias towards Shakespearean and other literary subjects, suggests that he aspired to be a history painter. From 1851 he worked almost exclusively on scenes from history, particularly Scottish subjects. It is as part of a transition from landscape to historical subjects that his 1855 entry may be considered, therefore. *The Glorious Charge of the Heavy Brigade at Balaclava, Oct. 15 1854* was the artist's first, and last, Academy battle painting. The absence of any critical attention and his failure to show any more pictures in the genre suggests that the experiment was academically and financially unsuccessful. The timing suggests that it was a speculative venture. The battle had taken place in mid-October 1854 and the news took three weeks to reach England. Selous must have worked swiftly to prepare a canvas for the RA in April the following year. It may have seemed to him that the enthusiasm aroused by the victories at Balaclava would have created a market. There is no evidence to suggest that such was the case. On the contrary, the dearth of battle paintings of anything more than cabinet size at subsequent Academy exhibitions suggests

that the audience were unwilling to buy large battle paintings in any style. In the pre-Crimean period large-scale, sometimes 'grand manner', battle paintings had been commissioned by groups who felt that the nation's victories should be exhibited in a public forum. The propagandist intention behind the British Institution competition and the St James's Palace scheme forced academic art debate on the status of the genre into the background. The Palace of Westminster and the critical discussion of the paintings intended for it, demonstrated that the question of the desirability of the genre to an 'anti-military' nation was also still unresolved.

Large-scale battle painting did enjoy a revival in the Crimean period, though outside the Academic or state systems. This was due to the patronage of print publishers and dealers, several firms of which commissioned ambitious works from Academic artists with a view to having them engraved and widely distributed. The Crimea was not the first war to receive such attention. Boydell's company had sent Devis and Atkinson to the field of Waterloo in 1815. In the 1830s Abraham Cooper had done a version of Waterloo for the print sellers Moon, Boys & Groves.[15] Art dealers had had an increasingly important impact on the contemporary art market from the 1840s.[16] In some ways their intervention was liberating, since it freed artists from the caprices of a patron. The relation between painter and dealer might take many forms: a dealer might buy a work from the artist's easel which had been painted speculatively, with no patron in mind. Alternatively a dealer right acquire the right to an unexecuted work on the grounds that a similar one had sold successfully. This competition for the work of living artists did much to send up prices and increase prestige, but it also led to artists being caught in a genre at which they were successful. Far fewer artists moved between genres in the 1860s than they had done in the 1830s. Consequently, despite the increase in numbers exhibiting at the RA in this period, proportionately fewer experimented with battle painting, and in the late 1870s artists found themselves 'type-cast' in one genre.

At the outbreak of the war the astute Ernest Gambart commissioned Armitage to go to the Crimea and produce two oil paintings which could be engraved and mass-produced. The choice of artist is indicative both of the wealth of the dealer and the importance he attached to the project. The fee is not known, but Armitage was one of the most important Academic painters of the day, having enjoyed a number of successes in the Palace of Westminster competitions. His *Battle of Meeanee* had been purchased for the royal collection by the Queen. Certainly he was the leading exponent of battle painting in the grand

manner. Gambart evidently wanted battle paintings that would go beyond topographical and military 'reportage' into the realm of High Art. Armitage was sent to the front to gather 'facts'.[17] Evidently 'truth' had become an indispensible criterion for any artist working on a military subject.

Armitage's two battle paintings, *Inkermann* and *Balaclava*, were exhibited in Gambart's Pall Mall Gallery in 1856, just after the close of hostilities. They formed part of a 'Crimean exhibition' designed to appeal to a public patriotically celebrating the peace and congratulating themselves on victory. The pictures were displayed with a portrait of the Queen by Barrett, underlining the relation of patriotism to monarchism. The bulk of the exhibition consisted of William Simpson's water colours. These had been commissioned by the dealer Colnaghi to be engraved and published in the form of a book. Entitled *The Campaign in the Crimea*, it was published at the same time as the exhibition, presumably affording Colnaghi valuable publicity.[18]

Armitage's paintings, although commissioned expressly to be engraved never were. The *Art Journal* attributed the omission to the outbreak of the Indian Mutiny and the consequent diversion of interest.[19] Since there was frequently a long delay between war and image, it is interesting to speculate whether Gambart was not in any case dissatisfied with the finished paintings and believed that they might not sell as engravings. The paintings attracted a great deal of critical attention but the reviewers were divided as to the merit of the works. One referred back to *Meeanee* :

> . . . in which he portrayed with marvellous power of drawing and skill in combination of forms and incidents the excitement of a soldier together with the spirit of an artist and the fidelity of a photographer. Mr Armitage works in the school of Vernet, and draws a battle as Sir Walter Scott would have described one. In his *Battle of Inkermann* we have a picture on canvas equal in merit to the celebrated description of the same great occasion by the Correspondent of the *Times.* [20]

The critic evidently believed Armitage's painting to be 'documentary' work, since he compared it with two media believed to convey pure 'fact' – the photograph and the news report. It is interesting that the name of Vernet was frequently mentioned in relation to British battle painting, to express approval or disapproval. It is difficult to gauge what the prevailing view of Vernet's art was at this period. He was invoked in relation to Barker's spirited but organised scenes of cavalry but also to Armitage's very different *mêlée* scenes. What is clear is that British battle painting was always compared with what was thought to be French battle painting, although perceptions of the latter seem to have

varied widely. Articles on Vernet began to be published in art journals from around this date.[21]

Another writer found the painting to convey an 'imperfect conception of the battle'. The reason for the reservation is interesting. Armitage had abandoned the 'panorama' view of the field and troop dispositions in favour of the 'close-up':

> It is historically true that our troops were opposed to and beat an overwhelming force of the enemy; but the vast disproportion does not appear in the pictures. We can perfectly understand the predilection of the painter for large figures; but perhaps, with all the facilities which he has enjoyed, it might have been better to have shown more of the field and more of the dispositions of the enemy: this would by no means have enfeebled his description of the incidents he has introduced.[22]

The critic has noted that the battle artist has a level of choice as to which incidents he represents and in which style. He does not draw the conclusion that this exercise of choice must logically prevent a painting being purely factual. It would seem that the 'panorama' of the battlefield, popularised by George Jones, was believed, at least by this critic, to be the form closest to the 'truth'. It is useful to quote at length from a third critic, who clearly admired the paintings and recognised the attention Armitage had paid to detail:

> The most notable feature. . . of the exhibition are by Mr Armitage of the Balaclava charge and the fight of Inkerman. The artist has treated both subjects with the strictest attention to truthfulness, as far as that was possible. Portraits of some of the most distinguished heroes of the two combats are of course introduced. Of the two pictures, perhaps that of Inkerman is the more successful in bringing before us the incidents of the event. The cold, drizzling grey mist, the Russian myriads, stealing furtively up the sides of the heath-clad hill, the bristling of bayonets and the confusion of hand-to-hand engagement, are well represented.[23]

Only one image of one of the paintings, *Inkerman*, has been traced.[24] It is clear from a rather poor-quality photograph that the work was an uneasy compromise between the grand manner and the demand for documentary 'truth'. The centre ground is filled with a jumble of rifles and busbies, men struggling desperately across the canvas. Some of the heads are clearly carefully studied portraits, whereas others are idealised. There are fallen men, trampled by the troops in the foreground, treated with 'realism' – that is, shown dying unheroically – but near them are dying men, reclining in classical attitudes reminiscent of West's dying Wolfe.

It may only be speculated whether Gambart was disappointed with Armitage's pictures. In commissioning a prominent history painter, he

was following a familiar tradition established by Boydell's commiss-
ions for the ambitious Shakespeare project.[25] The dealer's choice of an
artist trained in France, who had been rewarded for producing a battle
painting in the grand manner, bought by the Queen herself, surely indi-
cates that he wanted an heroic interpretation similar to the style of
Meeanee. The finished works were in a rather different style, and were,
in any case, received as 'factual' representations of the battles.

The career of Thomas Jones Barker (1815-82) is an example of an
academic battle artist whose career was successfully directed through
the intervention of dealers commissioning for the print market. Unlike
his contemporary battle specialists, Jones and Desanges, Barker was
able to sustain a practice in his chosen genre without deviating into
other genres. His survival in the under-patronised field of battle paint-
ing is attributable to two causes; his ability to modify themes to suit
the market, and the constant support of picture dealers. Like Armitage,
he had studied in France, entering the Paris studio of Horace Vernet
himself in 1834. He returned to England in 1845, when he began to
exhibit at the Royal Academy. His pictures showed a strong bias
towards equine subjects; hunting scenes and historical battles.[26]
Barker's first essay in recent battle painting was Wellington at
Sorauren (1853). It might be objected that Waterloo, some forty years
before, was scarcely 'contemporary', yet on the eve of the Crimean war
Waterloo was fresh in many minds as the most recent and glorious
battle of modern history. The Iron Duke had only recently died (1851)
and the elaborate funeral celebrations had given rise to a wave of nos-
talgia. The second Duke of Wellington was reported to be anxious to
commemorate his father's exploits, and it was he who purchased
Barker's painting.[27] It is not known whether he commissioned the
work.

With the outbreak of the Crimean war Barker began to produce more
military subjects, perhaps hoping, as did Selous, that the war would
result in patronage for military pictures. In the previous five years the
number of battle paintings at the RA had been the lowest since the
beginning of the century. Barker's first two Crimean pictures were
chosen to reveal his facility for equine subjects. An Incident in the
Battle of Balaclava (RA, 1855) was based on the proverbial loyalty of
horses. It was accompanied by the note 'I observed one horse stand
fully an hour beside his dead master.' The quotation purported to be
from a soldier's letter from the front, but it seems more likely that
Barker invented it to update a theme already depicted by Vernet. Ver-
net's The Trumpeter's Horse (1817) depicted a horse, with military
tack, standing anxiously beside the corpse of his master. The moral to

be drawn was that the devotion of the animal was superior to that of the soldier's human comrades.[28] This early work was essentially an extension of horse painting connected to a military subject. It belongs to the 'after battle' genre rather than to battle painting, yet it was read as closer to the latter form. Barker's other exhibit was another small-scale horse picture, *The Charger of Captain Nolan, bearing back his dead master to the British Lines.*[29] This use of animals to express moral ideas was common in the mid-Victorian period. Barker's use of horses can be compared with Landseer's *War* and *Peace* (1842), pictures which contrasted the two states in terms of the experience of animals.[30] In *Peace* sheep are able to graze in tranquil security, but in *War* two noble horses struggle amid the ruins of a shelled building. The horse in such representations functioned at two levels, as an animal and as an embodiment of innocent nature.

In the subsequent seven years Barker did not show another military picture at the RA. Instead he moved into huge-scale military subjects for picture dealers. The first of these were *The Allied Generals before Sebastapol* and *General Williams leaving Kars,* both commissioned by Agnew's. The works were not battle paintings but 'an assemblage of portraits, skilfully and most ingeniously brought together by an artist who is unrivalled in this way. Nearly all the persons represented sat to him and he had the valuable aid of Mr Fenton in reference to minor accessories'.[31] Fenton's photographs were also used by Augustus Egg for a similar project.[32] Barker's pictures in this manner were successful with both critics and public. In the form of engravings, executed by C. G. Lewis, they grossed '£10,000 for each plate'.[33] This high level of interest indicates a considerable market for 'documentary' works, especially with authentic portraits. Barker was influential on battle painters of the next generation and should be seen as a direct link between the French and such late Victorian battle painters as John Charlton and Ernest Crofts. It is curious that despite his fame as a military painter and his undoubted success he did not achieve election to the RA. It may have been that his branching out into other spheres of art and other forums for exhibition was frowned upon.

A large panoramic picture by Mr Barker – the subject *The Horse Race down the Corso during the Carnival* – is now exhibiting at the Auction Mart in Cheapside – the now recognized trysting-place for City men – who in feverish intervals between the rise and fall of stock and other commercial pulsations, devote a few minutes to toying with the Fine Arts. To look implies generally to think and so Art adult education goes on; not that Mr Barker's gaudy, lean, showy style of rather flimsy Art will very much help forward the good cause. There is a sort of careless,

Vernet vigour, muscular action, and strong swarthy, red and blue colour about the treatment. . .[34]

This scathing review, particularly associating Barker's 'vulgarity' with Vernet, seems outraged equally by the picture and the type of audience it attracted. By working in a frankly more commercial style and in a more commercial environment Barker put himself outside the Academic environment. His career indicates that the new forms of military art which were being evolved in the 1850s met with considerable resistance from elements of the Academic hierarchy.

Notes

1 J. S. Bratton, 'Performance and politics', *Popular Drama*, ed. David Bradby, 1980, p. 119.
2 Spiers, pp. 97-8.
3 Byron Farwell, *Queen Victoria's Little Wars*, 1973, lists over seventy small campaigns in this period, pp. 364-7.
4 Spiers, p. 98.
5 Kellow Chesney, *Crimean War Reader*, 1960, p. 2.
6 Alfred, Lord Tennyson, *Maude*, Part 3, VI, lines 38-42.
7 Cecil Woodham-Smith, *Queen Victoria: her Life and Times, 1819-61*, 1972, p. 446.
8 Spiers, pp. 98-108.
9 *Illustrated London News*, 5 May, 1855, p. 446.
10 Hew Strachan, *Wellington's Legacy: the Reform of the British Army, 1830-54*, 1984.
11 Lalumia, *Victorian Studies*, p. 5.
12 All statistics referred to are to be found in the author's doctoral thesis.
13 Helmut and Alison Gernsheim, *Roger Fenton: Photographer of the Crimean War*, 1854, p. 4.
14 Maas, p. 28.
15 *Art Journal*, 1863, p. 91.
16 J. Maas, *Gambart, Prince of the Victorian Art World*, 1975.
17 *Art Journal*, 1863, p. 180.
18 *Art Journal*, 1856, p. 67.
19 *Art Journal*, 1861, p. 30.
20 *Illustrated London News*, 22 March 1856, p. 298.
21 *Fine Arts Quarterly*, 'Horace Vernet, his life and work', 1864
22 *Art Journal*, 1856, p. 123.
23 *Critic*, 15 March 1856, p. 156.
25 Boase, 1959, p. 2.
26 *Art Journal*, 1878, p. 70.
27 *Critic*, 1858, p. 189.
28 London, Wallace Collection.
29 *Art Journal*, 1878, p. 70.
30 *Art Journal*, 1854, p. 144.
31 *Art Journal*, 1860, p. 183.
32 Pat Hodgson, *Early War Photographers*, 1974, p. 12.
33 Geoffrey Agnew, *Agnew, 1816-1967*, 1967, p. 67.
34 *Athenaeum*, 3 April, 1858, p. 440.

CHAPTER FOUR

New heroes

The Crimean war, as we have seen, was used as evidence of the aristocracy's 'unfitness' to rule the army. The middle classes increasingly claimed the right to a voice in its administration, and the system of purchase once more came under attack. It was the ranks which were the chief focus of middle-class agitation. The daily life of the common soldier was examined in a series of public and private investigations. The pay, living conditions, food and marital status of the soldier were all seen as areas for reform. The character of the common soldier was construed as brave, loyal patriotic and therefore essentially virtuous. The victories he had achieved in the war were advanced as 'evidence' of this and of the need for reforms in his favour. The heroicisation was aided by the crisis in India which arose in 1857.

'Indian Mutiny' is too broad a term for the revolt of the Sepoy regiments of the Bengal Army which occurred in a limited number of centres, but its persistence indicates the profound shock it caused in Britain. It gave the lie to long held racist myths about India: that the native population welcomed British dominance; that Indians recognised the 'natural' authority of their conquerors and would therefore never seek to overthrow their rule; and lastly that the Indians were too cowardly or indolent to attack their overlords.[1]

British rule was exactly a century old in 1857, but in the previous two decades the style of control had subtly changed. The 'old style' of officer, in the pay of the East India Company, had traditionally tried to blend in with and adopt native customs where appropriate. From the 1840s it was increasingly the trend for officers to bring their wives and families to India, and a much more distinct racial barrier grew up, with the British rigidly apart from the Indian high caste.[2] At the same time there was an influx of enthusiastically evangelical missionaries who sought to discredit Indian traditions and religion. Rumours abounded that Hindus would be forced to accept Christianity and the caste system would be abolished. In a climate of suspicion the well

known incident of the animal-fat greased cartridges was merely a catalyst for the uprising.[3]

To the British the most shocking aspect of the rebellion was that white women and children were in the power of the rebels. The dreadful massacre at Cawnpore led to calls for revenge, later answered by the indiscriminate slaughter of innocent village people. The following passage gives some indication of the strongly racist terms in which the 'mutiny' was discussed; it is from the *Church of England Magazine*, quoting a Rev. Dr Wilson of Bombay. The priest uses quotations from the Bible to imply that the 'rebels' were possessed by demons and that, far from being an imperial assertion of power, the drive to recover India was a religious mission:

> Europeans in India. . . have fallen not merely into the hands of men, but into the hands of ignorant, fanatical and diabolical men, – men of the very worst gentile type, men whose atrocities and cruelties show that 'they are filled with all unrighteousness, fornication, wickedness, covetousness, maliciousness'. . . Without provocation, and without offence on their part, and without remonstrance or warning on the part of those in whom they were confiding their own as well as the general defence, they have been betrayed, murdered, butchered and destroyed, without reference to age, sex, or employment, or condition.[4]

In Britain a kind of hysteria set in, with wild stories circulating about Indian atrocities, especially the sexual violation of English women. The rebellion was seen to transgress all 'natural' laws governing the coexistence of white and black races. The Indian population were believed to be inherently inferior but, if treated firmly, like naughty children, they would accept and appreciate British control. This myth of Indian acquiescence was in part exploded by the rising, and the British were brought to perceive how insubstantial was their hold. Only by acting harshly, in revenge, could they feel that the challenge to their supremacy had been beaten off.[5]

In Academic art, representations of the rebellion in genre scenes outnumbered battle paintings.[6] This was, in part, because the rebellion had been characterised more by guerrilla fighting than by set-piece battles, but it was also a reflection of the newspapers' obsession with the individuals caught up in the revolt rather than perceiving it as a political and military struggle. The sense of outrage at the behaviour of the Sepoys could be better expressed by visual representations that hinted at the breaking of taboos. Paintings such as J. N. Paton's *In Memoriam* (considered below) used the notion of white women in the hands of black men to stand for the other 'taboos' of power and control that had been shaken.

The production of other kinds of images of the revolt was impeded by the scarcity of visual information. As we have seen, 'authenticity' was increasingly valued in military paintings. In view of the distance involved it would not have been feasible to send an artist out and expect him to produce a work in time to have any topical impact. The ingenuity of the print dealers (and the very considerable rewards they could expect) is indicated by the way that Agnew's circumvented the problem. The only European artist in India during the revolt was a Swede, Egron Lundgren. Agnew's purchased hundreds of his sketches and put them at T. J. Barker's disposal.[7] The result was *The Relief of Lucknow*, showing the encounter between the three most popular heroes of the campaign, Havelock, Outram and Campbell. Outram and Havelock had become trapped in Lucknow after attempting to lift the siege, and it was Sir Colin Campbell's force of Highlanders who finally rescued them and the British garrison. The meeting between the three had been absorbed into the national mythology as an example of British *sang-froid*.[8] Campbell, having force-marched hundreds of miles in gruelling conditions, against 'overwhelming odds', walked forward to greet them, raising his cap and holding out his hand: 'How do you do, Sir James?'[9] The choice of subject is further evidence of Agnew and Barker's ability to produce highly commerical subjects for engraving. In the aftermath of the revolt the blood-chilling reprisals were less frequently recalled than the heroic deeds of Havelock and Campbell. Barker's painting was nicely calculated to appeal to patriotic notions of heroism under pressure without recalling the events that had called it into being. As we shall see, an artist could be bitterly criticised for attempting to recall the grimmer aspects of the war. Barker's carefully selective representation was regarded in some quarters as totally successful. The formula was the same as his Crimean group pictures; it showed hundred of portraits, integrated into a setting with local colour: '. . . a work which looks as if it must have been painted photograph fashion, on the spot, at the very moment when Sir Colin was grasping the hand of Havelock . . .' This reviewer went on to recommend that the picture be acquired for the National Gallery. 'These collections are destitute of pictures of the most impressive and engaging interest, so long as they comprise no British historical department.'[10]

The provenance of *The Relief of Lucknow* is better known than any other of Barker's paintings, many of which were lost or destroyed after the first world war. It was displayed in Agnew's gallery in 1860, presumably in an attempt to attract subscribers for the engraving. It was sold, for an unknown sum, to a private collector, S. Mendal, who later gave it to Glasgow City Art Gallery. It was destroyed in an air raid

during the second world war.[11]

George Jones was much slower in embarking on two similar paint-ings with Mutiny subjects. In 1865 he exhibited at the RA *Lucknow, Study for a large Picture in Progress.* This sketch showed Campbell leading the sick and wounded from the liberated city towards his camp.[12] The picture was exhibited at the RA in 1869, accompanied by a quotation from Lord Clyde, as Campbell had since become, as well as an assurance that 'This and the companion picture of Cawnpore were painted for, and entirely under the direction of, the Late Field Marshal Lord Clyde, who died before their completion.'[13] Clyde did not live to take possession of the large pictures, which were eventually given by Jones's widow to the Tate Gallery.[14]

One of the most remarkable 'public' pictures of the revolt was Edward Armitage's huge painting *Retribution,* an allegory of the revenge which many people thought could justifiably be taken. It depicted a bare-breasted female embodiment of Britannia driving a sword through a tiger, emblematic of India. At the feet of the two huge figures lay an English woman and two children:

> Mr Armitage's *Retribution* (531) is allegory rather than history and is less adapted to popular taste than the last mentioned work. It is statues-que rather than picturesque in treatment – but is on the whole, an un-deniably fine work; the subject, a female who may be Britannia, Justice or the East India Company, according to the fancy of the beholder, about to execute vengeance on a tiger which she grasps by the throat . . .[15]

Armitage donated the painting to Leeds town hall shortly after its com-pletion in 1858.[16] This sort of uncommercial gesture was presumably designed to re-establish his reputation as a painter of national subjects in the grand historical manner. His Crimean battle paintings, although well received critically, had not advanced his career as a History painter. *Retribution* may have been an attempt to establish his ability to handle an 'elevated' theme on a large scale. As his biographer pointed out, 'owing to his independent position Armitage was never obliged to conform to the chance variations of fashion but was absolutely free to follow his own artistic ideals'.[17]

The small number of Sepoy Revolt pictures exhibited at the RA under-lines the conclusions drawn from the Crimean war; large-scale works were still almost unsaleable whatever the subject, and such as were painted speculatively or sprang from unusual circumstances. In the case of Barker the painting was commissioned by a dealer who wanted not only the basis of an engraving but the prestige that oils conferred. In the case of Armitage *Retribution* was intended not for the open market but to enhance the artist's reputation. Only Jones's pair of pictures were com-

missioned – by a general eager to commemorate his finest hour. After his death no other buyer came forward. The intense military activity of the years 1854-8, with the wide publicity given to the wars, did not create a market for or school of battle painting. These years, however, did sow the seeds of change in the market for and character of the genre.

The rebellion in India, so profoundly shocking to the British, was transformed in the media. The political and social conditions which had given rise to it were played down, and the personal suffering of British people in India was stressed. The troops despatched to the sub-continent were painted as heroes speeding to the rescue. Genre painting such as *Eastward Ho!* (see chapter 10) depicted the soldiers as family men leaving their loved ones to save their brothers in India. The tendency to heroicise the private soldier may be seen to emerge first in genre painting. In battle paintings the new heroes were initially middle-class soldiers and only later men from the ranks.

Desanges and the 'Victoria Cross series'

The British painter Louis William Desanges was important, as Barker had been, in assimilating French military art into British subject matter. Desanges working for a middle-class audience, transformed middle class gentlemen into 'god-like' military heroes. Despite his name, Desanges was a London artist, born in 1822. His antecedents were French and aristocratic; his great-grandfather, the Marquis Desanges, had settled in England in 1742 as a political exile. The artist was willing, when it seemed useful, to exploit his claim to the title *chevalier.* Desanges was an aspirant History painter, competing unsuccessfully in the Westminster Hall competition. He was also unsuccessful in getting such works as his *Excommunication of Robert, King of France, etc.* hung at the Royal Academy.[18] He abandoned history for portraiture and showed his first work at the RA in 1846. *Portrait of An English Lady* was stylistically influenced by Ingres, and owed much to that artist's modelling and treatment of texture. Desanges established a successful practice as a painter of society ladies. A critic later commented acidly on this move into a more rewarding genre:

> Mr L. W. Desanges, many years ago, gave hopeful indications of being able to achieve some very praiseworthy results as a painter in the higher paths of art, but the seductions of money-making beguiled and turned him aside to the allurements of fashionable female portraiture, which he generally invested with a pseudo-sentimentality. . .[19]

Despite this excursion into a lower-regarded genre, Desanges did continue to paint biblical and historical subjects. According to the only

biographical material on him, a short study in the *Art Journal* of 1863, it was through his practice as a portrait painter that he began his series of battle pictures. He was working at the time in the home of Robert Loyd-Lindsay, equerry to the Prince of Wales. Loyd-Lindsay had been one of the first men to be awarded the Victoria Cross, for saving his regimental colours at the battle of the Alma.[20] The financing of so large a project as a series of fifty pictures is not clear, but it seems likely that Desanges hoped for patronage either from the state or from the royal family. In view of the monarchy's policy of associating itself with the Victoria Cross and the army, it is not unlikely that some help was offered.

Desanges' intention was to depict the incidents which had won the Victoria Cross for its holders. The pictures were done at high speed: the first award ceremony took place in Hyde Park in June 1857, and Desanges exhibited the first twenty-four works at the Egyptian Hall, Piccadilly, in April 1859.[21] Eight were large-scale 'finished' works and the rest were oil sketches for larger pictures. It seems that the artist may have been forced to abandon the idea of 'working up' the sketches and have gone on to execute more paintings on the smaller scale. By 1862, when the full series was exhibited at the Crystal Palace, he had completed fifty pictures. The series was at one stage sold to an unknown patron, but remained almost constantly at the Crystal Palace until about 1880.[22] Given the popularity of the Crystal Palace as a place of amusement and edification for a predominantly bourgeois public, the series must have been the best-known images of war around the mid-century.[23] By 1900 they had passed into the possession of Robert Loyd-Lindsay, Lord Wantage, who presented them to Wantage town council.[24]

The history of the series, highly popular yet unsaleable, is part of the familiar story of battle paintings in this period. The works were not engraved but reproduced by photography.[25] The choice of medium suggests that the series was designed to appeal to the lower middle classes, since engraving was a more ususual means of reproduction for connoisseurs. The *Illustrated London News* recommended the works not as an artistic achievement but 'to all those who have a wholesome patriotic regard for the character and reknown of our brave army'.[26] Another review of the paintings suggested that photography was the appropriate medium since it could show action and portraiture, implying that the omission of 'painterly' qualities was not here of paramount importance.[27]

The belief in the documentary nature of Desanges's series distracted most reviewers from observing the artist's bias towards certain

sections of the forces and modes of representing them. A recent writer has echoed nineteenth-century critics in assuming that 'the democratic appeal of soldiers of all ranks deemed martial heroes in art ensured the gallery's success'.[28] Desanges' series covered the chronological period from 1856 to 1862, when 302 Victoria Crosses were awarded. Since the completed series comprised no more than fifty pictures it is clear that the artist must have been forced to select particular heroes for representation. The criteria may, partly, be reconstructed by an analysis of his choice. In the Crimean campaign, 111 Victoria Crosses were awarded, ninety-six of which went to the army. A rough computation of the ranks then held by the VC winners yields twenty-nine officers, twenty-four non commissioned officers and thirty-three other ranks.[29] Although the terms of the creation of the VC emphasised that it was open to both services and to all ranks, it is clear that there was a bias towards officers and NCOs. A list of the VC pictures in the 1900 Wantage catalogue shows that in the Crimean pictures Desanges represented ten officers, compared to nine NCOs and only four private soldiers. In the whole series of fifty there were only six paintings which took the heroism of the private soldier as their subject. Far from representing private soldiers 'democratically', on terms of equality with officers, Desanges's pictures relegated them to inferior status. To an extent he was merely exaggerating the class bias inherent in the system by which the medal was awarded. The military hierarchy construed the role of ordinary soldiers as merely supportive and discouraged individual initiatives from the ranks. In Desanges's series four out of the six working-class VCs were shown distinguishing themselves by rescuing superior officers and in one case fellow soldiers. Such representations reinforced the myth of common soldiers as brave and enduring but able to function only under the guidance of their commanders, and existing only to serve them. The 1865 official guide addressed the problem of how to classify private soldiers who stepped outside the parameters of their class by winning the Victoria Cross. 'The private, graced with such a distinction, is no longer a plebian. He is not one of the multitude. Even if his social and military rank remain unchanged he is raised morally much above his former self.'[30] Desanges's series incorporates a similar sense that a heroic working-class soldier lifted himself beyond his peers. The oil sketch of *Private Sims winning the VC* is a crudely executed work in which only the figure of the hero is clearly delineated. The *Official Chronicle of the Deeds of Personal Valour* (1865) gives a very general account of Sims's achievement:

> For having on the 18th June 1855 after the regiment had retired into the trenches from the assault on the Redan, gone out into the open ground

under heavy fire, in broad daylight and brought in wounded soldiers out-
side the trenches.[31]

Desanges's sketch omitted the Redan and placed the scene in a feature-
less setting. Sims confronts two Russian infantrymen over the
wounded form of an officer who is gazing imploringly up at the hero.
Sims is thrusting pugnaciously towards the enemy, the dangerous
nature of the confrontation implied by the gesture of another wounded
comrade who tries to restrain him. The fate of the wounded officer but
for Sims's intervention is indicated in the background where a Russian
bayonets a fallen Englishman.

The sketch of Sims, like the five other representations of private
soldiers, was never worked up into a large-scale 'finished' picture.
Indeed, a list of the eight large works out of the first batch of twenty-
four shown in 1859 gives only one NCO and seven officers. This addi-
tional discrimination in favour of officers was undoubtedly dictated
by Desanges's mode of financing his project. It appears that the artist
would approach the family of a VC and invite them to commission a
portrait. His reputation as a fashionable portraitist probably made
people eager to own a likeness of their relative wearing the newly
acquired honour. While executing the commission Desanges would
make a sketch for his own later use, as well as taking the opportunity
to get a first-hand account of the action from his sitter.[32] It seems likely
that at least the first eight large oil pictures were executed on this basis
and that he hoped they would stimulate further orders. As we shall
see, the series was mooted as the basis for a gallery of British heroism.

Desanges's heroes, then, were predominantly the 'distinguished
young officers', wealthy enough to command his services. A glance at
their backgrounds reveals that most came from the upper middle
classes rather than the aristocracy. The artist's work can be understood
in terms of the contemporary class struggle for control of the army.
The aristocracy were attacked by the bourgeois press for 'inefficiency'
in the conduct of the Crimean war. The rising class was represented
by Desanges as behaving with exemplary efficiency and unfailingly
cool courage. This image was satirised by a contemporary critic:
'Irrisistible colonels and indomitable majors do terrible acts with that
calm grace the Greeks ascribed to the immutable gods and revolver a
rebel with the look of Apollo shooting Python.'[33] Desanges presented
the acts of heroism as 'natural' and effortless. *Major Charles Gough
rescuing his Brother Hugh, winning the VC* is balletic in his move-
ments and devoid of all expression except boredom. The artist is
articulating a view of these upper middle-class officers as a race of
'natural' warriors, predestined to be effortlessly heroic. He shows his

young patrons with the noble, passionless faces also attributed by the Victorians to the medieval knights of chivalry. Desanges's contemporary 'knights' are represented as infinitely superior beings, set apart from their enemies and their social inferiors by physical beauty and natural heroism. This conception extended to a strong sense of the superiority of the Anglo-Saxon over other races, whether allies or enemies.[34]

Desanges's innovation in this series was to focus on a single action by a few protagonists. The change is clearly linked to a new set of constructions around the notion of 'heroism', and particularly to the idea of a chivalrous deed, which need not be in any way productive of victory. The convention also overcame any difficulty which might have been raised about the representation of destruction and death, since the depiction of an act of courage was a patriotic duty and could be seen as didactic. Although Desanges's series was not 'democratic' in the sense it was widely thought to be, his subject matter did shift in its focus away from aristocratic generals towards middle-ranking and middle-class officers. In these departures Desanges was clearly influenced by French military painting, particularly by Vernet and Charlet. It is not my intention to chart specific borrowings; here it is enough to note that the adoption of smaller-scale and more tightly focused individual acts derive from this source, as did the use of bravura brush strokes. Desanges's work was extremely influential upon the battle painters who worked in the 1870s, providing as he did the formula of close-up focus on a dramatic incident which allowed a psychological study of heroic national character.

The series was the focus of considerable lobbying for the establishment of some kind of national collection of battle paintings. Prominent in this was the *Art Journal*:

> We have intimated that this series of war pictures was a venture on the part of the artist, but it is one of great national interest and ought to be therefore duly recognised and appropriated by the country.[35]

In the early 1860s there was a move to buy the pictures so as to keep them together. Those involved were members of the Junior United Service Club. Their manifesto, published in the *Art Journal*, again suggests that the 'Art' qualities of the series were felt to be dubious and not an important factor in their acquisition.

> This small collection of pictures affords us an easy opportunity of publicly prolonging a record of their [the VCs] deeds. Whether we care much or little about Art, such pictures form the nucleus of an entirely novel collection, a pictorial Gazette, improving to the living and invaluable to their successors. The consideration of such deeds not only elevates the mind but gives a just pride in our noble countrymen. Let us prove our-

selves worthy of our noble Queen's ideas, by aiding her in perpetuating it.[36]

The idea of using the club as a repository came to nothing. The *Art Journal* suggested that the Crystal Palace might be an appropriate venue:

> they fill but a very small portion of the space that might with ease be devoted in the Crystal Palace to a grand collection of national historical pictures, representing British naval and military achievements, as well as the minor and more personal incidents and exploits in the greater and more comprehensive battles.[37]

The writer makes it clear that, as always, it is with French military art and with Versailles in particular that comparison is to be drawn:

> . . . if once it were determined to regard Mr Desanges' collection as the nucleus of a grand national gallery, the Crystal Palace might soon prove as formidable a rival to Versailles, with its military pictures, as it does with its high-soaring and beautifully varied fountains.[38]

Even this appeal to national pride was resisted by the art world of the 1860s. In the previous decades there had been similar moves to establish a national collection. Siborne's wooden model of the battle of Waterloo had been given to the United Service Institution in Scotland Yard as the first exhibit in a museum and gallery which was never completed.[39] After the Crimean war Lord Elcho had proposed that William Simpson's ninety water-colour sketches be purchased for the nation as a 'visual history'. Colnaghi offered them to Palmerston's government at a loss, but the gesture was refused.[40]

It is clear that though a small body of interested persons considered the lack of an English military gallery reflected badly on the nation, there was a more general resistance to establishing such a collection. The objections were threefold: a reluctance to glorify war, a conviction that military art was not 'good' art and, more pervasively, that the British were not a militaristic nation. Some commentators offered a combination of excuses for the lack of a strong school of military art. William Michael Rossetti, reviewing the Academy exhibition of 1861, invoked the mythology of anti-militarism but also disputed whether war was a suitable subject for art at all. 'The military is one of the most hopeless and barren phases of art and British painters have always shown themselves peculiarly abroad in it.'[41] By contrast, the French 'excelled' at the genre:

> Art can hardly thwart its own best purposes more than by dealing with masses of red-coats and pipe-clay, bayonet-thrusts, gashes, blood, agonized and distorted features and widespread slaughter. Yet these are

the essentials of the subject, anything short of them is a mere trifling with it, half-hearted and *self-condemnatory*. British painters have never fully grappled with military art, they have only hovered around the edges, touching and trimming.[42]

Rossetti's words contain an interesting contradiction: he laments the poor performance of British art in the military genres, yet is offended by the gruesome details which, he insists, are an essential part of the subject matter. His use of the term 'self-condemnatory' is revealing, surely implying that the practice of battle painting involves a guilt-provoking celebration of war. The insinuation is that the French excel at the genre only because they like war and lack the scruples which make the British hesitate.

The notion that British artists turned from battle painting because of their superior moral sense and refined sensibilities was not confined to Rossetti. Richard Redgrave commenting, in his journal, on the Exposition Universelle of 1855, compared British and French art. He noted a:

> . . . marked difference between the French and English in their choice of subjects. French art shows a people familiarized with blood, and with the horrors of war. Subjects from their former Russian war, and their present one [in the Crimea] abound everywhere. Even in their religious pictures, martyrdoms of the most dreadful character seem to please them more than tender and devout subjects.
>
> Now on the English side, taking our pictures generally, there is nothing of this sort. Battles there are, and murders, but such subjects are rare; and wounds and deaths far less prominent than in French subjects of the like nature. The pictures more generally speak of peace, of a placid life, of home. Our subjects are undoubtedly of a *less elevated* and of a lower and more familiar character in England, but they are works which a man can live with and live to look upon obtruding no terrors on his sleeping or waking fancies.[43]

A comic dialogue in the *Art Journal* of 1856, between 'Amicus' and 'Magister', overtly linked French militarism with that country's thriving school of battle painting. 'Our neighbours' military tastes and the delight they take in the pomp and circumstance of glorious war, familiarise them, no doubt, with such crimson results.'[44]

The equation was frequently drawn in the 1850s and '60s, always with a note of ambivalence. The French excellence in the genre might be taken to prove only their blood-thirstiness, their moral inferiority, but might it not suggest that they had more military victories to celebrate?

> As a nation we are not famous for immortalising ourselves in painting, though we have, shut up in our books, a list of victories to which some

of our neighbours would have devoted many miles of canvas.[45]

The debate about the importance and desirability of battle painting as articulated by Redgrave is suggestive of a reassessment of the hierarchy of genres. The notion that History painting was the only honourable pursuit for a great artist was under attack as early as 1840, when critics like Thackeray were able to argue that the national taste was not at fault in preferring small-scale domestic scenes,

> A young man has sometimes a fit of what is called 'historical painting', comes out with a great canvas, disposed in the regular six-foot heroical order; and having probably half-ruined himself in the painting of the piece, which nobody (let us be thankful for it!) buys, abuses the decayed state of taste in the country and falls to portrait painting or takes small natural subjects, in which the world can sympathise and with which he is best able to grapple. . Art is a matter of private enterprise here, like everything else; and our painters must suit the small rooms of their customers and supply them with such subjects as are likely to please them.[46]

This kind of reaction against the High Art lobbying of such as Haydon was given theoretical reinforcement by Ruskin in the second volume of *Modern Painters*, published in 1856.

> . . . it does not matter whether he toiled for months upon a few inches of his canvass or cover a palace front with colour in a day, so only that it be *with a solemn purpose* that he has filled his heart with patience or urged his hand to haste. And it does not matter whether he seek for his subjects among peasants or nobles, so only that he behold all things with a thirst for beauty and a hatred of meaness and vice.[47]

Ruskin's emphasis on sincerity gave theoretical acceptability to the genres of art which already dominated the market. The burden of *Modern Painters* was that 'true criticism of art can never consist in the mere application of rules'. Thus 'the difference between great and mean art lies, not in definable methods of handling or in styles of representation or choices of subject but wholly in the *nobleness of the end to which the effort of the painter is addressed*'.[48] Earlier C. R. Leslie, a less influential theorist, had written in his *Handbook for Young Painters* (1855), that:

> The essence of vulgarity, is pretension and it. . . generally aspires to the high places of Art, where it shows itself in every species of false sentiment. It openly affects the superfine – it produces the mock heroic – and all the numerous mistakes of the exaggerated for the grand and the poetic.[49]

A critic writing in the *Art Journal* in 1867 was able to opine confidently that mere 'decorative styles' had frequently been confused with the essentials of High Art, which were 'nobility of thought, simplicity and

severity of treatment'. It was possible, therefore, that works of 'less ambition' might be closer to the true meaning of High Art than those which 'vainly strive to comply with the ancient traditions'.[50] Despite this it is plain that the term had come to be interchangable with 'Good Art'. The invoking of the older term was merely a device for proving its redundance.

The situation of battle painting in this theoretical debate was not overtly discussed. The deficiencies of various strands of battle painting had been identified in the context of the Palace of Westminster competitions. Despite the liveliness of the dispute, consensus had never been reached as to what constituted a desirable form of battle painting for Britain, doubtless owing to the persisting mythology of anti-militarism.

The inability of either Barker or Desanges to gain admittance to the Royal Academy suggests that there was still resistance to their genre at a number of levels. Yet the style evolved by Desanges was very close to that of the academically successful artists of the next generation. A number of adjustments in art theory took place in the intervening decade, from about 1865 to 1875. The new acceptance of the 'personal' picture has been noted as one factor. The concept of factual accuracy which, in the 1820s, had been taken to signify paucity of imagination, became in Ruskinian theory one of the hallmarks of good art. The call for 'historical accuracy' affected all branches of historical painting at roughly the same time, undoubtedly through the influence of archaeological and historical research and the popular interest in those subjects.

As well as these theoretical adjustments which gathered strength in the decade 1865-75, the new bourgeois view of the army was a critical factor in creating a market for military painting. The struggle between the classes for control of the army played an important role in changing that view. The Volunteer movement, begun in 1859, marked a significant phase in the 'militarisation' of bourgeois ideology. In addition, the value of the army was enhanced by the growing realisation that European powers were able to challenge British supremacy. The most shocking evidence of new developments in the power struggle of Europe, and indeed in the nature of war itself, emerged from the Franco-Prussian conflict of 1869-70.

Bismarck's moves to unify Germany under Prussia by fighting a series of small European wars had been regarded sympathetically in the 1860s. There were strong political links between the two nations, strengthened by the dynastic alliances of the royal families. There was also a frequently voiced belief that the German national character was

closest to the British. France was the traditional enemy, and the notion of permanent menace from across the Channel had been reawakened by the establishment of the Second Empire in 1851.[51] The war between the two European powers was regarded as advantageous to Britain, in that it curtailed the supposedly expansionist aims of Napoleon III. The nature of the war was alarmingly new, however, fought as it was upon new principles, drawing upon reserves and moving mass armies swiftly by means of the railway network:

> Eye-witnesses have told how, day after day. . . the railway lines of Germany bore the mighty host in endless succession; how mass after mass of armed men, attended with all the material of men, rolled rapidly yet in order.[52]

Events were closely monitored in the press, especially the illustrated newspapers. Scores of special artists were despatched to follow the armies and to keep an avid readership up to date. The annihilation of the French army and the fall of Napoleon III were thus reported in shocking details. It is instructive to notice in passing that this foreign war provided subject matter for a number of British military painters.[53]

The nature of warfare was perceived to have changed radically, and military commentators urged the reorganisation of the army to meet the challenge. The Cardwell reforms were the most far-reaching of the nineteenth century, and the culmination of moves to 'democratise' the army. This largely meant that the officer class should be open to all 'gentlemen' by virtue of merit rather than wealth. The reformed army was increasingly construed in bourgeois mythology as a desirable, patriotic institution which should be the object of national pride.

> When Mr Cardwell became Secretary of State for War in December 1868, he entered upon office determined to make the Army popular with the classes from which it obtained recruits. It was his resolve also to make the officers feel that they belonged to a great profession, in which as in all others, men could secure advancement only by diligent study and hard work, zeal and well-grounded knowledge of their duties.[54]

The other main effect of the reforms was to establish a reserve force. The Army Enlistment Act of 1870 made provision for a nucleus of reserves which might be activated in an emergency. It was an economical way of having a larger Army without paying the full price, and made it easier to offer shorter terms of service to the ranks.[55] The minimum was now three years, and the maximum twelve, but of the twelve, a soldier might opt to serve some time in the Reserve. One of the aims was to attract a 'better class' of recruit, artisans rather than drifters. The strategy was only marginally successful. Despite the efforts to glamorize the army, it remained unpopular among the work-

ing classes, regarded as the resort of the desperate or vicious.[56]

The period from the Crimean war to the Cardwell reforms was a watershed in civilian-military relations. After the reforms the army was increasingly construed in ruling-class ideology as the instrument for the heroic conquest of the empire. Battle painting also underwent transition in this twenty-year period. A number of crucial changes took place, including the assimilation of French battle painting into British subject matter and the overthrow of the dominance of History painting. It was in the following decades, however, that a new generation of painters was to emerge and establish battle painting as an important genre.

Notes

1 Spiers, p. 124.
2 *Ibid.*, pp. 122-3.
3 *Ibid.*, p. 123.
4 *Church of England Magazine*, 19 June 1858, p. 424.
5 Douglas A. Lorimer, *Colour, Class and the Victorians*, 1978, p. 184.
6 See, for example, Abraham Solomon's *Escape from Lucknow* (Leicester City Art Gallery).
7 *Art Journal*, 1860, p. 184.
8 Olive Anderson, 'The growth of Christian militarism in mid-Victorian Britain', *English Historical Review*, January 1971, p. 44.
9 Christopher Hibbert, *The Great Mutiny*, 1978, p. 345.
10 *Art Journal*, 1860, p. 183.
11 I am indebted to Glasgow City Art Gallery for providing me with this information.
12 Royal Academy Catalogue, 1865.
13 Royal Academy Catalogue, 1868.
14 My thanks to Robin Hamlyn of the Tate Gallery for this information.
15 *Critic*, 15 May 1858, p. 235.
16 Boase, 1959, p. 291.
17 *Pictures and Drawings of Edward Armitage, RA*, 1898, p. 1.
18 James Dafforne, 'British artists, No. LXIX', *Art Journal*, 1863, pp.41-3.
19 *Critic*, 23 April 1859, p. 399.
20 H. S. Loyd-Lindsay, *Memoir of Lord Wantage, VC, KCB*, 1907, p. 420.
21 *Art Journal*, 1863, p. 41.
22 *Art Journal*, 1873, p. 192.
23 London: Albert Palace, 'The Victoria Cross Gallery', 1885, p. 1.
24 Loyd-Lindsay, p. 420.
25 *Athenaeum*, 6 April 1861, p. 61.
26 *Illustrated London News*, 2 November 1860, p. 61.
27 *Critic*, 17 November 1860, p. 616.
28 Lalumia, 1984, p. 112.
29 Statistics taken from *The Victoria Cross Gallery: an Official Chronicle*, 1865.
30 *Ibid.*, p. viii.
31 *Ibid.*, p. 87.
32 I am indebted to Squire De Lisle, of Quenby Hall, Leicestershire, for this information.
33 *Athenaeum*, 6 April 1861, p. 471.
34 J. Hichberger, 'Democratising glory? The Victoria Cross paintings of L. W. Desanges', *Oxford Art Journal*, 7, No. 2, pp. 42-55.
35 *Art Journal*, 1863, p. 42.

36 *Ibid.*, p. 43.
37 *Ibid.*, p. 12.
38 *Loc. cit.*
39 *Art Journal*, 1850, p. 265.
40 Hansard, 1857, Vol. 142, 1100-3.
41 William Rossetti, *Fine Art, Chiefly Contemporary*, 1863, p. 13.
42 *Loc. cit.*
43 F. M. Redgrave, *Richard Redgrave, CB, RA*, 1891, p. 131.
44 *Art Journal*, 1856, pp. 33-4.
45 *Art Journal*, 1861, p. 287.
46 William Thackeray, 'An exhibition gossip', *Ainsworth's Magazine*, June 1842, p. 78.
47 John Ruskin, *Modern Painters*, 1863, Vol. 3, p. 22.
48 *Loc. cit.*
49 C. R. Leslie, *A Handbook for Young Painters*, 1855, p. 56.
50 *Art Journal*, 1867, p. 137.
51 E. Butler, *An Autobiography*, 1922, p. 95.
52 W. H. Russell, *My Notebook of the late War*, 1871, p. 21.
53 E. Butler, *Missing*, RA, 1873; C. Green, *The Poison Test*, RA, 1873; T. J. Barker, *The Battle of Sedan*, RA, 184.
54 Spiers, p. 188.
55 *Loc. cit.*
56 General Viscount Wolseley, 'The army', *The Reign of Queen Victoria – a Survey of Fifty Years' Progress*, ed. T. H. Ward, 1885, pp. 115-6.

Elizabeth Butler
High Victorian battle painting I

The period from 1874, the year of the Ashanti expedition, until 1914 saw a dramatic increase in the number of battle paintings displayed at public exhibitions. Statistical analysis of the exhibits at the Royal Adacdemy shows that, even allowing for the general increase in the quantity of pictures, the number of battle pictures tripled the pre-1855 figures.[1] All military subjects, genre as well as battle pictures, attracted more practitioners, better audiences amd greater critical attention. The new popularity was, in part, connected with the pro-military and pro-imperial ideologies of the middle and upper classes. It is not adequate merely to read the works as 'jingoistic' reflections of contemporary military aggression. The ways in which the paintings related to the dominant ideologies was more complex, and also the meanings they conveyed were less crudely affirmative than might be expected of the 'age of imperialism'.

Many commentators at the time reflecting on the upsurge in the popularity of the genre, attributed it to the influence of one artist, Elizabeth Thompson, Lady Butler. Still the best known of all the Victorian artists who practised the genre, her remarkable achievement in gaining critical and popular success with a neglected genre has attracted less attention in the late twentieth century than the fact of her doing so as a woman painter. While it is very right to examine the career of one of the few popular female academic artists, it is necessary to do so with an understanding of the specific conditions for the production of the genre within which she practised. The few non-feminist authors who have examined Butler's career have sought confirmation of crude jingoism in bourgeois ideology in High Victorian England. To construct her in such a way is to fail to understand the sometimes subtle workings of patriotic feeling in Academic paintings and thus to misread their message.

The details of Butler's career are better known than those of any other British battle painter and need no more than brief rehearsal here.

She was born in Lausanne in 1846.[2] Both parents were cultured and fond of the arts, and when in London formed part of the literary and artistic circle around Charles Dickens. Her father, T. J. Thompson, had means enough to exempt him from the practice of a profession but not for him to live in England. Accordingly Elizabeth and her younger sister Alice were brought up in an atmosphere of genteel bohemia in Italy. Their education was undertaken by their father, who encouraged them to believe in their destiny as creative artists. The family fostered Elizabeth's career by taking her to study in London and Florence, and by travelling to allow her to visit practising artists and masters.

Although she had been showing pictures in London for about five years, notably at the Society for Lady Artists, she achieved her greatest success in 1874 with her second Academy picture, *Calling the Roll after an Engagement, Crimea.* The work was admired by many leading Academicians, taken to the sick bed of the national heroine, Florence Nightingale, and bought by the Queen herself.[3] Kilvert recorded in his diary that there was a continual press of people around the picture and a policeman had to be employed to keep the crowds moving.[4] Not since Wilkie's *Chelsea Pensioners* had a military painting enjoyed such success.

> It represents a muster of foot-guards while the call is read by a sergeant, himself wounded, and passing slowly along the thinned ranks. One soldier stands still and full of thought; another weeps for, it may be a lost brother; one offers rough consolation to his neighbour; and one, next to the last, binds up his own badly wounded wrist, and has a face full of *rude sympathy* for those who suffer more. One, in agonies, leans on his rifle, while another supports himself on his companion's arm. At this instant a man has fallen, fainting or dead and his next man stoops to see which it is.[5]

To what might the popularity of this work be attributed? The choice of the Crimean campaign as subject had been influenced by recent re-assessments of the war as having been won by 'the ranks'. In particular Kingslake's mammoth *History of the Crimean War* had endorsed the view of the bourgeois media during the campaign that the aristocrats who commanded the army had failed their country and that only the heroism of the ordinary soldiers had won the war.[6] As we have seen, this mythology had played an important part on the emergent middle classes claim to control of the army which culminated in the Cardwell reforms. The army of 1874, whose senior ranks were to help further Butler's career, was under the new generation of officers.

Butler's reputation was boosted by the favour shown to her picture by the royal family. The Prince of Wales had made flattering reference

to her work at the Royal Academy banquet, prior to the opening of the exhibition. The Queen not only bought the picture but sent the artist a diamond bracelet as a token of her admiration.[7] This kind of publicity made her a celebrity and her work the focus of the exhibition. Over a quarter of a million photographs of her were sold in a week, and the press speculated on her private life.[8] The Queen regarded the army in the Crimea as her own, and was anxious to emphasise her nominal position as its head. In the aftermath of the war, she had instituted the Victoria Cross and had personally visited wounded soldiers in hospital. The monarchy was not averse to associating itself with the anti-aristo-cratic sentiment which underpinned Butler's painting.[9] Her work, then, formed part of this discourse which elevated the ranks into national heroes. She did not 'happen' to hit a popular vein which 'inspired' other artists to follow her example; royal patronage showed an existing read-iness to encourage the production of such works.

The army's hierarchy also greeted Butler as an ally, mounting special military displays to allow her to sketch them in action, 'lending' soldiers as models, uniforms to work from and volunteering 'expert advice'.[10] It seems safe to assume that the authorities approved of the representation of their history she produced. Other painters, recognis-ing this positive climate, turned to the production of similar images.

It is possible to discern a few basic types of battle pictures in the last three decades of the nineteenth century: 'the last stand', 'the charge' (with or without heavy guns), 'after the battle' and 'the march past'. All were first exhibited by Elizabeth Butler, and her influence cannot be overestimated. There were important differences in the ways in which these types were applied, and a wide range of meanings could be drawn from them. It is necessary to explore the alternative meanings of late Victorian battle paintings in terms of the ruling classes' obsess-ion with the empire and Britain's military and social role within it.

The period of British history from approximately 1870 to the first world war is often designated the 'Age of Imperialism'. The use of the term should not be taken to mean that there had not been colonial expansion in early periods. Vast tracts with great wealth in mineral and other resources had been appropriated in the first three-quarters of the century.[11] The phrase further implies that the whole population was united in seeing it as the most significant aspect of their era. In fact the term was coined to describe the economic and political interests of a limited section of the upper and middle classes. It has been pointed out that the rise of 'patriotic' imperialism was coexistent with the emergence of working-class and feminist politicisation:

The ruling class sought in patriotism a means of defusing the conscious

ness of the working class. The call for loyalty to the state rather than to any section of it was seen as a way of both reducing class conflict and of facilitating the imposition of greater demands on the citizen by the state.[12]

Patriotic emotion focused on loyalty to the empire, the Queen and by extension the army as the instrument of empire. Benjamin Disraeli, the Tory Prime Minister, was influential in his appeal to national pride, asserting that it was 'England's mission' to civilise the empire in her own image, thus making imperialism more a moral duty than a fiscal policy.[13] His appeal to lower-middle-class-voters, after the broadening of the franchise in 1867, was based on the prestige to be gained in Europe from the policy of expansionism:

> It is whether you will be content to be a comfortable England, modelled and moulded upon continental principles and meeting in due course with an inevitable fate or whether you will be a great country, an Imperial country, a country where your sons, when they rise, rise to paramount positions, and obtain not merely the esteem of their countrymen but the respect of the world.[14]

Disraeli's dark allusion to the 'inevitable fate' threatening an isolationist Britain is clearly connected with a fear that other powers, notably Germany and the United States, were increasingly able to challenge her economic and military supremacy. The expansion of the empire was seen as providing markets for British industry, at a time when Britain was falling behind in production, new technology and organisation.[15] The time of glamorous exploration and conquest overseas also coincided with economic and agricultural depression at home and concomitant social unrest.[16]

The army partook of the aura of glory created around the notion of empire by press and politicians. Popular illustrated journals particularly represented soldiers as bold conquerors, subduing 'savages' for their own and England's good. The middle-class construction of 'Tommy Atkins' was thus extended into the role of imperial warrior. In the post-Crimean era the common soldier was regarded as honest, Christian, instinctively moral, however ignorant and rough. If sterling qualities were to be found in her humblest representative abroad, did it not 'prove' that Britain had a moral duty to conquer the world and reshape it in her own image?[17] Kipling's stirring poetry was important in encoding 'Tommy' as an imperial hero. While exploiting the 'amusing' working-class eccentricities and coarseness of the common soldier, Kipling stressed that the greatness of the task of fighting for the Empire served to exalt 'Tommy' beyond the station he might have enjoyed in civilian life.[18]

[78]

Charles Kingsley, in his *Sermons for the Times*, traced this process of elevation from the pride that was fostered around the concept of the regiment '. . . the talisman which has harmonized and civilized from the mire the once savage boor'.[19]

The theme of the corporate body being far greater than the sum of its parts is surely a device for distancing the army from the class of men who made up its ranks. 'The army', 'the regiment' and 'the colours' were all constructs in ruling-class mythology which could be used to simultaneously deify and dehumanise the men.

Garnet Wolseley took an almost mystical view of the soldier's role in the empire – a view which presupposed the desirability of imperial conquest. He saw the empire as having been colonised, 'claimed' by the corpses of the British soldiers buried there – a precursor of the 'foreign field that is for ever England'.[20]

> How many such gallant British soldiers lie thus buried all over the world, marking the routes of the armies that have made our Empire what it is. These men die that England should be great and they die without a murmur and it is their valour and their self-sacrifice that enables tradesmen to made fortunes. . .[21]

It is evident that radical changes had taken place in the middle and upper middle-class view of the army; changes that dated from the Crimean war but were reinforced by the growing emphasis on Britain's imperial mission. It might be argued that the virtual canonisation of 'Tommy Atkins' was designed not only to encourage recruitment and affirm the imperial policy but to defuse the soldier's working-class consciousness. There is substantial evidence to suggest the the new-found militarism was by no means the nation-wide phenomenon claimed by such people as Wolseley, and that many sections of the working class remained profoundly suspicious.[22] Historically the army had been instrumental in the repression of strikes and demonstrations; a sense of soldiers as the enemy is well documented as late as the 1880s.[23] Poor recruiting figures similarly indicate that, despite propaganda and real improvements in conditions, the army was still regarded, in the 1890s, as the resort of the desperate or the depraved.[24]

The upper middle classes' enthusiasm was undoubtedly reinforced by the cult of masculinity. Army officers were represented in the press as vigorous, manly fellows whose masculinity proved that Britain was neither effete nor decadent.[25] Violence was regarded as a natural concomitant of masculine commitment to the imperial cause.

> You cannot have omelettes without breaking eggs; you cannot destroy the practices of barbarism, of slavery, or superstition. . . without the use of force; but if you will fairly contrast the gain to humanity with the

price which we are bound to pay for it, I think you may well rejoice in the result of such expeditions as those which have recently been conducted with such signal success in Nyasaland, Ashanti, Benin and Nupe. . .[26]

The means by which the empire was taken were justified by the ends, at least in the mind of such men as Joseph Chamberlain. The capacity to seize foreign lands was evidence that the nation was still 'healthy' and 'manly'.

The period 1870-1914 also contained a powerful alternative discourse of anti-imperialism, supported by a broad range of political and religious groups, including liberals, radicals, socialists, liberal Catholics and Quakers.[27] Some strands of anti-imperialist thought were linked with pacifism and anti-militarism. The study of Butler as a particularly well documented battle painter reveals how anti-war and anti-imperialist discourse modified criticism of her work within an important but isolated social group – the liberal Catholic circle connected with Wilfred Scawen Blunt.[28] Her sister was the poet Alice Meynell, who with her husband Wilfred was involved on a large number of literary projects, including a Liberal Catholic periodical, *Merrie England*. The editorial policy of the journal was strongly anti-imperialist.

> We may accept it then as a settled fact. . . that the people of England have ceased to be *flattered* by the thought of Empire.[29]

Concern in liberal Catholic and other circles about the empire seems to have centred on the moral problem involved in the use of force to achieve political ends. The traditional attitude of the Catholic Church was not pacifist but one of support for war fought in 'just' causes. *Merrie England*, in the main, argued that wars fought to gain or retain colonies did not fall into the category of 'just' wars.

Wilfred Scawen Blunt, the fiercely anti-imperial poet, novelist and historian, was closely associated with the Meynell circle. During the 1880s he was evolving his ideas about the immoral exploitation which took place in the British empire – retreating slowly from an earlier belief in the moral rectitude of the nation and the:

> . . . common English creed that England had a providential mission in the East and that our wars were only waged there for honest and beneficient reasons Nothing was further from my mind than that the English could ever be guilty, as a nation, of a great betrayal of justice in arms for our mere selfish interests. . .[30]

It was this disillusionment which informed his controversial book *The Secret History of the British Occupation of Egypt* (1907). Sir William Butler, Elizabeth's husband, found it 'illuminating', since it argued that

the occupation of Egypt had been set in train not by altruistic concern for the fate of the region but by financiers.[31]

Elizabeth Butler's writings do not reveal disquiet with current imperialism, but they do reflect a common contemporary equivocation over the issue of war. 'My own reading of war – that mysteriously inevitable recurrence throughout the sorrowful history of our world – is that it calls forth the noblest and basest impulses of human nature.'[32] This attitude was commonly voiced by liberals who revered the army but who were aware of the reformist view. General Sir Garnet Wolseley, a military colleague of William Butler's, believed that 'war with all its horrors exercises a healthy influence on all classes of society'.[33] This is close to the Tennysonian view that in war time the ennobling, chivalric influence of the soldier temporarily supersedes the petty influence of merchants and businessmen. It was challenged by the claim of men like Blunt that war was waged at the desire of Mammon, rather than to purge its influence.

Writing of Butler's picture *Balaclava*, which showed battered and wounded men after a bloody engagement, a critic stressed that the inspirational lessons of war still outweighed its evils:

> Here is war, shorn of its glitter if you will, but so shorn that the brave virtues which make war so terrific a good, so potent an educator, so wor-shipful an influence, shine out with a power making all the heart in a man rise to the godlikeness of self-sacrifice. The wreck of a Brigade [the Light Brigade] may be standing on the Causeway Height, but compassion at the sight is swallowed up in exultant pride.[34]

This was a standpoint which stripped the politicians and military hierarchy of all responsibility for war and its conduct. Butler chose to see war as 'inevitable' rather than arising from political activity, in the same way as the critic saw Balaclava as merely a didactic incident in British history. It was clearly an attempt to depoliticise war and to play down controversial aspects which might have obtruded upon the interest of an exciting battle picture or war report.

Butler's art may thus be read as a compromise between the anti-war ideologies of her immediate family circle and her chosen genre. She achieved the compromise in two ways: by selecting only subjects that carried suitably moral and inspiring overtones and by avoiding the actual depiction of bloodshed. Her *oeuvre* was concentrated upon three main episodes of military history (in order of numerical prominence): the Napoleonic wars, the Crimea and the Nile expedition. The first two were major wars fought against a European enemy with similar weapons and conditions of service. One of the chief complaints of the anti-imperial war lobby was that the native enemy were hardly ever

trained soldiers and were forced to face rifles with spears and clubs. Butler's experiments with colonial subjects invoked severe criticism from her family. Her husband, for example, was enraged by her choice of *After the Victory – Lord Wolseley and his Staff riding into Tel-el-Kebir*. Refusing to be flattered by the depiction of himself with Wolseley as a conquering hero, he objected that Tel-el-Kebir had been a grotesquely easy victory gained by well equipped forces over an unprepared, non-professional party of defenders.[35] Butler did not exhibit the work, and destroyed it 'in a fit of remorse' after her husband's death.[36] *The Defence of Rorke's Drift*, one of her least critically success-ful works, was also a source of conflict between her anti-violence prin-ciples and her patron's expectations of a battle painting. The picture was commissioned by the Queen, who clearly specified the subject she wanted. Despite the importance of her patron, Butler was at first unwil-ling: '. . . it was against my principles to paint a conflict'.[37] She proposed alternative subjects from the Zulu war which would have allowed her to evade the depiction of hand-to-hand fighting. The Queen insisted, and Butler was forced to accept the original subject. A piece of art-world gossip from a contemporary magazine suggests that attempts at com-promise were not acceptable to her patron and that she was forced to make changes.

> Miss Thompson's work suffers from not giving the main idea of the engagement in question and rumour says that a certain great personage for whom the picture was painted, expressed disappointment at there being so few Zulus in the composition, whereupon Miss Thompson stuck a few more into the corner of the picture.[38]

The absence of violence in her paintings was a deliberate strategy, designed to accommodate the conflicting ideologies of anti-imperialism and pacificm as well as patriotism and militarism. The Meynells, who edited the *Magazine of Art*, were prominent critics of Butler's work, and they frequently ran articles which eulogised her paintings or attacked 'conventional' depictions of war and tried to point up what they saw as Butler's innovation. 'War seen from a distance, from the distance of conventionality and heartlessness, whether by writer or by painter is both stupid and inhuman.'[39] Alice Meynell, writ-ing as 'John Oldcastle' in 1879, voiced her misgivings about the moral-ity of artists earning their living by painting death and misery. In the early 1870s Butler had been pressed by her mother into an abortive attempt at religious subject matter. Meynell's article associated her sister with a contemporary group of French battle painters, Detaille and de Neuville, 'young reformers':

> From the most conventional, heartless, and insincere of the arts they

made it the most human, the most intensely true and the most realis-
tic. . . the situation and the emotion of war. . . are so great, so dramatic,
so strong, being matters of life and death – that they need only realisation
to be the highest objects of the highest art.[40]

It is interesting that although Meynell's formula for the 'highest art'
was in direct opposition to the great tradition of High Art battle paint-
ing she still felt the need to underpin her preferred style with termino-
logy conveying the suggestion of artistic merit and intellectual im-
portance. Butler's method was, theoretically, based on genre painting
in its stress on unidealised individuals. Her art alluded to but did not
attempt to delineate the progress of a battle; rather she captured the
sentiments and emotions of the men caught up in the event. Alice
Meynell endorsed this approach:

Art has rightly nothing to do with the history of war, it should be con-
cerned only with its anecdotes. Art should go into the byways of battle.
It must love the soldier and love him individually, not in battalions.[41]

Butler's art has recently been described as celebratory of flag-waving
imperialism. Her marriage to an important soldier is 'evidence' that
her art was uncritical of the military and that she personally relished
war. Yet she had a strong moral resistance to depicting bloodshed, and
regarded her art as celebratory only of the virtues which emerged
during the extreme situations of war. Contemporary reviews of her
work by the Meynells and others show that her approach was recog-
nised and admired, in some circles, as a response to anti-war discourses
in the 1870s and early 1880s. It might be argued that her work attemp-
ted and failed to respond to the increasingly extreme 'patriotic'
militarism of the 1890s.[42] It is important to stress, however, that
Butler's art was not read in this way by the majority of her audience,
who merely appreciated her choice of subjects and the entirely positive
and flattering representation of the army. It is clear that her imitators,
Stanley Berkeley and Ernest Crofts among the earliest, neither
appreciated nor emulated her anti-violence stance. The forms she
invented that were most frequently taken up by her imitators were the
most stirringly patriotic and the least concerned with the horrors of
war. Berkeley, for example, produced a number of versions of the fron-
tal charge, clearly derived from Butler's *The Charge of the Scots Greys
at Waterloo* (known as *Scotland for Ever!*). I can find no painting which
imitates the melancholy foreboding of *The Dawn at Waterloo*, a pic-
ture which represents the cannon fodder as tragically young and unpre-
pared. At the end of the 1880s, when she produced this dramatic anti-
war study, other battle images were manifesting a much cruder racism
and imperialism, with which she was inextricably associated. In the

early 1880s, perhaps at the apogee of her success, Butler was credited with the foundation of the British school of modern battle painting.

> The battle painters of England in past time have not greatly distinguished themselves; their work has been marked rather by the sincerity of its patriotism than by the qualities of a purely artistic kind; but in our own day we can fairly claim that a new impetus to this branch of art by the deserved success of the talented painter of the Roll Call.[43]

Militarism and High Victorian battle painters

The notion that a psychological gulf must exist between 'the artist' and 'the soldier' dates only from the end of the nineteenth century as a widespread myth. From the 1880s the artist was increasingly constructed as a nonconformist bohemian whose behaviour was governed only by abstract notions of beauty rather than by adherence to the moral codes of society. The soldier, or, more correctly, the officer, was increasingly regarded as integrated with society and working for its best interests. The soldier was thus the antithesis of the artist: conformist, mindful of authority, at worst chauvinistically philistine. Gilbert and Sullivan's comic opera *Patience* (1880) made play with the opposing characteristics of these two stereotypes. If such an ideological gap had existed in reality in the period 1874-1914 it might have posed grave difficulties in relating the work of bohemian, nonconformist artists to the subject matter of and market for battle paintings. An analysis of the social background, career patterns and known interests of late nineteenth-century Academic artists reveals that a significant number had pronounced military interests. That is, Academic artists identified more strongly with the interests of the middle class from which most of them sprang than with the bohemian preoccupations assigned to them by popular myth.

A number of London-based, Academy-exhibiting artists seem to have identified with militarism to the extent of joining the Volunteers. This included not only battle painters but artists like Leighton, Morris and Rossetti, who worked on more 'aesthetic' themes.[44] Artists active in the genre of battle painting, not surprisingly, can be shown to have had strong connections with the army. The accurate detail which was considered desirable in High Victorian painting meant that substantial study was necessary to produce a successful picture. Any special taste or access to information must not only have dictated the genre the artist pursued but have been prized as an advantage over rivals. The strong presence of high-ranking soldiers in the audience of the Royal Academy in earlier decades has been noted earlier. In the 1870s artists

felt that they were obliged to produce paintings which would satisfy the supposed desire of this 'expert' audience for absolute fidelity to detail. Elizabeth Butler, in 1875, clearly believed this professional group's criteria for judging a picture to be different from those of civilians. Further, she seems to have accepted that they were criteria she must strive to satisfy:

> I dread to think what blunders I might have committed. No civilian would have detected them but the military would have been down on me. I feel, of course, rather fettered at having to observe rules so strict and imperative concerning the poses of my figures, which I hope will have much attention. I have to combine the drill book and the fierce fray![45]

This note in her diary suggests that she felt fidelity to the 'drill book' would inhibit her ambition of capturing the suggestion of the 'fierce fray'. The relationship with illustration and the compulsion to please a military audience meant that battle painting was regarded by admirers of 'Art for Art's sake' as a genre for militarists totally deficient in taste. The view that soldiers were necessarily philistine was again a stereotype. Many high-ranking officers were keen collectors and connoisseurs of art, attended art events in London, mixed with artists and were integrated with strands of the cultural life of the capital.[46] The association between philistine obsession with details and battle painting is revealed in an article, entitled 'The decline of art', published in 1885:

> An old connoisseur has been known to remark over a picture of Waterloo that Wellington does not sit straight in his saddle, and so the critic, fresh from a ride in the Row, rejoices in his superior sense of eyesight... An old veteran fights his battle over again in the face of charging cavalry and a furious battery, and pays no ill compliment to the painter when exclaiming, 'By Jove! I hear the clatter of the horses' iron hooves and the very roar of the guns!' and thus a silent art has its victory in rousing the sense of sound![47]

A lengthy discussion of the Aesthetic Movement would not be appropriate here.[48] It is enough to note that the art press – *The Art Journal*, *The Studio* and the *Magazine of Art* – paid diminishing attention to battle painting in the late 1880s. In this the genre shared the fate of narrative pictures in general. Landscapes and portraits, left until the end of art reviews in the 1860s and 70s, were now admired first. The disillusionment of 'art circles' with narrative art was matched by disdain for the Royal Academy as the home of old-fashioned art. The Grosvenor Gallery (opened 1877, closed 1890), the New English Art Club (founded 1886) and the New Gallery (founded 1890) all presented a challenge to the supremacy of the RA as the most 'important' forum

of contemporary art. The art world became polarised as never before. The *avant-garde* dismissed the Academy as dull and reactionary, while conservatives regarded the RA as the mainstream, divorced from the alarming excesses of the Aesthetic Movement. Discussing the battle pictures in the Royal Academy of 1882, a reviewer was relieved to discern that '. . . they bear also traces of new life – life strong and earnest and healthy, not resulting in any great achievement but producing little that is VAPID and UNHEALTHY.'[49]

The language in which battle painting was discussed was also the language of sporting art, another genre which was considered reassuringly traditional and 'national'. A critic writing of the work of John Charlton, a sporting painter who later worked on military subjects, found his work to be '. . . above all things, healthy, manly, appealing to the temperament, that is, more readily roused by a trumpet-call or the sweet discord of a hound chorus than the thrilling vibration of the lady's lute.'[50] In his *Academy Notes* of 1875 Ruskin had asserted that battle painting was a masculine activity and therefore only to be successfully practised by a male painter. Confronted by an obvious contradiction in the art of Elizabeth Butler, he designated her 'An Amazon', a woman with the warrior qualities of a man,[51] indicating an unarticulated equation between the practice of war and the practice of painting representations of war. Sporting art, representations of fox hunting and horse racing, was also considered a masculine preserve, since it celebrated 'manly' attributes of courage, energy and aggression.

This strident insistence on the 'manly' and 'healthy' aspects of British art has been identified in the work of Rudyard Kipling. Preben Kaarsholm has shown that his imperialist and militarist poems and stories demonstrate a terror of the 'degeneration and feminisation' of the British nation.[52] Aesthetic art and literature were manifestations of a dangerous tendency towards effeminacy and homosexuality which would weaken the country and lead it to lay down the 'white man's burden'. These fears lie below the surface of the writings of a number of contemporaries. Elizabeth Butler regarded her own work as an antidote to the 'disease of the 'Aesthetes' whose 'sometimes unwholesome productions' she saw at the Grosvenor Gallery:

> I felt myself getting more and more annoyed while perambulating those rooms, and to such a point of exasperation was I impelled that I fairly fled, and breathing the honest air of Bond Street, took a hansom to my studio. There pinned a seven-foot sheet of brown paper to an old canvas and with a piece of white chalk, flung the charge of 'the Greys' upon it.[53]

Thus, in the early 1880s, the practice of battle painting and the ethos of militarism was increasingly invoked as an 'antidote' to what was

perceived as the dangerously 'effete' tendencies of the time. The extent to which art was equated with these social anxieties reminds us of the extent to which culture was seen as a social barometer and force for change.

Notes

1 See Hichberger, thesis, 1985.
2 There is as yet no full-length biography of the artist. Wilfred Meynell's 'The life and word of Lady Butler', *Art Annual*, 1898, is a useful source, as is the artist's own memoirs, *An Autobiography*, 1923.
3 E. Clayton, *English Female Artists*, 1879, p. 183.
4 *Kilvert's Diary*, ed. W. Plomer, 1940, III, p. 43.
5 *Connoisseur*, No. 79, 1927, p. 127.
6 Spiers, p. 103.
7 *Times*, 4 May 1874, p. 8.
8 E. Butler, 1923, p. 114.
9 Spiers, p. 116.
10 E. Butler, 1922, p. 188.
11 John Bowle, *The Imperial Achievement*, 1974, p. 300.
12 Hugh Cunningham, 'The language of patriotism', *History Workshop Journal*, 12, autumn 1981, p. 24.
13 C. C. Eldridge, *Victorian Imperialism*, 1978, p. 241.
14 Benjamin Disraeli, speech delivered at the Crystal Palace, 24 June 1872, in George Bennett, *The Concept of Empire*, 1953, p. 258-9.
15 Eldridge, p. 124.
16 *Ibid*, p. 4.
17 C. Kingsley, 'Public spirit', *Sermons for the Times*, 1855, pp. 344-5.
18 *Kipling: the Critical Heritage*, ed. R. L. Green, 1971, p. 21.
19 C. Kingsley, 1855, pp. 344-5.
20 Rupert Brooke, 'The soldier', *Collected Poems*, 1919.
21 G. Wolseley, *The Story of a Soldier's Life*, 1903, I, p. 58.
22 Spiers, p. 49.
23 *Ibid.*, p. 219.
24 *Ibid.*, p. 50.
25 W. E. Henley, introduction to C. Thierry, 1898, p. viii.
26 *Mr. Chamberlain's Speeches*, ed. C. W. Boyd, 1914, I, p. 25.
27 Spiers, p. 49.
28 Edward McCourt, *Remember Butler!*, 1967, p. 130.
29 *Merrie England*, Vol 3, October 1883, p. 45.
30 Edith Finch, *Wilfred Scawen Blunt, 1840-1922*, 1938, p. 67.
31 William Butler, *An Autobiography*, 1911, p. 219.
32 E. Butler, 1923, p. 47.
33 Wolseley, 1903, I, p. 20.
34 *Times*, 2 May 1876, p. 4.
35 W. Butler, 1911, p. 237.
36 E. Butler, 1923, p. 47.
37 *Ibid.*, p. 187.
38 *The Spectator*, Vol. 54, 25 June 1881, p. 830.
39 W. Meynell, 'The life and work of Lady Butler', 1898, p. 8.
40 *Magazine of Art*, 1879, p. 209.
41 *Merrie England*, Vol. 8, 1886, p. 209.
42 McCourt, p. 58
43 *Artis and Letters*, Vol. 1, 1881-82, p. 98.
44 W. B. Richmond, *The Richmond Papers*, ed. A. M. W Stirling, 1926, p. 165.

45 E. Butler, 1922, p. 124.

46 *The Letters of Lord and Lady Wolseley*, ed. George Arthur, 1922, p. 30.

47 'The decline of art: the Royal Academy and the Grosvenor Gallery', *Blackwoods*, CXXXVIII, July 1885, p. 5.

48 Dennis Farr, *English Art, 1870-1940*, pp. 15-48, *passim.*

49 *Academy*, Vol. 521, 29 April 1882, p. 309.

50 *Art Journal*, 1892, p. 34.

51 John Ruskin, 'Academy notes, 1875', *Ruskin's Works*, ed. E. T. Cook and A. Wedderburn, 1904, XIV, pp. 308-9.

52 Preben Kaarsholm, 'Kipling, imperialism and the crisis of Victorian masculinity', *Patriotism*, ed. Raphael Samuel (forthcoming).

53 E. Butler, 1923, p. 186.

High Victorian battle painting II

The artistic treatment of war has been marked, even in modern times, by the strongest transformation of sentiment and style. The battle pieces of a hundred years ago with the effective qualities of panoramic represen-tation have ceased to be acceptable to the realistic spirit of the present day. The vast scale on which military movements are now conducted, and the altered conditions of strategy and tactics, have driven painters to take refuge in the minor incidents of warfare, and to abandon all attempt at scenic completeness of display. They portray with fidelity and skill the soldiers' daily life and occupation, and still render with vigour and exactness suggestive incidents in the byways of a campaign; but the great battles that decide the fate of armies and of great empires are now almost always left without record.[1]

This quotation from the journal *Art and Letters* was written in 1881-82. The author has obviously identified what he/she believes to be a radically new phase in the representation of battles. Developments in the conduct of war are one factor in the change: battles were now so huge as to be impossible to comprehend as a single image on canvas. Yet implicit in the next sentence is the knowledge that the choice of new subjects is not merely due to historical events; that shifts in senti-ment must have precipitated these artistic developments.

In the preceding chapters this issue has been explored in a number of ways. The power struggle between the emergent bourgeoisie and the aristocracy over the administration of the army mobilised middle-class opinion in favour of the private soldier, with concomitant interest in his daily life and work. Adjustments in the concept of history painting allowed importance to the representation of everyday subjects of milit-ary life, and the integration of French artistic ideas into the British military vocabulary have been noted. Finally, Elizabeth Butler's suc-cess showed that the public and the art establishment could accommo-date what had been considered a foreign genre.

These factors all encouraged artists after 1874 to experiment with military paintings. More specialised in the genre than ever before, yet the type of work they produced and their careers were far from uniform. Although we cannot hope to enumerate all the military artists practis-

D

ing at the time, it is hoped that selected examples will shed more light on the art and the artists than has previously been possible.

Although the writer in *Art and Letters* claimed that contemporary battle artists were painting new subjects in new ways, this may not always have been entirely the case. John Charlton (1849-1917), merely used the post-1874 upsurge in interest in military painting to rework an old genre. His route into military painting was in fact remarkably traditional. Coming from Newcastle, the city which had produced Bewick and Clennell, he established a strong practice as an animal painter before settling in London in 1874.[2] At first his work was almost exclusively hunting scenes, notably of prestigious hunts such as the Pytchley. In 1883 he showed the first of his battle pictures at the Royal Academy, *British Artillery entering the Enemy's Lines at Tel-el-Kebir, 13th September 1882*. This subject was apparently chosen to give maximum scope for his undoubted, and known, ability for depicting horses in action, thus providing him with a bridge between his established activity as a sporting painter and his excursion into the new genre. The strategy was similar to that adopted by the sporting artist T. J. Barker three decades earlier. Like Barker, Charlton made his move when a higher level of interest in a contemporary war might have assured him of a market.

Charlton appears to have been heavily indebted to Barker, both for his approach and in borrowing direct from the older artist's subject matter; in 1884 he exhibited *After the Battle: Sedan*, which depicted abandoned horses roaming after the battle. Barker had shown an earlier version of this subject, *Riderless War Horses, after the Battle of Sedan*, in 1873. No critics appear to have recalled Barker's earlier essay, acclaiming Charlton's work as innovatory.[3] Charlton's strategy, like Barker's, was to 'suggest' the battle, the feelings of the absent human protagonists and their fate through the depiction of their horses. A lengthy discussion of his *Bad News from the Front* (RA 1887) describes Charlton's method and is suggestive of how this type of 'battle' painting was read:

> This subject was suggested by a description sent from the seat of war to the *Graphic*; for which newspaper, I believe, Mr. Charlton's original study in black and white was made. . . In the limpid half-light, the long stretches of barren hills and the empty saddles of horses that stoop to bury their nostrils in the cool stream as they ford it. Mr. Charlton tells us a story that is as perfect and poetical in sentiment as it is artistic in his way of treating it. In imagination we see the fight in the first flush of dawn when half a score of troopers on outlying picket were surprised by a sudden swoop of natives, the hasty rush for horses, which they had

barely reached before the fierce spearmen were on them, the stubborn
stand on foot and the stampede of riderless horses across miles of. . .
sandy hills before they reached the welcome pool.[4]

The critic bases the success of the picture on the assumption that the
viewer would be able to imagine the events that led to the abandon-
ment of the horses. Another believed that the 'vivid suggestion of the
unseen but tremendous tragedy' stimulated the imagination so that
the desired emotion was aroused 'without requiring intermediate pro-
cesses of thought for its full realisation'.[5] Charlton was able to rely on
the 'correct' interpretation of his painting because of the powerful net-
work of mythologies surrounding the relation of horses to humans.
Their loyalty was 'well known', i.e. was a familiar element of Victorian
discourse, and there was a long tradition of representing animals as
'faithful unto death'. Landseer's *The Old Shepherd's Chief Mourner*,
Horace Vernet's *The Trumpeter's Horse* and Harvey's *Incident in the
Life of Napoleon* all showed that animals could display superior qual-
ities of 'humanity'. Charlton could rely on his viewers 'knowing' that
the horses would not have strayed or bolted but that they could only
have been driven away from their masters by some disaster. The critic
was able to construct a narrative around the limited information given
by the artist, drawing upon the imagery and clichés of newspaper war
journalism. The phrases 'sudden swoop of natives' and 'stubborn stand'
had such common currency that they seemed factual, to describe the
way all British soldiers confronted their colonial enemies.

Charlton's pictures, like those of Butler, were always described as
battle painting. Since both artists in different ways and for different
motives evaded the representation of fighting, the term 'battle paint-
ing' must have had a broader definition than we have hitherto under-
stood. The work of Elizabeth Butler, in particular, can be shown to
have been modified by the conflicting ideologies of war, imperialism
and the military, which pervaded her social group in the 1870s. It is
clear that despite her enormous importance as the first of the 'new
generation' battle painters and as the establisher of 'new' military
genres, her followers did not share her moral objection to depicting
violence. The genres which she had used to convey sadness over war
were used by them to celebrate it.

In the period 1874-1918 the illustrated press had an important impact
on academic battle painting. Many of the most respected and popular
battle painters were in some capacity connected with one of them.
These publications were, in some cases, a vital source of additional
employment, to sustain an academic career. In the largest number of
cases academic artists had worked previously for a paper, which

provided a kind of 'apprenticeship' in the increasingly specialised field of military representation. The newspaper illustration industry was an important economic factor in the working life of many late nineteenth-century battle painters. The close relation between the academic genre and commercial art had a detrimental effect on the status of battle painting.

French Impressionism, the aesthetic theories of 'Art for Art's sake', combined with the opening up of alternative exhibiting venues for the 'new art' all called into doubt the narrative, didactic and highly finished art favoured by the Royal Academy as the most important and progress- ive art of the age.[6] At the very time when battle painting seemed to have gained some standing within the academic milieu, the Academy and its values were being undermined by other, increasingly influential sections of the art world. The poor rate of success achieved by battle painters in the elections for the honour of Associate and Membership is evidence that artists in the Academy were biased against battle paint- ing rather more than against other narrative genres. The prejudice stemmed partly from its associations with the topographical tradition. The close friendship which was perceived between it and the illus- trated press must also have contributed to the low status of battle painting. Illustrated weekly newspapers had made their appearance in the 1840s with the publication of the *Illustrated London News* by Herbert Ingram. The *ILN* soon proved enormously popular: in 1843, only a year after its inception, the circulation had reached 66,000. In 1881, despite the competition which had sprung up, the most notable of which was *The Graphic*, the *ILN* was averaging a weekly circulation of 70,000. The circulation of *The Graphic* was only slightly lower. The social group towards which the *ILN* was directed was the middle to upper middle classes, presumably with a metropolitan bias.[7] These social strata would undoubtedly overlap, to some extent, with the Academy-visiting and art-buying public. The Royal Acadamy summer exhibitions were extensively reviewed in the *ILN* and carried reproduc- tions of the pictures.

The most important single subject in either paper was colonial war- fare. Military scenes formed nearly 40 per cent of all illustrations in an average year from 1875, and almost every issue carried news and illustrations of the campaigns being fought in outposts of the empire. In the post-Crimean era the desirability of sending out an artist to pro- duce sketches at 'the seat of war' was recognised. Speed of coverage and the claim of 'absolute fidelity' to the facts became important factors in the circulation war. Prior to this development, journalists' reports had been amplified by no more than 'an artists impression',

executed in the newspaper office in London. The growth of war illust-
ration as a media form called into being a new race of artists who had
to combine the skills of explorer, soldier and journalist with artistic
ability. These 'special artists', as they were called, became personalities
in their own right, some publishing racy autobiographies or writing
articles about their adventures. Archibald Forbes, Frederick Villiers and
Melton Prior were all famous for the daring with which they pursued
pencil-worthy military news across often dangerous and hostile
country.[8]

The illustrated papers continued to employ artists based in London
to 'work up' sketches sent back by front-line artists into material suit-
able for publication. The task of finishing sketches was a highly skilled
exercise of the imagination. The sketches received from the front were
often rough-and-ready. It required knowledge to transform them into
a comprehensible picture. Luke Fildes and Hubert Herkomer were
among a number of accomplished artists who did this kind of work in
their youth.[9]

Frederick Villiers was a typical front-line 'special'. He became a well
known personality in the late Victorian newspaper industry. He was
a relentless self-advertiser, always emphasising his own courage and
skill in producing his sketches, thus increasing his readers' sense of
their value. His arch-rival, Melton Prior, frequently included a self-por-
trait in his own sketches, presumably to underline his participation in
the drama.[10] Villiers's art training was the conventional one of an
academic artist. He attended the South Kensington School of Art, as
well as a number of evening classes, as a prelude to gaining admittance
to the Royal Academy schools. His first experience of military art was
to paint a panorama of the Franco-Prussian War, 1869-70. He went to
Paris, with a forged passport, to gather sketches and information. In
this, his first adventure, he showed the resourcefulness and disregard
of authority which was to characterise his career as a war artist. After
five years' study at the RA schools he applied to be sent to cover the
Serbo-Turkish war for *The Graphic.* [11] In the next fifty years he was
almost constantly abroad covering British colonial and other wars.

Villiers exhibited two battle paintings at the Royal Academy, in 1882
and 1883, so far as is known his only excursions into academic art,
both now lost. They were painted at his studio at Primrose Hill during
brief interludes between working trips.[12] The first was based on the
Afghan war of 1878-80, which he had covered for *The Graphic*.[13] This
work depicted *The Road Home: the Return of the Imperial Brigade
from Afghanistan.* The title suggests that it showed men on the march
rather than engaged in a battle.[14] The second seems, however, to have

been a battle scene, *Fighting Arabi with his own Weapons: Tel-el-Kebir.* Tel-el-Kebir was the culminating battle of the expedition to suppress the Arabi rebellion in 1882. General Sir Garnet Wolseley had crushed Arab resistance at the desert fortress in a daring night attack; the British contingent compelled the numerically superior Arab force to surrender. The battle was greeted by Wolseley's admirers as proof of his powers of generalship and vindication of the Cardwell reforms. Villiers, who was evidently willing to participate in the celebration of Wolseley's command, based his painting on sketches he had made on the spot. He also sold some sketches of the same battle to the British-based French battle painter Alphonse de Neuville.[15] Woodville, another special artist at the front, also made sketches and photographs for de Neuville, who had been given a commission for an oil painting of the battle and had been too ill to make the arduous journey to the Sudan.[16] This episode, recorded in Villier's autobiography, is most revealing of the practice of academic battle painters, who seem to have had a symbiotic relation with newspaper artists. The high reputation of the newspapers for fidelity to the facts undoubtedly increased the pressure on academic painters to achieve accuracy in depicting events they perhaps had not seen. Certainly, in the 1880s, critics were more likely to condemn a battle picture for its inaccuracy, although what constituted 'truth' in such contexts was by no means straightforward. Such transactions as that mentioned above appear to have been common. Villiers further recounts that another of his sketches, 'finished' in London by John Charlton, was purchased by a 'lady artist' who 'paid a good sum for the rights of painting the subject'.[17] This tantalising reference is the only information known about the practice of buying the rights to a pictorial motif.

Without referring to the missing picture by Villiers, it is impossible to pronounce on the artistic relation betweeen them and his newspaper sketches. It seems likely, in view of his constant struggle to enhance his reputation, that he moved into the field of oil painting to demonstrate his ability in the sphere for which he had originally trained. In this he was probably stimulated by his close association with the architect and artist Alfred Waterhouse, with whom he shared a studio.[18] His excursion into battle painting does not seem to have been successful, if critical attention was his object, since none of the newspapers or journals mentioned the pictures in reviews of the exhibitions, nor do they seem to have been engraved or reproduced by photogravure. Ironically, in view of the considerable support and help given to academic artists by the illustrated newspapers, the connection may have materially lowered the status of the genre within the Academy.

Naturally it is difficult to quantify a nebulous commodity like prestige, but as will be seen, from the late 1870s battle painting was increasingly dismissed as 'inartistic' and too 'factual' to qualify as Art. No artist who specialised in contemporary battle pieces was admitted to associateship of the Academy in this period, despite the greater number of practitioners. Artists like Wollen and Crofts, who specialised in *historical* battle scenes, were granted the accolade. In the first half of the century Jones and Cooper had received admission to the Academy quite early in their careers, when they were specialising in contemporary military subjects. None of the battle painters of the two succeeding generations had achieved similar recognition. Some degreee of prejudice seems the only reason why an artist of the celebrity of Richard Caton Woodville, enhanced by royal patronage, should have failed to win honour with the Academy. Woodville's credentials as an academically trained artist were impeccable. He had studied in Düsseldorf with the religious subject painter Gebhardt from 1876 to 1877. Woodville probably worked as an illustrator and later as a 'special' to subsidise his academic paintings.[19] He was regarded as highly skilled at making 'artist's impressions' of events he had not witnessed. In 1879 he drew a 'two-page spread [which] showed the gallant Prince Imperial of France in a highly romanticized pose, facing the onset of the Zulus with his back to the wall of the gully; the caption was 'At Bay'.[20] Since no one had witnessed the death of the prince, the use of an 'artist's impression' was acceptable. An artist in the locality could have done no more than supply 'local colour'. Woodville's impression satisfied his audience because it fulfilled expectations that the prince had died nobly. It was said by a contemporary that Woodville's work represented 'an artist's victory over many a British defeat'.[21] He was adept at transforming authentic-seeming detail into highly romantic art. The chief quality embodied in it was moral conviction – he wholeheartedly believed in the righteousness of the imperial cause. Like Elizabeth Butler, he revered soldiers and their trade. His style as an illustrator, which has been described by Peter Johnson as *'Boys' Own Paper'*, is reflective of his fervent admiration for all things military.[22] The soldiers in his drawings are always heroic, chivalrous, handsome and brave, their actions always graceful. Himself clearly influenced by Desanges, Woodville spawned many imitators.

He began to exhibit at the Royal Academy in 1879. His first battle pictures, such as *Before Leuthen, December 3rd 1757* and *Blenheim*, were executed in a highly refined, detailed manner reminiscent of Meissonier. After 1881, the year in which he showed his first contemporary battle picture, his work began to be described by critics as 'care-

less'. At this time Woodville appears to have been trying to synthesise the dashing freedom of his newspaper drawings with the demands of an academic audience:

> I painted with fewer and larger figures, much broader in the brushwork and in its execution, so as not to hamper the movement and to give an idea of the rush of men.[23]

A fellow artist noted that his approach to these battle pictures was close to that of an illustrator.

> There is no man so rapid in his work or who works in such a unique manner. I have seen him sit down before a huge canvas and start in the centre of the cloth with the pivot figure of his picture and finish it straight away. . . Woodville apparently has the whole composition fixed and centred in his brain and with wonderful rapidity conveys it to the canvas as faithfully and directly as the lens of a camera registers a subject.[24]

This technique stands in strong contrast to Butler's more traditional approach, in which she built up a composition only after taking scores of painstakingly detailed sketches. The influential critic G. A. Sala of the *Daily Telegraph* attacked his technique as 'slapdash'.[25] The issue of 'finish' had been given great publicity in the recent Ruskin v. Whistler libel case. In the course of giving evidence the art establishment had reinforced the ideal of workmanship over inspiration as the vital ingredient of a good painting. A work of art must be seen to have involved effort and expertise. Perhaps disappointed by the failure of his experiment in evolving a new style of battle painting, Woodville reverted to a tighter, more detailed and highly finished style. The quality for which he was praised by all critics was 'dash', which must be taken to mean the illusion of lively movement, conveyed by drawing rather than painting, enabling the artist to avoid accusations of carelessness. Paradoxically, in diminishing the 'painterly' qualities of his art he moved closer to the newspaper illustrations for which he was famous. From the mid-1880s Woodville's work was often condemned as 'pass[ing] little beyond the province of newspaper illustration'.[26] The accusation was levelled at other painters with very different styles and no professional connection with the illustrated press, a fact which suggests that the similar subject matter of the two media, and the fact that a number of artists worked in both spheres, may have had a detrimental effect on the status of battle painting generally. The status of the genre was undermined by the association with a form that was considered both documentary and intellectually facile. At a time when the increasing interest in the military assured battle painters of a market stronger than they had enjoyed since 1815, military

[96]

Production and patronage of battle paintings: the Zulu wars

The large number of battle paintings exhibited at the Royal Academy during the period 1874-1914 makes it impossible to account here for the genesis of more than a few. In this section, the paintings inspired by the Zulu war of 1879-80 are examined, to determine the process by which they were commissioned, their appearance and the critical response.

The Zulu war was regarded as the most important of the colonial wars up to the Sudan campaign in 1883-84. In some respects it was typical of many expeditions in the mid and late nineteenth century, fought to supress a native nation for territorial and commercial motives.[32] Donald L. Morris has published a masterly history, *The Washing of the Spears,* which reveals the repressive nature of the action in Zululand, and British ignorance of the customs and motivation of the Zulus.[33] B. Farwell gives this account of the British reason for going to war.

> Ostensibly, the campaign against the Zulus was undertaken because of alleged encroachment by them on territory and because Cetewayo, their chief, was said to misgovern his tribe. The real reason was that the presence of the large, well-trained Zulu army was a standing menace to the British colonists in Natal, who knew that the Zulus could overwhelm them if they chose.[34]

What marked the Zulu war from the Ashanti war, the Maori wars and the other colonial expeditions was that the British were humiliatingly defeated. The war brought a series of political embarrassments. The only son of the late French emperor, Napoleon III, was allowed to accompany the army of Lord Chelmsford. The Prince Imperial was carelessly permitted to go out with a small foraging party and was massacred by a few Zulus. This was a humiliation for the Queen and for the army, who had guaranteed the prince's safety.[35] The greatest disaster of the war occurred on 22 January 1879, when Lord Chelmsford, marching in pursuit of the Zulu army, recklessly split his force into three. The base camp at Isandhlwana was left unprotected and, although well armed, appallingly disorganised. Almost everyone in the camp was massacred by a swift-moving Zulu force. On the same day a huge force of Zulus laid siege to a makeshift hospital and camp at Rorke's Drift. The few soldiers left to guard the sick and wounded put up a powerful defence although heavily outnumbered. The Zulus were eventually crushed at the battle of Ulundi in July 1879. Cetewayo was imprisoned and the emergent military empire of the Zulus

dismantled.[36]

The massacre at Isandhlwana had been a severe blow to national pride, and was largely due to Lord Chelmsford's persistant under-estimation of the speed and discipline of the Zulu 'impis' or battalions. He was the victim of his own misconception of 'the African character', since he believed them as a race to be cowardly, stupid and ill-disciplined.[37]

Only three oil paintings of the Zulu war were exhibited at the Royal Academy, and one large water-colour. Water-colour painters, not considered here, made an important contribution to the representation of war in the nineteenth century market, although they catered for a different section of the market. Orlando Norie, whose *Battle of Ulundi: Charge of the 17th Lancers* (RA, 1882) may have been a large water-colour painting, was an important practitioner of military art.[38] He came from a Scottish family of artists but spent most of his professional life in England. From 1870 he maintained a studio, in Aldershot, to enable him to make continual studies of soldiers in action. Norie's history shows that, despite the vagaries of the market for oil paintings of battles, there was a steady demand for scenes of military life in the less expensive medium of water-colour. He also produced several extensive series of the uniforms of the British army which were mass-produced as steel engravings.[39] As a watercolourist he was felt to be less significant within the Royal Academy, and despite his reputation he exhibited there only twice, in 1882, and two years later with *Tel-el-Kebir.* Neither painting received any attention in the art press. As a general rule there were about 200 water-colours in the exhibition, compared to approximately 900 oil canvases, but despite this comparatively high proportion water colours were only rarely mentioned in reviews. Norie's work was much admired by the Queen, who acquired thirty-eight of his works for the royal collection. He also won the enormous accolade of a commission from the Queen, to paint *The Royal Procession leaving Buckingham Palace on its Way to Westminster Abbey* to commemorate the Jubilee celebrations in 1887.[40] It is likely that Norie had regarded acceptance of his work for the Academy exhibition as a necessary prelude to establishment recognition.

Only one of the oil paintings represented a British military victory. John Charlton's *After the Charge: 17th Lancers at Ulundi, July 4 1879* was in his accustomed mode, showing the grim consequences of war by depicting its effects on the equine participants. Ulundi was a symbol of ultimate victory despite setbacks. The work might be read as merely ritual mourning over the sadness of war, since it indirectly celebrated a British victory, one, moreover, in which few British lives had been

lost. Nothing is known about the provenance of this now lost picture. Charlton's works appear to have been cabinet-size and therefore may have been produced speculatively.

Charles E. Fripp's *The Last Stand of the 24th Regiment at Isandhlwana* (RA 1885) is one of the most direct and powerful battle pieces which survive from the late nineteenth century. The 'last stand' formula was the basis of some other memorable works. W. B. Wollen's *Last Stand of the 44th at Gundamuck, 1842*, when compared with Fripp's picture, demonstrates how diversely the formula could be applied. Fripp's painting showed over a hundred figures in striking scarlet uniforms against a dramatic African veldt. Wollen's showed only ten or so soldiers, clad in winter rags, huddled together in the lonely mountains of Afghanistan. The premise of both was, however, identical: in extreme circumstances, and against overwhelming odds, the soldiers stood together and died bravely. The phrase 'last stand' itself implied that the men were doomed. The work was therefore more about the way in which British soldiers conducted themselves than how successfully they did so. In most 'last stand' scenes, including those just mentioned, the soldiers are gathered into a semblance of the defensive four-square drill formation, a device which demonstrated their discipline in the face of death. It was also a useful means by which the artist could group the figures tightly together and focus their facial expressions. Fripp was undoubtedly influenced by the first British picture to show the formation, Butler's *Quatre Bras* (RA, 1875). Fripp's reworking of the theme was effective in exploiting all the possibilites: the contrasts between the different ages, physical types and races engaged in the struggle.

Late Victorian battle painters manipulated a number of stock characters. One of the most familiar was the little drummer boy. The juxtaposition of children and war was considered peculiarly poignant, a theme considered in greater depth in the last chapter. Drummer boys in battle paintings seem more idealised than in contemporary literature. Those in Kipling's poem *The Drums of the Fore and Aft* were given to swearing, lying and fighting, while remaining impressively heroic.[41] Such gradations of personality would have been difficult to convey in a painting. Fripp's little drummer was angelically beautiful, with blond hair and a noble expression. The presence of a boy at the massacre was well documented, as was the fate he suffered.[42]

Another stock character prominently featured in Fripp's picture was the sergeant major. This character began to appear in battle painting after the Crimean war, and should be read in terms of the contemporary movement to heroicise the ranks. In pre-Crimean paintings officers

had mainly been the heroic figures, supported by the generalised mass of the troops. That it was the sergeant-major who was the favourite figure in post-Crimean paintings is not surprising. Sergeants, as non-commissioned officers, were the cream of the ranks, promoted for such qualities as reliability, obedience, intelligence and above all, respectability. From the view point of the army and the civilian middle classes, the sergeant embodied all the best characteristics of the regenerate working class.

In Fripp's painting a sergeant is posed prominently in the centre, standing alert and erect, although already suffering from a head wound. His sense of responsibility is indicated by the protective arm he stretches across the drummer boy. It must be assumed that the prominent featuring of the boy was a way of demonstrating the 'cowardly' conduct of the Zulus in killing him. That the standardisation of characters was recognised is clear from a review of Caton Woodville's *Tel-el-Kebir* :

> A number of picturesque figures of soldiers appear on the battle-field, including, of course, that handsome young officer with the sad eyes and drooping fair moustache whom Mrs. Butler invented.[43]

It is instructive to compare Fripp's work with the remaining Academy picture of the Zulu war, Butler's *The Defence of Rorke's Drift* (RA, 1880). There is a strikingly higher level of violence in Fripp's picture; the corpses of both British and Zulu soldiers are liberally scattered in the foreground, and Zulus are shown in the act of killing the redcoats. The two armies are shown to be suffering equally; in the left foreground two warriors, one white, one black, lie dead, side by side, like a mirror image. In Butler's picture the violence is literally put to one side. The defenders of Rorke's Drift occupy nine-tenths of the canvas; the enemy are indicated only by two gracefully laid out bodies. The Zulus to the extreme left are shown less as fighting than as feeling the impact of British bullets.

Butler's scruples about depicting hand-to-hand combat have already been mentioned. She had a further reservation about executing the Queen's commission for the picture because she felt that Rorke's Drift had received undue attention. '. . . as though it were a second Waterloo'.[44] The obsession with Rorke's Drift may be attributed to the fact that it provided a welcome distraction from the greater humiliations of that war. The subject demanded by the Queen was also one which left no doubt as to who were the villains of the piece. At Rorke's Drift the Zulus had attacked a hospital base defended by only a few men. The subject provided visual evidence of the righteousness of and neces-

sity for the annihilation of the Zulu army. Queen Victoria continued to privilege Rorke's Drift over the rest of the campaign and indeed other imperial expeditions, by awarding eleven Victoria Crosses to participants – the most ever given for a single engagement.[45]

Notes

1 *Art and Letters*, 1881-82, p. 93.
2 Journal, Henry S. Pearse, 'John Charlton', 1892, p. 34.
3 *Art Journal*, 1892, p. 34.
4 *Ibid.*, p. 37.
5 *Academy*, 21 May 1887, p. 368.
6 Dennis Farr, *English Art, 1870-1940*, 1976, has a good account.
7 Alvar Ellegard, 'The readership of the periodical press in mid-Victorian England', *Acta Universitas Gothenburgensis*, LVIII, 1957, p. 37.
8 Peter Johnson, *Front Line Artists*, 1978, pp. 6-17.
9 Frederick Villiers, *Five Decades of Adventure*, 1921, I, p. 228.
10 Johnson, p. 80.
11 Villiers, 1921, I, pp. 4-5.
12 Anthony Hobson, *The Art and Life of J. W. Waterhouse, RA. 1849-1917*, 1980, p. 38.
13 Villiers, 1921, I, p. 42.
14 Butler's *Halt on a Forced March: the Retreat to Corunna*, (RA, 1892) is an interesting essay in this genre.
15 Joseph H. Lehmann, *All Sir Garnet*, 1964, p. 324.
16 R. C. Woodville, *Random Recollections*, 1914, p. 61.
17 Frederick Villiers, *Peaceful Personalities and Warriors Bold*, 1907, p. 27.
18 Hobson, p. 28.
19 Woodville, p. 80.
20 Johnson, p. 95.
21 *Ibid.*, p. 15.
22 *Ibid.*, p. 3.
23 Woodville, pp. 82-3.
24 Villiers, 1907, p. 25.
25 Woodville, p. 82.
26 *Spectator*, Vol. 54, 25 June 1881, p. 830.
27 Gernsheim, p. 56.
28 *Illustrated London News*, 17 May 1884, p. 491.
29 *Art Journal*, 1885, p. 258.
30 *Times*, 25 May 1885, p. 4.
31 *Illustrated London News*, 28 April 1883, p. 425.
32 B. Farwell, *Queen Victoria's Little Wars*, 1973, p. 224.
33 Donald S. Morris, *The Washing of the Spears*, New York, 1965.
34 *Ibid.*, p. 516.
35 *Ibid.*, p. 378.
36 *Ibid.*, p. 599.
37 *Ibid.*, p. 340.
38 *Academy*, 15 October 1881, p. 65.
39 Wood, p. 345.
40 Haswell-Millar, p. 341.
41 Kipling, *Barrack Room Ballads*.
42 Morris, p. 379.
43 *Athenaeum*, 21 June 1884, p. 799.
44 E. Butler, 1922, p. 186.
45 Farwell, p. 234.

CHAPTER SEVEN

The imperial crisis

The period 1885-1914 was the most prolific time for the production of battle paintings and other celebrations of the military glory of the empire. Despite the preoccupation of the middle classes with army and empire, it is perhaps not enough to speak of the pictures as merely 'celebratory'. It was rather a time in which battle paintings showed a redefinition or hardening of ideological standpoints. Notions about the Empire and its relationship with other European powers, ideas about the 'natural' dominance of the white race over the black races were all given pictorial attention, suggesting concern or even a sense of crisis. These new feelings of anxiety were most frequently located in representations of the past; the military history of England was a safe site in which to explore contemporary problems and reconstruct 'historical truths' for the new era.

Although we cannot spend too much time on pictures that drew their subject from the more distant past, it is interesting to note that in the last two decades of the century, the 1890s particularly, representations of the battles of the Napoleonic era outnumbered contemporary incidents by two to one. In the 1860s and '70s the proportion had been roughly equal. Many late nineteenth-century reviewers did not make a distinction, and would discuss a Blenheim picture in the same category as a Sudan war subject.[1] Many of the battle painters discussed in this book worked on both historical and 'contemporary' subjects with equal ease.

Richard Caton Woodville began his exhibiting career at the Royal Academy by showing two battles from eighteenth-century wars.[2] The subject matter of his subsequent eight pictures was 'contemporary' but in 1894 he turned back to the Peninsular campaign with *Badajos, 1812*. In subsequent Academy exhibitions he showed a Charge of the Light Brigade, a Relief of Lucknow, and a scene from the Peninsular battle of Fuentes Onoro. The only link between the four is that they all depicted acts of gallantry by significant military figures. With *Badajos*,

1812 Woodville submitted a quotation from William Napier's famous *History of the War in the Peninsular* which was included in the exhibition catalogue:

> When Wellington saw the havoc of the night, the firmness of his nature gave way for a moment and the pride of conquest yielded to a passionate burst of grief for the loss of his gallant soldiers.[3]

At the siege of Badajos the town had been taken only at the sacrifice of 5,000 men. In the following days the troops got completely out of control and commited atrocious acts of rape, murder and pillage.[4] The memory of Badajos was by no means entirely creditable. Woodville chose to direct his audience's attention on the image of the Iron Duke, as the aristocratic hero weeping for his men. This theme, the 'price of victory', had been current some years before and would have been familiar to his audience. *The Charge of the Light Brigade,* Woodville's next picture, was also a celebration of aristocratic leadership. The Earl of Cardigan, who in his day had been admired and detested equally, could be represented twenty years after his death as an example of dis-interested chivalric courage. Warfare, after the Franco-Prussian con-flict, was becoming more a matter of weapons and railway timetables than dependent on the inspiration and courage of individuals. The Cardwell reforms, almost contemporaneous with the Prussian war (1870-71), appeared to signal the end of aristocratic leadership of the army. Despite Cardigan's obvious weaknesses as a general, he undoub-tedly had, with hind-sight, a glamour that some of Woodville's contem-poraries lacked.

The battles of the Waterloo campaign formed the centre of late nineteenth century military nostalgia. In the Royal Academy exhibi-tion of 1897 there were eleven paintings which took their subjects from those few months in the summer of 1815, with only one picture depict-ing a contemporary event, Stanley Wood's *Surrender under Protest: an Incident in the Matabele War.* The significance of Wellington, and more particularly Napoleon, has been touched upon in the introduc-tion. The Regency era stood as a symbol of Britain's ability to win, even against the greatest military genius in history.[5] In Chapter ten it will be suggested that the Regency period was looked back upon as an era of social harmony and uncomplicated social relations. There was undoubtedly a sense in which the warfare of that age was seen as more dignified because the technology was traditional.

In looking back into history artists may have been motivated by the desire to evade contentious issues. Armitage's *Meeanee* had been criti-cised not only as a picture but as a battle. Depicting a battle was taken

as a tacit act of glorification, of the battle and of the reputation of the general who had fought it. The tendency to confuse aesthetic with military issues did not decrease towards the end of the century, when battle scenes were often judged primarily on technical grounds. Elizabeth Butler remarked that she rarely undertook very recent subjects, preferring to let her themes 'mature'. This may be taken to mean that she liked to wait and see how history viewed a battle before attaching her own name to it.

There was, of course, a sense in which artists and writers used the military experience of the past to articulate ideas about the present. During the Boer war Butler turned back for her subject matter to the Crimea – the last time the British had fought a full-scale war against an army of the same race. Her *The Colours: Advance of the Scots Greys at the Alma* was exhibited in 1899, accompanied by a passage loaded with nostalgia for 'old-fashioned' battles. 'It was the last battle of old order. We went into action in all our finery, with colours flying and bands playing.'[6] The words suggest a longing for set pieces, two armies confronting each other in a series of orchestrated troop formations. This kind of encounter had become almost extinct, not least owing to the unsuitable terrain upon which most colonial encounters were fought and the long range of modern guns. It was now possible to kill the enemy without seeing them at all.

Butler's art enjoyed a revival of popularity during the first world war. In the early years of the new century she had virtually retired into oblivion, but during the war she was given several 'one man' shows, which were both retrospective and carried new work.[7] Her pictures represented the world war as though it were being fought with cavalry skirmishes by dashing, khaki-clad officers. Her failure to even acknowledge the realities of trench warfare and barbed wire was not remarked upon by critics, who were, perhaps, only too glad to accept her construction.

One of the most memorable images of war from the Victorian period was Robert Gibb's *The Thin Red Line* (RA, 1882). The painting, once used to advertise Dewar's whisky, sums up many familiar strands of High Victorian battle painting. The image is of a regiment engaged in an important battle; hundreds of men acting in perfect unison, each depicted as brave, steadfast and cheerful. Most significantly, the regiment is a Highland one, the 93rd making an heroic stand at Balaclava.[8]

Despite the numerical minority of Scottish regiments in the late Victorian army, the Scottish soldier received more pictorial coverage than any other. The Highland regiments, with their kilt and plaid uniforms, dominate. Their picturesque uniforms and bagpipes made them an

attractive subject; the heroic history of the Highlanders in the Crimea, Egypt and India provided excellent material. However, the prominence of the Highlanders must be seen in relation to contemporary Scottish nationalism and the romantic cult of Scotland.

Gibb was himself Scottish, but the representation of the Highland soldier was not limited to Scottish artists. Memorable examples were exhibited by Henry Nelson O'Neil, Elizabeth Butler, Stanley Wood and Richard Caton Woodville. That Scottish painters should have chosen to depict national regiments is not remarkable; what is, is the total exclusion of the Lowland regiments, comparable to the domination of Highland over Lowland culture in the perception of the rest of the British Isles.

Hugh Trevor-Roper has shown that 'the creation of an independent Highland tradition, and the imposition of that new tradition with its outward badges, on the whole Scottish nation, was the work of the late eighteenth and early nineteenth century'.[9] Far from being a miraculous survival from the Celtic past, the hallmarks of Highland culture, Celtic poetry, the tartan kilt and the clan system were all manufactured or artificially revived by people who were enamoured of the idea of the Highlands as the true Scotland. The Highland revival was another manifestation of Romanticism. It had been given a European boost by the 'discovery' of the poems of Ossian by the enterprising McPherson and by the novels of Sir Walter Scott.[10] Whereas the Jacobite rebellion in the early and mid-eighteenth century had prompted the Hanoverian dynasty to obliterate the Scottish tradition, its last king, George IV, joined enthusiastically in its revival. In 1822 he went to Edinburgh on an official visit organised by Sir Walter Scott, president of the Celtic Society.[11] The royal visit stimulated the manufacture of 'traditional' Scottish dress, and an interest in the ancient culture of a remote part of Britain which seemed to move ever further into the lowlands.

Queen Victoria acquired Balmoral Castle on 1847 and was frequently depicted wearing tartan and mounted upon Highland ponies. Sir Edwin Landseer was the most famous artist of this aspect of Victorian fantasy. Indeed, it might be argued that he extended the myth of the Highland savage into the realm of animal imagery. His depictions of wild deer and hunting hounds in magnificently wild scenery were among the most widely circulated pictures of the whole century.[12]

Scottish Romanticism was essentially apolitical. Indeed, it was because the notion of Scottish autonomy was effectively dead that Queen Victoria could safely indulge her taste for Scottishness without jarring contradictions between political allegiances. During the 1850s,

however, a movement grew up which asserted that Scotland had been wronged and neglected after the Act of Union in 1707, and pressed Scotland's claim for a fairer share of political power. In 1853 the National Association for the Vindication of Scottish Rights was formed, and in May that year an 'Address to the People of Scotland' was published. Its main demands were that taxes raised in Scotland should be spent on Scotland; the removal of certain government offices concerned with Scottish affairs to Edinburgh, and more parliamentary legislation for Scotland.[13] James Grant (1822-87) was the central figure, providimg a link between Scottish Romanticism, Scottish nationalism and Scottish militarism in the 1850s. Grant was related to Sir Walter Scott, and had strong Jacobite sympathies. He had served as an ensign in the 63rd Foot, 1840-43, before entering an architect's office as a draughtsman to support his main career as a novelist. The majority of Grant's novels were about military history and many dealt with the Highland regiments. He was motivated by a desire to show that the nation owed a debt to the Highlands. He was a founder member of the National Association, and was later to be an ardent supporter of the Volunteer Force and an adviser to the War Office.[14]

Grant's importance was that he put the notion of the Scottish soldier as the ideal warrior into common currency. In his novels the Highland soldier laddie is elevated into a character with military instincts who cleaved to his officer as mystic clan leader. The Highland regiments were given a wealth of history and romantic tradition. Grant's approach influenced other popularists, such as Samuel Beeton, editor of the *Boys' Own Magazine.* In a book for boys Beeton devoted four chapters to the history of Highland regiments, indicating that it was the primitive nature of Highlanders which made them perfect soldiers, and that in their simple devotion and simple aggression they set an example to other fighting men.[15]

By the 1870s the depopulation of the Highlands due to changes in agricultural policy meant that there were fewer men available. In view of the mythology of the 'natural' Highland warrior this was believed to be a serious matter: Scotland and Ireland had always provided a disproportionate percentage of the army, owing to high unemployment.[16]

When Gibb began exhibiting battle paintings in 1878 the Highland regiments filled entirely by clansmen were very much a nostalgic memory, and the Golden Age of the Highlanders was set firmly in the past, in the age of the Peninsula and Waterloo campaigns and the Crimea. *The Thin Red Line* had a quality of great simplicity, with a rhythmic arrangement of heads and bayonets trailing away into the distance. The famous phrase may have come from Russell's report in

The Times, where the Highlanders were described as 'a thin red streak'.[17] Its emotional impact was enormous, summing up the isolation of the 93rd as they stood awaiting the onslaught of the Russian cavalry. The first wave is suggested only by a solitary horseman, falling after a shot. As in Butler's paintings the attention of the viewer is transferred away from the conflict towards the moral quality of the defending soldiers.

A lengthy article on Gibb, published some fifteen years later, laid great emphasis on his Scottishness. Anxious to account for Gibb's expertise as a battle painter despite his lack of a military background, its author claimed that his inspiration came from his 'strong sense of patriotic feeling'. His knowledge of Scotland and its soldiers was enough to give him the power to choose the right scenes and to imbue them with 'spirit', the 'force and fervour which instinctively awaken, a responsive chord of sympathy in the heart of the spectator'. The mythology surrounding the Highland warrior was an important way in which artists were able to key in to the romantic and patriotic feelings of an English audience, to 'awaken a responsive chord'.[18]

The past could also be utilised to articulate ideas about the contemporary colonial experience. W. C. Horsley's series of paintings executed during a British occupation of Cairo can be read as part of a discourse which claimed the British 'right to rule' in Egypt. The role of policing and repressing a colonised country was a more familiar but less picturesque aspect of the army's role in the empire. Academic artists rarely turned their attention to such subjects, but in this case Horsley's pictures may have seemed justified by the 'God-given nature' of the British presence in Egypt.

The series of events by which the British took over the administration of Cairo are necessary to an understanding of Horsley's pictures. After Wolseley's force had defeated a 'rebel' army which had risen against the puppet king, Tewfik, it occupied the capital for his 'protection' but primarily to ensure that loans from British financiers were repaid. Britain's great rival for influence in the region was France. France also owned shares in the Suez canal and had close links with the Ottoman empire, which was nominal ruler of Egypt. When British troops moved into Cairo in 1880 they objected to the large number of Frenchmen working in government posts. The British clearly feared that they might subvert the native population. The intense rivalry between the two powers in the near East was to lead to the edge of war in the Fashoda crisis of 1898.[19]

If the reasons for the British presence were mainly fiscal and diplomatic, a lofty mythology was soon constructed around it by such

men as Alfred, Lord Milner, Under-Secretary of Finance in Cairo. He saw the revival of Egypt after a few years of British rule as almost a fairy tale:

> Look where you will – at the Army, at finance, at agriculture, at the administration of justice, at the everyday life of the people and the relations to their rivals – it is always the same tale of revival, of promise, of a slowly developing faith in the existence of such a thing as equity, of a nascent. . . spirit of self-reliance and improvement.[20]

In 1884, two years into the British occupation, Walter Horsley exhibited the first two of a series of four pictures dealing with the colonisation of Egypt. *The Whirligig of Time, Egypt 1800 and 1884* and *The French in Cairo* (RA, 1884); and *Great Britain in Egypt, 1886* (RA, 1887) and *A Friendly Power in Egypt* (1888). *Great Britain in Egypt, 1886* showed a confrontation between native and coloniser. The terms in which the two races were described by a British reviewer made it clear that the Arabs were viewed as both comic and suspicious. They were summed up as 'envious', 'idle' or 'uninterested'. The first two paintings in the series articulated the British right to rule in 1882, through a contrast with the rule of the French army of Napoleon in 1800.[21] The French occupation had been quite short. In contrasting the two eras, Horsley aimed to show that the French had been oppressive and their behaviour insensitive. His other exhibit that year was a comment on the French occupation, which again was contrasted with the benign rule of the British. *The French in Cairo* was exhibited with a paragraph:

> During the French occupation of Cairo by the army under General Buonaparte, the latter caused the names of his principal generals to be inscribed upon the towers and gates of the walls of the city. The native population was much incensed by this, the more so that the chief of each quarter was obliged to be present at the work.[22]

Reviews of the picture show that Horsley's audience were quick to pick up the criticism. One reviewer added his own narrative suggestion, that the French were looking so bedraggled because of the severe beating they had been given at the battle of Aboukir.[23]

In *A Friendly Power in Egypt* the native population are shown looking thrilled or amazed by a military band marching through the bazaar. Clearly British rule is to be construed as a source of pleasure to the Arabs, as against the cruelty of the French. Horsley's audience were also anxious to believe that a nation which had committed acts of harshness in the past was unfit to bear any part in the 'revival' of the modern Egypt.

Race and the imperial crisis, 1890-1914

It is usual to see the second Boer war (1899-1901) as the point at which British attitudes hardened into the jingoism that led to the first world war. It is clear from examination of paintings themselves and the art world more generally that the kind of racist, nationalist and militarist attitudes which were discerned after 1900 were already present by the late 1870s. Notions about the supremacy of the white races, the particular rectitude of the British among European nations and the country's moral duty to defend her authority were all closely interwoven, as has been shown by such authorities as P. D. Curtin.[24] It is therefore important to consider the dramatic shifts in the way British artists represented 'the enemy' in nineteenth-century battle paintings.

In the post-Waterloo paintings of such artists as George Jones and William Allan there was no differentiation between the conduct of French and British. Representations of the French in late nineteenth-century works depict them as brave, enduring and mutually supportive. It is in the representation of other races that the shift in attitude is discernible. George Jones's *Battle of Meeanee* showed a conflict with the Indian army of Sind. In the campaign Indian soldiers of the East India Company's army had fought alongside British soldiers. An Indian soldier on horseback is featured prominently among Sir Charles Napiers's staff. Although there is a great deal of bloodshed it appears to be equally divided. The arrangement of the troops, however, conveys the impression that the British were disciplined and the Ameers chaotic. They are shown as effective soldiers though, brave and proficient with their weapons. Jones was at considerable pains to depict their dress, physiognomy and accountrements. The work was purchased by Charles Napier himself, who is known to have approved the handling of technical detail.[25]

In British paintings in the last two decades of the century, artists placed more emphasis on the question of racial 'difference' than they had done before. In the 1880s, when Fripp's *Battle of Isandhlwana* and G. D. Giles's *Tamai* were executed, there was a rise in 'scientific' study in the difference between races. The trend was to 'prove' that the black, white, yellow and brown races had been separately created and thus entirely separate species. This kind of 'evidence' was interpreted as proof that each race had different capabilities and that the non-whites were by nature inferior.[26]

In such works as Giles's *Battle of Tamai* the artist exploited current notions of racial difference to diminish respect for military achieve-

ment by black warriors. The battle of Tamai took place during the campaign across the Sudan, in the Gordon rescue expedition, and Giles was probably a participant.[27] The battle was of considerable interest to Giles's military colleagues, since it contributed to a long-standing debate about the efficacy of 'drill book' tactics in colonial warfare. In simplest terms, Tamai was used by traditionalists to 'prove' that the drill taught at Sandhurst to cadets since the eighteenth century was still effective. Giles made this his argument by depicting the superiority of the British over their Dervish enemy. The Dervish army, some 12,000 strong, had made an entirely effective onslaught against the British force of about 3,500 men. A British square, manned by the Yorkshire and Lancashire Regiment, broke under pressure and was forced to retreat. The battle was saved only by the initiative of the men of a four-gun battery, who locked the guns before abandoning them. The Dervishes were thus unable to turn them on the fleeing soldiers and annihilate them. The British were able to regroup, and with their superior weapons beat the Dervishes back.[28]

Giles's painting was exhibited at the Royal Academy in 1887, entitled *An Incident at the Battle of Tamai, East Soudan, 19 March 1884*. There was some precedent for representations of black enemies struggling against superior technology. Frederick Villiers, the war correspondent and battle painter, had used the formula in 1883, *Fighting Arabi with his own Weapons: an Incident in the Battle of Tel-el-Kebir*. The term 'incident' was used of a moment in the course of battle, small perhaps but significant, either in symbolising the character of the protagonists or in encapsulating the nature of the conflict as a whole. Giles selected the point just after the Dervishes had broken the British square and captured the guns, but found themselves unable to use them. The implication is that the Dervishes did not understand how to use them rather than that they were locked. Giles was reworking a familiar formula for the implication of racial inferiority. By emphasising and caricaturing the features of the Dervishes he was able to make them look ridiculous. The main effect was to distract attention from their very considerable achievement. The second implication was that since they were evidently incompetent the British had never been in danger of defeat and the loss of the square was not disastrous.

Giles's representation of the two sides, in this and a companion picture seeks to establish that the British won because they were better fighters and better men. The second picture is a later version of the battle of Tamai, from behind the British lines. In the *Incident*, although the British have supposedly been driven back, they are shown standing straight and composed in the distance. The Dervishes, in the fore-

ground, are crouching among the rocks. The state of mind and moral qualities implied by the postures are obvious; standing straight equals bravery and crouching cowardice. So Giles contrived to reverse the reading of the picture.

The Dervishes are shown as having suffered considerably more than the British, when the two pictures are compared. In the foreground of the *Incident* blood pours from the head of a dying Dervish, and his comrades are sprawled in postures of anguish. In the companion piece the British wounded are depicted by polite formula, a shoulder or head neatly bandaged or a dead body lying composed behind a bush. The Dervishes evidently died with less dignity. It is true that the British ultimately lost fewer men at Tamai, but to have shown British soldiers in pain would have offended the audience and suggested that the Dervishes were a worthy foe.

The British are compassionate to their wounded comrades, but there is nothing comparable among the Dervishes. The latter, referred to by all reviewers as 'fuzzy-wuzzies', are depicted as incompetent, cowardly, undignified and lacking in compassion. The effect of the two canvases, when hung as they are together, at the National Army Museum, is to reduce the Dervishes to inconsequentiality. They occupy far less space and are more scattered. The British present a solid line of khaki. Although the pictures were probably meant to hang as a pair, with a continuous horizon line and matching landscape, the Dervishes are much smaller than the British troops.

Giles's representation stands in strong contrast to Kipling's picture in the dialect poem *Fuzzy-wuzzy:*

> We've fought with many men across the seas,
> An' some of 'em was brave and some was not:
> The Paythan an' the Zulu and' Burmese
> But the Fuzzy was the finest o' the lot.

and

> So 'ere's to you, Fuzzy-wuzzy, at your 'ome in the Soudan.
> You're a pore benighted 'eathen but a first class fightin' man;
> An' 'ere's to you, Fuzzy-wuzzy, with your great 'ayrick of 'air,
> You big black boundin' beggar – for you broke a British square![29]

Giles's paintings were discussed as though his physical presence at the battle ensured absolute fidelity to the facts. The artist aimed at producing a naturalistic effect by abandoning the traditional compositional formulae. No one area was the main group, with all action devolving from it, nor was any strong geometrical shape imposed upon the composition. The 1887 *Incident* shows an unconventional distribu-

tion of figures, scattered among the rocks. In the foreground, however, Giles established a scale by including a 'repoussoir' group. The painting shows his use of photographic 'accidents': cutting off figures to suggest that they are moving in and out of the frame, and also catching figures in 'instantaneous' unposed poses. Giles has used the technique to great effect, even placing the head and shoulders of a Dervish warrior in the right foreground, cut off by the frame, setting him in the viewer's space.

The picture also had a feeling of authenticity through the detail it contained and in the 'frank' way it showed violence. This was an important concern at the time. In the 1890s the 'discretion' in not depicting actual bloodshed, for which Butler had been praised in the '70s, was attacked as evasion. Giles's picture maintained convention for the British soldiers but showed the Dervishes with a 'realism' that was praised as truthful. This, combined with the knowledge that he had been an eye-witness and was a military 'expert', ensured that his very biased picture was taken as a 'record' of the battle, serving to re-inforce stereotypes of racial capacities.[30]

The Boer War

It was argued above that many of the racist and nationalist attitudes which become familiar in the art of the Boer war period were already present in preceding decades. The war was shocking enough for these attitudes to harden, and to be articulated as a coherent policy for the first time.

The war, declared by the Boers on 11 October 1899, proved to be a severe shock for the army and the nation as a whole. Years of military success in the empire had made the army complacent and ill prepared for a prolonged struggle.

> It proved to be the longest (two and three-quarter years), the costliest (over 200 million), the bloodiest (at least twenty-two thousand British, twenty-five thousand Boer and twelve thousand African lives) and the most humiliating war for Britain between 1815 and 1914.[31]

The Boer war can be considered the final break between the 'sporting', self-confident attitude of the early imperial era and the growing sense of grim struggle. In relation to battle painting there was a new sense that war art was an important factor in building morale and must there-fore only reflect positive aspects of the war effort. This perception of battle painting as propaganda seems to have been limited to private individuals. In the Great War the state would devote financial resources to the depiction of war. The origins of the idea are discernible in the reactions of the press to the first winter of the Boer war.[32]

At the outbreak of war there had been tremendous enthusiasm among a wide variety of social groups, many 'jingoists' seeing the war as an opportunity for Britain to assert herself over a recalcitrant group of subjects. Within weeks alarming losses had been sustained, and it became clear that the war was by no means the 'walk-over' it had at first appeared. Thousands of Volunteers were sent out and there was a sense of national participation; for the first time war was not solely the business of the professional soldier.

In the art press this sense of crisis and national war effort was reflected in calls for battle painters to produce works which would encourage the nation to fight, paintings which would be 'a noble encouragement in patriotic devotion'. An article in the *Art Annual* for Christmas 1900 made it clear that what the artist should produce was a positive, pleasant, stirring view of war, rather than 'realism' or 'sensationalism'. The reasons for eschewing 'realism' were both artistic and political:

> Art has no home amongst the horrors of realism or of carnage. The warrior needs no reminders of these. He hopes they may be buried deep beneath the paths of peace. (Preachings on canvas against the strife of battle have always been in vain and a gallery of pictures by Delacroix will not prevent a people rushing into war).[33]

The last sentence seems to be a warning against anti-war sentiments: visual protest would be not only undesirable but ineffectual. The artist was evidently required to tread a narrow path, demonstrating 'the stolidity, eagerness, coolness and self-sacrifice incarnated in Tommy Atkins' without showing him killed or in the act of killing.[34] The writer goes on to call for more battle pictures which would support national morale. The adversities of the Boer war led to calls for an all-out, national effort from every class in society. For the first time Academic battle paintings were perceived not as a neutral reflection of history but as part of the process of building a pro-military ideology.[35]

Statistics of Royal Academy exhibits register an upsurge in the number of battle pictures and an even larger upswing in the number of genre depictions of the military. One reason was of course that artists were keen to be topical. Another, more pressing one, was that the art market, like the art-book market, slumped during the war:

> The publication of important artistic books has almost stopped in England at this time [early 1901] . . . The reasons for this are not difficult to find, the general one being the unhappy prolongation of the South African War, and the special reason the death of Queen Victoria. These have combined to prevent the public purchasing books on Art, in the same way that they have prevented the sale of pictures and drawings. . .[36]

Those writers who had for years advocated a British school of battle painting perceived that a new era had dawned which would give the ambition impetus. One writer argued that the war finally disproved the mythology of Britain as an anti-military nation:

> The mighty enthusiasm that quivered from end to end of the British Empire on the outbreak of hostilities, once for all disillusioned us of the idea that we are not a military nation. Another illusion, which if not entirely dispelled, has yet been considerably shaken is that we cannot produce a school of battle painters.[37]

The sense that there was a coherent 'school' of battle painters was deliberately fostered in publications such as *The Year's Art*, which, in 1901, carried photographs of battle painters, newspaper specials and illustrators who were engaged in producing pictures of the war.

The most striking difference between pre- and post-war pictures is that, after the first catastrophic winter, there were no representations of defeat or failure. All the paintings exhibited at the RA were celebratory, implying only a successful war effort. In the 1880s there had been a minor fashion for heroic failures, at Kabul, Isandhlwana and Maiwand. Such subjects reflected well upon the army; 'more true courage is often displayed in the retreat than in the onslaught'.[38] Moreover, that such scenes could be admired and valued was further evidence of national fairness and lack of militarism:

> . . . art is not concerned either with politics or with strategy, and the artist need not ask himself if a blunder which cost England a whole regiment might have been avoided or whether a murderous and resultless battle need have been fought at all. He has only to inquire whether the subjects are worth painting. . .[39]

The war did much to restore the prestige of battle painting as a genre. In the 1901 volume of the *Magazine of Art* representations of the war and the funeral of the late Queen at the RA were reviewed before landscapes and portraits, a reversal of the practice of the preceding fifteen years. The reviewer devoted space to battle painting after an almost apologetic introduction, explaining that, although it might not be 'the highest art', being close to journalism, it had the merit of reflecting the 'spirit of the times'.

> The other overshadowing topic which has inspired a number of canvases is the Boer War. This is as it should be, for no art can be convincing and earnest which is not build upon the emotions and the experiences of a nation. The only surprise is that the demonstration is not more general, yet, in truth – and in spite of Mafeking Day it must be said – that we are so reticent a people that relatively few have cared to treat what is uppermost in men's minds. Of all the most satisfying is Mr. Wollen's

Imperial Light Horse at Wagon Hill, Jan. 6 1900. It is not the highest art, but we are made to feel that the man was here – that it is all true – that those little tragedies enacted by the grim yellow warriors, fighting amid the boulders as they lie prone under partial cover – this is realism controlled by admirable judgement and taste.[40]

The review appeared shortly after the end of hostilities. People immediately resumed the position that Englishmen were reticent about war and nationalism. It also reveals the view of war art as not of the 'highest' category remaining to conflict with the notion that war art was necessary in some sense to a war effort. In the Great War these questions were to rage more fiercely, and to some extent were answered by the development of new forms of representation which could be both pleasing to devotees of New Art and fulfil the expectations of the 'patriotic art' lobby.

Despite the large numbers of 'eye-witness' artists who were rushed to the front to 'record' the Boer War, the battle pictures which resulted were traditional in their selection of subject and method of representation. Cavalry charges with lance and sabre had largely given way to long-range artillery exchanges, and traditional tactics to guerilla warfare. Farm burning, barbed wire, concentration camps never appeared on the walls of the Royal Academy.[41] The problems presented by the new warfare were discussed discreetly by one writer:

> The enormous area. . . now covered by military operations has so completely altered the artist's opportunities. He must perforce endeavour to depict stirring incidents but where the conflicting armies are miles apart, it is very difficult to find subjects which follow the old conventions.[42]

The type of painting characteristic of the war was the charge or the retreat, showing horses and riders in headlong gallop. Frequently, as if in concession to contemporaneity, the horses were pulling heavy artillery. Such works as John Charlton's *Routed – Boers Retreating* (1900) allowed the artist to depict a 'stirring' incident in a familiar mould but to combine it with a sense of authenticity:

> Mr J. Charlton, one of the ablest horse painters of our time, has designed 'Routed – Boers Retreating' (956) with extraordinary spontaneity and singular animation. They gallop furiously, horses, guns, teams of waggons and what not, vehicles in all the confusion of the panic and are urged by the extremes of confusion and pain.[43]

The choice of such a propagandistic subject as defeated Boers retreating indicates the new tone of war painting. Emphasis has shifted from moral qualities to a more aggressive attitude according to which war needs no justification.

The period between the Boer war and the Great War saw no changes in the appearance of battle paintings. Battle scenes continued to be reviewed as 'truth', painted by 'experts', but were generally passed over in specialist art journals in favour of the Newlyn school and the portraits of Sergeant. The split in the art world which had appeared in the 1870s was by now a positive chasm, with the New Art on the opposite side from battle painting and the Royal Academy. It would not have been possible for an Academy battle piece to hang at the New English Art Club without looking wholly out of place. In the pre-Reform days work which was exhibited at the Academy could have been and was, hung at rival galleries such as the British Institution. In the years 1901-14 the proportion of battle pictures was higher than it had been at any time in the nineteenth century. The stage was set for the close integration of establishment and art which crystalised during the Great War.

Notes

1 *Magazine of Art*, 1894, p. 274, describes a Gow picture of a seventeenth-century subject with three Waterloo works.
2 Royal Academy Catalogue, 1879, Nos. 511 and 453.
3 Royal Academy Catalogue, 1894, No. 441.
4 Thomas Harbottle, *Dictionary of Battles*, 1971, p. 37.
5 Lean, p. 209.
6 E. Butler, 1922, p. 187.
7 She had several shows at the Leicester Galleries, including a 'Waterloo Centenary' exhibition in 1915.
8 *Academy*, 26 February 1881.
9 Hugh Trevor-Roper, 'The Highland tradition of Scotland', *The Invention of Tradition*, ed. E. Hobsbawm and T. Ranger, 1983.
10 D. and F. Irwin, *Scottish Painters at Home and Abroad, 1700-1900*, 1975, p. 283.
11 Trevor-Roper, p. 29.
12 Richard Ormond, *Sir Edwin Landseer*, (Tate Gallery), 1982, pp. 15-16.
13 J. Hanham, 'Mid-century Scottish nationalism: romantic and radical', *Ideas and Institutions of Victorian Britain*, ed. Robert Robson, 1967, pp. 164-5.
14 'James Grant', *DNB*, XXII, 1890, p. 392.
15 S. O. Beeton, *Our Soldiers and the V.C.*, 1867, p. 68.
16 Skelley, p. 289.
17 William Kinglake, *The Invasion of the Crimea*, 1863-67, p.
18 *Art Journal*, 1895, pp. 26-7.
19 Raymond Flower, *Napoleon to Nasser*, 1972, pp. 119-21.
20 Alfred Milner, *England in Egypt*, 1892, pp. 6-7.
21 *Athenaeum*, 7 June 1884, p. 735.
22 Royal Academy Catalogue, 1884, No. 516.
23 *Art Journal*, 1885, p. 368.
24 P. D. Curtin, *The Image of Africa*, 1964, p. 81 and *passim*.
25 J. Hichberger, 'Captain Jones, R.A.', *Turner Studies*, Vol. 4, No. 1.
26 Douglas A. Lorimer, *Colour, Class and the Victorians*, 1978, pp. 14-15.
27 *Art Journal*, 1885, p. 258.
28 Harbottle, 1971, gives a clear account of the battle.

29 Rudyard Kipling, *Barrack Room Ballads*, 'Fuzzy-wuzzy', 1893.
30 *Art Journal*, 1885, p. 258.
31 Thomas Pakenham, *The Boer War*, 1979, p. xv.
32 Wilkinson-Latham, pp. 254-80.
33 *Art Journal*, Christmas No. 1900, p. 30.
34 *Loc. cit.*
35 Newspaper censorship operated in this war; Wilkinson-Latham, pp. 284-9.
36 *Art Journal*, 1901, p. 254.
37 *Loc. cit.*
38 *Illustrated London News*, 13 May 1882, p. 467.
39 *Times*, 25 May 1885, p. 467.
40 *Magazine of Art*, 25 May 1901, p. 339.
41 The battlefield pictures which were exhibited tended towards the extremely sentimental, e.g. G. W. Joy's *Dreams on the Veldt*, 1901.
42 *Art Annual*, 1900, p. 4.
43 *Athenaeum*, 26 May 1900, p. 663.

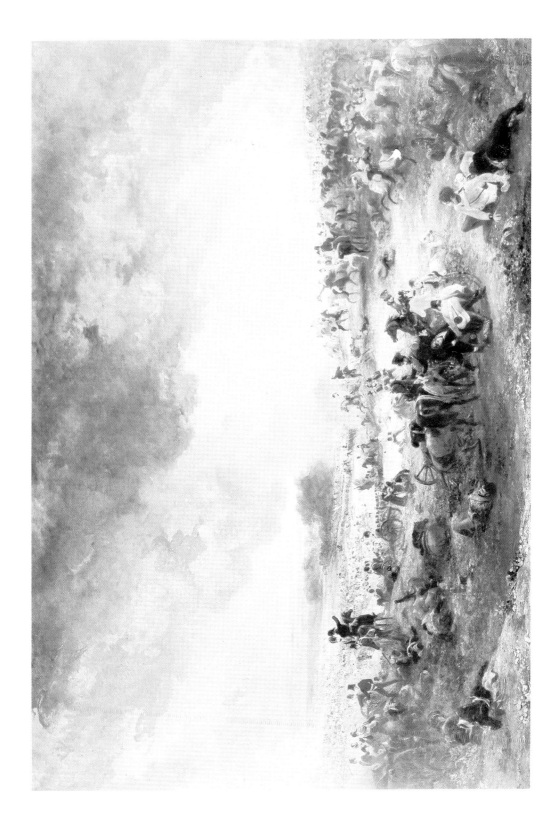

1 [facing] George Jones, *The Battle of Waterloo*, oil on canvas

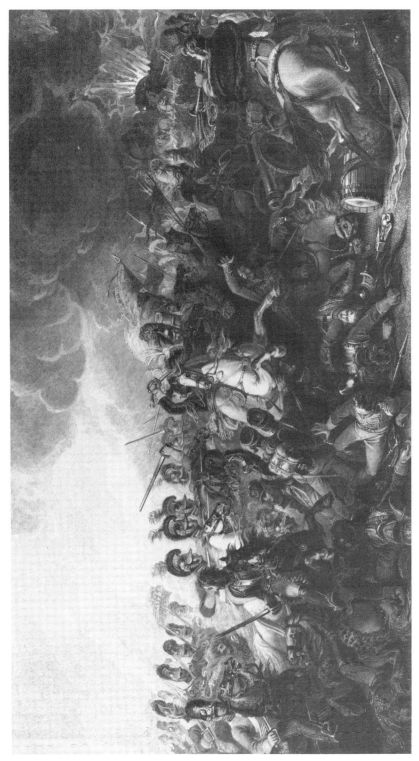

2 Luke Clennell, *Sauve qui peut!*, engraving

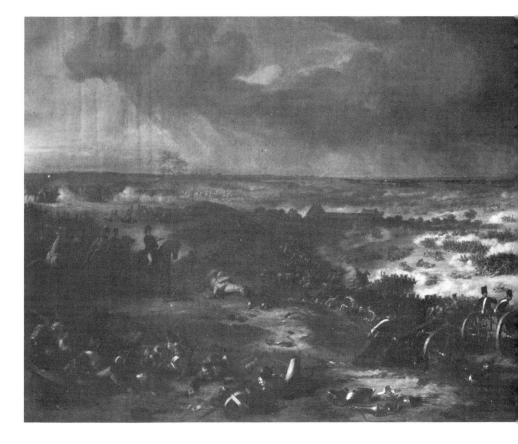

3 *[facing]* T. S. Cooper, *The Defeat of Kellerman's Cuirassiers and Carabineers*, oil on canvas

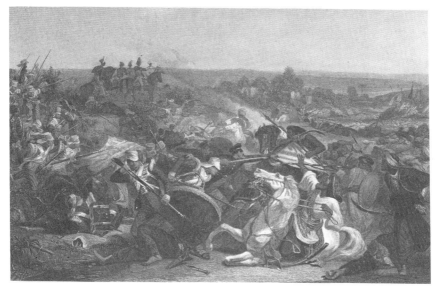

4 Edward Armitage, *The Battle of Meeanee*, engraving
5 William Allan, *The Battle of Waterloo*

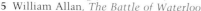

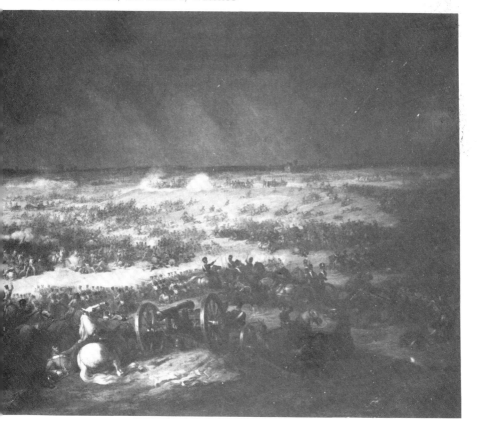

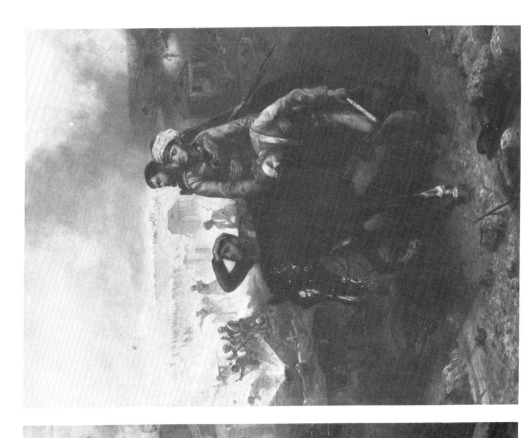

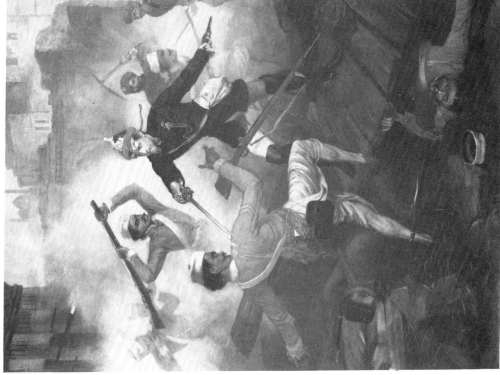

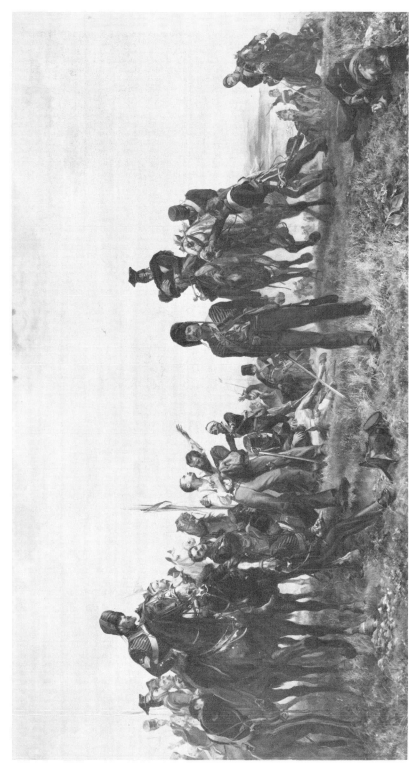

6, 7 [facing] Louis Desanges, *Lieutenant William Kerr winning the V.C., July 1857 and Colonel Cubitt winning the V.C.*

8 Elizabeth Thompson, Lady Butler, *Balaclava*

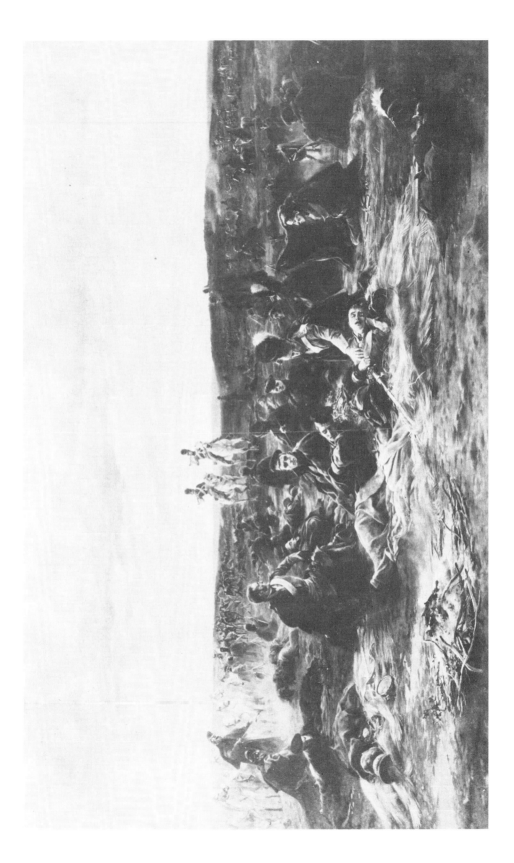

9 [facing] Elizabeth Thompson, Lady Butler, *Dawn of Waterloo,* lithograph

10 C. E. Fripp, *Last Stand of the 24th Regiment at Isandhlwana*
11 W. B. Wollen, *Last Stand of the 44th Regiment at Gundamuck*

12, 13 G. D. Giles, *An Incident in the Battle of Tamai* and *The Battle of Tamai*

14 *[facing]* E. V. Rippingille, *The Recruiting Party*

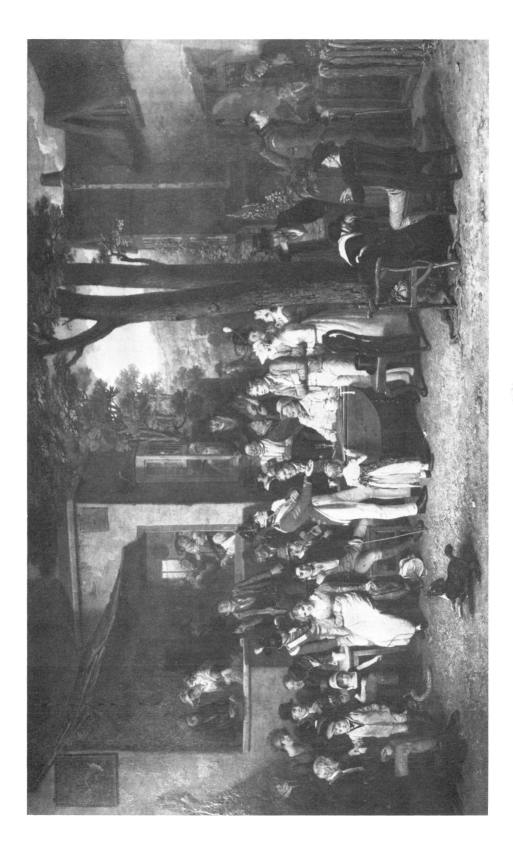

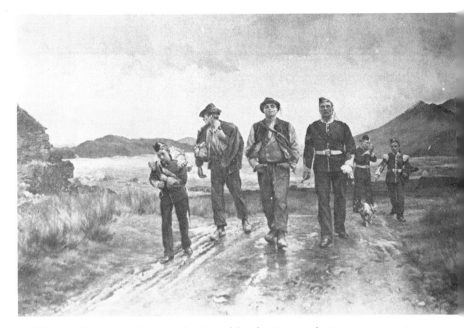

15 Elizabeth Thompson, Lady Butler, *Listed for the Connaught Rangers*, engraving
16 H. Collins, *The Deserter*

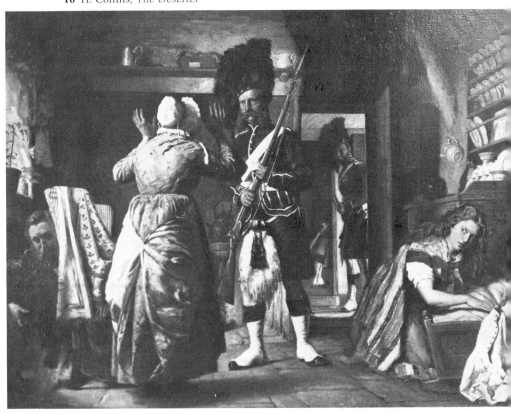

17 *[facing]* David Wilkie, *Chelsea Pensioners receiving the London Gazette Extraordinary of 22nd June 1815, announcing the Battle of Waterloo*

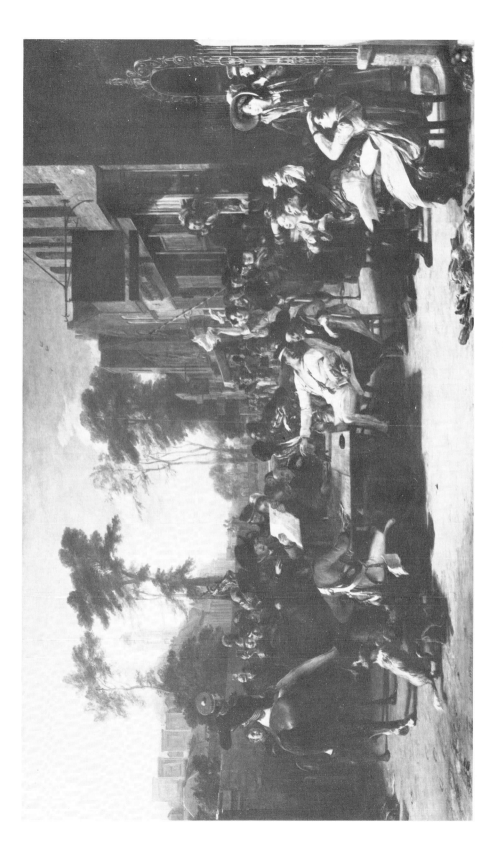

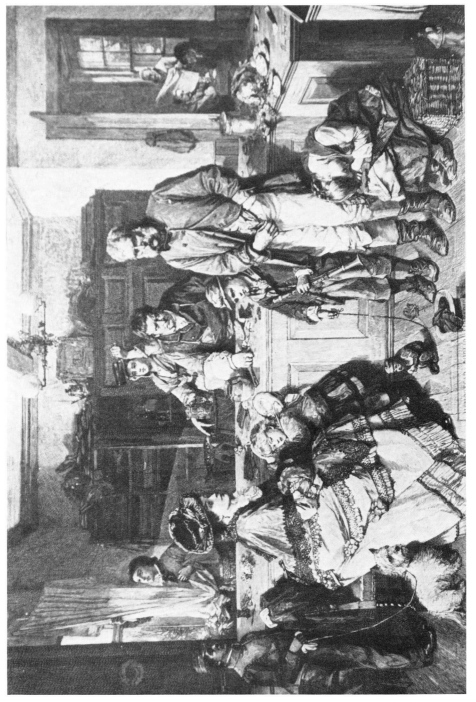

18 Thomas Faed, *From Hand to Mouth*, engraving

Genre painting

CHAPTER EIGHT

Recruitment, enlistment and desertion

The intention in Part Two is to examine the ways in which themes connected with military experience were represented. Military genre paintings outnumber battle pictures by more than two to one.[1] Within limitations of space, therefore, a few pictures from the most popular catagories must indicate the issues which arise from the whole corpus of images. These images are examined in the context of contemporary ideologies of the army and military-civil relations.

Recruitment

Paintings of this subject appeared only rarely in the Royal Academy exhibitions of the period 1815-1914. The genre had a wider currency, however, and appeared frequently in other exhibitions and in the form of engraving and popular prints. The four pictures discussed below represent ruling-class attitudes to different aspects of the topic: the entrapment of a young innocent into the ranks; the impact upon his family; the reasons for enlistment and its impact upon a love affair. The four subjects were by no means equally popular; 'entrapment' images recur constantly until the 1880s, whereas Butler's work showing poverty and desperation as the cause of enlistment seems to have been an isolated event. The occurrence of recruitment pictures at the Royal Academy shows that they were, as might have been expected, most likely to appear at times of intense military activity.

A number of paintings executed early in the century endorse the fact that recruiting was often carried out at fairs and other gatherings at which there was excessive drinking. Rippingille's *The Recruiting Party* at first glance strikes a merry note, but was intended to convey a sober reflection upon the danger to civilians in contact with soldiers. The most obvious menace comes from the recruiting party itself. The methods of recruiting sergeants were notoriously corrupt and designed to ensnare young men ignorant of the realities of life into the Army.

One of the most familiar was for the victims to be plied with drink and tales of the benefits, the handsome pay, excellent conditions and prospects of promotion. The recruiting sergeants were paid according to the number of men they brought in, rather than their quality.[2] Allan Cunningham in his *Life of Sir David Wilkie* bitterly attacked the methods of recruiters in describing Wilkie's picture *The Bounty Money, or, The Village Recruit* (1804-05):

> Some unsteady lad – crossed in love or crazed with drink – moved by the drum, taking the enlisting shilling from the recruiting sergeant, who assured all listeners that his regiment was the most blackguard corps in the service and steady men were sure of preferment and mounting the cockade marched off in quest of glory. These are fellows who look forward to the enlistment of a fresh candidate for glory as a circumstance which may not increase the honour of the army but will put some loose silver into circulation.[3]

Implicit in this is the belief that the intoxicated recruit would deeply regret his action. The Religious Tract Society was able to play upon the widespread fear among working-class people of being trapped into the army to deliver a warning against the evils of drink. *The History and Adventures of Ben the Soldier*, published in 1816, described the terrible fate of an honest country boy who was made drunk and tricked into taking the king's shilling. This 'sober and moral lad. . . not used to liquor' was deeply shocked by the foul language and debased life style of soldiers.[4] During the Napoleonic wars it was never possible to find enough men to fill the ranks. The authorities were reduced to the conscription of vagabonds and criminals released from prison.[5] Anti-militarism among the labouring classes was undoubtedly increased by such practices. Only desperation or intoxication would induce a respectable labouring man to join an army made up of what Wellington had described as 'the scum of the earth'.[6] As an institution the army was widely distrusted, in part because it was used to enforce the power of the ruling classes and hence to join it was a dishonourable act.[7] An anonymous late eighteenth-century pamphlet said of going for a soldier:

> In a country like Great Britain, which at least is pretended to be free, it becomes a matter of no small surprise that so many thousands of men should deliberately renounce the privileges and blessings attendant on Freemen, and voluntarily sell themselves to the most humiliating and degrading slavery for the miserable pittance of sixpence a day.[8]

In the immediate post-war era feeling against the army was strengthened by the lack of provision for sick or wounded veterans.

Rippingille's paintings were, for the most part, rural genre scenes

with a strongly didactic element. His later series of six paintings, *The Progress of Drunkenness* (c. 1834) was in the tradition of Hogarth. *The Recruiting Party* partakes of this ruling-class view of the evils of drink among the working classes and operates in much the same way as the Religious Tract Society's story of Ben the Soldier. The difference between the two is that the tract was aimed at reforming working class people whearas the painting was designed for a predominantly upper-class audience. Rippingille's picture might at first seem to pose problems of interpretation, since the enemy is clearly the army. In the post-Waterloo period, however, the army did suffer a diminution of favour among sections of the aristocracy and upper middle classes. The Liberal Party, in both the Commons and the Lords, urged cutbacks in military expenditure, inspired by a desire to reduce taxation and party's 'traditional' opposition to a standing army.[9] Despite the extent to which officers were integrated with the aristocracy and landed gentry, the army as an institution was sometimes treated as though it was an alien organisation whose powers should be curbed for the sake of 'democracy'. Pictures such as Rippingille's form part of this 'anti-militaristic' discourse, one which could contain an element of criticism without seriously challenging the army or moving towards its reform. Recruiting parties were a highly visible infringement of personal liberties, and when the threat of invasion was over opposition groups called for the abolition of such corrupt practices.[10]

The scene of Rippingille's painting is a village green on a festival day. To one side of the picture is an inn outside which rustics are drinking. The central group is gathered at a table, a young man laughing drunkenly up at a recruiting soldier. A fresh faced lad, very much the bumpkin, has risen to his feet, evidently inspired by alcohol and the soldiers' stories to enlist. A young woman watches, appalled. The other groups function as 'elaborators' either of the moral or of the fate of the recruit. Two more soldiers court innocent young women, one meeting with disdain, the other with success. The pairs exemplify the proverbial immorality of soldiers, and suggest the degradation which will be the lot of the recruit (see chapter ten). They serve to intensify the sense of danger caused by the presence of the recruiters at the village festival.

Another group surrounds a well dressed woman, weeping and clad in mourning. The meaning is ambiguous; maybe she is the widowed mother of the new recruit, now to be left all alone, or mourning some other lost relative. At the extreme right a decrepit figure stands at the gate of a humble cottage: an old soldier, back from the wars, ravaged by the harsh conditions and the horrors he has experienced.[11] The outcome of the picture is unresolved – the king's shilling has been offered

but not yet accepted. The tipsy youth has folded his arms and may yield to the entreaties of his female companion in time.

Although other views of recruitment exhibited at the RA are now lost, one can get some idea of the genre from contemporary works shown at other public exhibitions. Henry Liverseege's *The Recruit* (1821) stressed the disjuncture between home and army life. Reviews suggest that this was one of the most familiar forms. Liverseege's scene is set inside an inn. Two soldiers are seated at table with a rustic lad obviously stupified by drink. The recruiting party was watching their victim with an air of complacent amusement, confident of securing him. The new recruit gazes into space, oblivious of a beautiful young woman addressing him. She is clearly urging him not to enlist and his fate hangs in the balance.

It is not the recruit who is the focus of concern but his female companion:

> Who without some touch of emotion, could gaze on the imploring countenance of the poor female, the sister of the besotted fellow, seduced by a fine cockade and glittering sword, whose friendless condition the artist has explained in eloquent terms. She is an orphan; the tears for the misfortune of her brother fall on the mourning dress she wears for the loss of her parent.[12]

The vulnerable state of the sister, without a male protector, introduces an element of tragedy into a work which would have otherwise been humorous. That she is to be read as a finer being than her brother is indicated by the different ways they are depicted. She is idealised, delicately boned, pale and graceful. He is red-faced, solidly built and glassy eyed. Not only will the girl be destitute but her brother will bitterly regret his foolish action. Their likely fate is embodied in a scene glimpsed through an open door. In the kitchen an old soldier is slumped over a glass. He is plainly in poor health, with a few belongings tied in a bundle to a stick. He is of a similar build to the new recruit, but bent and worn by suffering. More terrible, his right foot has been amputated and replaced with a crude wooden stump. He is a grim warning against the recruiting party's tales of glory and prosperity. The kitchen drudge may foretell the future of the abandoned sister.

The drama of such paintings rested on the knowledge that a moment's rashness committed the recruit to a lifetime's service. From 1815 to 1849 the minimum period of enlistment was twenty-one years at a time when life expectancy among the working classes was not much above forty. Twenty-one years was effectively the whole of a man's working life. A family whose son joined up was unlikely to see or hear from him again. Contemporary authorities suggest that these

images of the 'unwary lads' seduced by drink were only rarely based on fact. Despite the poor wages, unhealthy conditions and harsh discipline, men were still compelled to enlist when other methods of subsistence failed. The statistics compiled by Skelley make it clear that recruiting figures improved during the harsh winters or times of high unemployment.[13]

The physical conditions of military service were acknowledged as brutal and dangerous, even compared with the harshness of civilian life. Soldiers were increasingly moved out of billets and into barracks. Conditions there were cramped and unhealthy, and diseases such as consumption and fever were rife. Despite the youth of the men, mortality rates were higher than in the civilian population. On foreign tours of duty the rates of mortality were even higher.[14]

Rates of pay for soldiers were theoretically generous compared with the wages of rural labourers, though they did not match factory pay. Soldiers received the same basic pay from 1815 to 1847, the amount varying according to regiment. The infantryman received 1s per day and the cavalry in the more prestigious regiments 1s 3d. It is clear from memoirs that soldier's families were often horrified when a son enlisted. One who enlisted early in the century recorded that his mother had told him she would prefer to see him 'in his grave than gone for a soldier'.[15] Young men were sometimes driven to recruit to escape the consequences of a social or civil crime.[16] The process of enlistment made no effort to gauge the character or aptitude of the applicant, nor to weed out the unsuitable. Apart from a physical examination, a man was merely required to affirm that he was not already a soldier, discharged for health or discipline reasons; that he was not a former prisoner, nor married. It was, however, easy to enlist under a false name. The desire for better-quality recruits, from the 're-spectable' working class, was constantly voiced, but resistance was still far from overcome well into the 1870s.[17]

The recruits in Academy genre paintings are all countrymen rather than town-dwellers. Early in the nineteenth century it was not unreasonable to portray recruits as agricultural labourers, since England remained predominantly rural. As late as the 1880s, though, the rural recruit was still ubiquitous in art. By the end of the century, with rural depopulation, especially in Ireland and Scotland, and increasing urbanisation of the population, he had almost ceased to be a reality. By 1907, the first year for which figures are available, he represented a mere 11 per cent of new recruits.[18] It may be assumed that the trend had begun decades earlier.

The preponderance of the country boy in academic images of recruit-

ing may, in part, be attributed to the traditions of genre painting. Artistic conventions, dating back through the eighteenth century to Dutch art, established peasants as the subjects for humorous or nostalgic scenes. But, as John Barrell has shown, after the 1770s 'the comic was deliberately and almost entirely expelled from the art, as it was from the poetry of rural life'. The literature of the late eighteenth century was 'continually anxious to take the problem of rural poverty seriously *as* a problem: it offers to take a more benevolent indeed a more guilty attitude towards their sufferings'.[19] By the mid to late nineteenth century the concern of the ruling classes had shifted to the problem of urban poverty. In particular the vast aggregates of working people in the big cities represented a threat to social order. The country retained the late eighteenth century associations of seriousness and increasingly seemed to epitomise the good old days. Raymond Williams points out that in the novels of George Eliot and Anthony Trollope there is a return to a rural idealised England in which

> . . . a natural country ease is contrasted with an unnatural urban unrest. The 'modern world', both in its suffering and crucially in its protest against suffering, is mediated by reference to a lost condition which is better than both and which can replace both; a condition imagined out of a landscape and a selective observation and memory.[20]

The working-class countryman was believed to have retained the virtues of an earlier age of social harmony. Army authorities extolled the virtues of the rural recruit over his urban counterpart. Traditionalists saw the agricultural labourer as likely to uphold the pre-Reform view of the army as officered by 'gentlemen' from the landed gentry, 'served' by peasants from their country estates. Officers giving evidence to the Commission on Military Punishments (1836) praised the agricultural recruits as more malleable, more obedient and more contented with their lot.[21] Town recruits were believed to be sharper, with more initiative, and therefore less desirable as soldiers.

> Recruits who are enlisted in the manufacturing districts and large towns are frequently idle and dissolute and require all the means in the power of their officers to correct the intemperate and vicious habits in which they have indulged and to enforce subordination.[22]

The ruling classes, after the social unheavals which preceded the Reform Act of 1832, were anxious about the revolutionary potential of the towns. Army officers shared the prejudice of their class in idealising the rural labourer. The health of men from country districts was superior to that of their 'slum bred counterparts'.[23] Rural pursuits such as animal husbandry and outdoor labour were felt to prepare men for soldiering. In 1903 L. S. Amery complained that 'though war is pre-

eminently the open air profession, very little is done to change the soldier from a townsman into a countryman'.[24] The rural recruit's relation to the army seemed unproblematic, almost 'natural'. The problem soldiers are those from cities, those who come from an 'unnatural' environment. The implicit equation effectively removes any anxieties about the army as an institution or the working man as a soldier – for in the 'natural' state of things no problem would exist.

It is in the context of these related mythologies that W. H. Gore's picture *Listed* (RA, 1885) must be seen. A handsome young countryman, the perfect recruit, is comforting his sweetheart, having just enlisted. The picture was deliberately anachronistic: enlistment is denoted by ribbons in his hat. The landscape against which the couple are set, is painted in a misty post-Impressionist technique. The soft edges and pastel colours, influenced by Bastien-Lapage, suggest a rural paradise. There is none of the drama of the two earlier paintings; since in the 1880s, enlistment was no longer viewed by the middle classes as a punishment for moral turpitude, it no longer made sense to present the enlistment as a tragedy. Gore has scaled the drama down into a romantic conflict between patriotic duty and private sentiment. The theme is more frequently found in paintings of a soldier going to the wars (see chapter ten). This latter genre is most often found in the last half of the century and is different from the enlistment genre in that it encompssses both the officer class and the ranks.

Finally, in *Listed for the Connaught Rangers* (RA, 1879) Lady Butler depicted two Irish peasants marching away from their native glen, accompanied by a recruiting party. In part, this picture can be interpteted as a celebration of the Irish contribution to the army. During the agricultural depressions of the 1830s and '40s, large numbers of men from Ireland (and Scotland) enlisted as an alternative to emigration or unemployment. Subsequently the number of Irish recruits declined:

> In 1830 and 1840 over half of the noncommissioned officers and men came from Scotland and Ireland. By 1912 79.6% of the NCO's and men were either English or Welsh.[25]

In the late 1840s large-scale emigration to America began. The typical emigrant was the young, fit, unattached male, exactly the type who might previously have joined the army. By the late 1870s then, the country boy who 'went for a soldier' was a thing of the past. In the case of the Gore painting the style of execution suggests a vision which was nostalgic and idealising. Butler's reflects her anger with the social conditions that had forced so many Irish to enlist. She first visited

Ireland in 1878, on honeymoon with her Irish Catholic husband. The published account of her trip through the west of Ireland refers to her sense of outrage at the depopulation of rural districts. She noted the sad contrast between the abandoned peasant cottages and the fertile beauty of the landscape:

> The village was deserted in the awful famine year of '47, some of the inhabitants creeping away in fruitless search for work and food, to die further afield, others simply sinking down on the home sod that could give them nothing but the grave.[26]

She might have added that the alternative was to join the army. Her painting explicitly juxtaposed her written symbol of the famine, the abandoned cottage, with the new recruits. This pictorial reference to the motives for enlistment seems to have been unique and is problematic for its implicit criticism of the government's handling of the famines. No review chose to see in the painting a critique of national policy. The artist experienced a similar lack of outrage when she exhibited a scene showing an Irish woman being evicted and her cottage burned.[27] The artist recorded that she waited 'with bated breath' for the reviews of the Academy. The few who referred to the painting did so only to praise the 'truthfulness' of the landscape.[28]

Butler's brother-in-law, the radical Catholic author Wilfred Meynell, referred to the picture in his short biography. It must be assumed that she concurred with his description of her recruits as:

> . . . noble types. . . they leave their native glen with a tender regret concealed under masculine reserve and march with a steadfastness, but yet with a melancholy in keeping with the atmosphere and the scene. . . Lady Butler's young peasant recruits have been obliged to confess themselves beaten in the fight with poverty. . .[29]

Meynell's description, though hedged about with apology, confirms that the artist intended the picture as an attack on the English treatment of the Irish. By the time he was writing, in 1898, the situation had deteriorated, and it was even less acceptable to describe Irish people as 'noble peasants'. Meynell's language is revealing. He uses terms which draw attention to the violent history of Ireland rather than deflect criticism from the choice of pictorial elements:

> In the midst of the wild glen a disroofed cabin or two stand as a sign; and these poor wrecks are not introduced into the picture by any violence, or for the sake of forcing a dramatic effect. Glens like this have deepened solitudes. Nor has the artist put any great emphasis upon the pathos of such a vestige of defeat; the hopeful young soldier, who casts a glance upon one of the lost homes of his people, does not march to his own new life with an enfeebled heart.[30]

This episode suggests that critics were unwilling to read Academy paintings as attacking the *status quo*; that 'protest' pictures were not recognised as such, but were always related to the closest traditional genre.

Butler's realisation of the figures of her two recruits was in the heroic style: they are tall, handsome and of noble bearing. The conception of the poor as heroic in their struggle against circumstance was part of a new trend. The 'social realist' painters, Fildes, Holl and Herkomer, all depicted the underprivileged as heroic. This treatment of the working class would have been impossible before 1860/70 when the poor were depicted as diverting or touching, suitable only for inclusion in essentially frivolous genre paintings. This new form for the representation of the poor in art was, importantly, connected with the assimilation of French realism into British painting.

Recruiting paintings appeared in a number of forms and were modified to changing mythologies of the army and society. This mutability of forms must now be explored in the other genres.

Desertion

The problem of recruitment, as has been remarked, haunted army administrators throughout the century; many reforms were motivated by the need to attract more recruits. To prevent serving men leaving the ranks was no less important. The attitude of the ruling classes towards desertion did not remain consistent, and shifts in ideology were, in different ways, discernible in Academic representations.

The scale of the problem was great. The number of enlisted men who actually served in the ranks was rarely higher than 66 per cent. Statistics for the period 1860-82 show that between 20 to 36 per cent of recruits failed on medical grounds or did not meet the minimum height requirement, although the standards of both tests were low.[31] A small number of recruits 'paid smart money', that is, were bought out by their friends. The only area where 'wastage' was preventable was desertion. Brian Bond asserts that in 1843 1,510 men were reported to have deserted; in 1862, 2,895, and during the period 1872-79 there were an average of 5,000 deserters a year, of which perhaps half either re-enlisted or were captured.[32]

No single cause can have motivated desertion on such a huge scale. In popular literary accounts romantic or family ties were almost always given as the cause. The small body of documetary evidence on the subject suggests that it was more likely to have been motivated by dissatisfaction with the army. There seems to have been a series of crisis points

at which desertion was most likely to occur. Immediately after the first encounter with the recruiting party was a common time for the army to lose men, often because the lad had not seriously wanted to enlist or had done so under the influence of alcohol. Once the process of attestation had taken place the new soldier was paid 'bounty money'. Certain criminals seem to have perfected the process of absconding with the bounty money and then enlisting elsewhere. Fortescue cites the example of a man who claimed to have enlisted forty-seven times.[33]

The first year in the service seems to have been another critical time. Of the 30,899 desertions in the period 1872-79, three-fifths were by men in their first year. The incidence decreased according to the age of the recruit. In 1843 there were 1,510 deserters, of whom only 147 were over the age of twenty-five.[34] These statistics build up a profile of very young men unable to cope or disillusioned with army life. It was not difficult for unprincipled noncommissioned officers and officers to defraud men under their control. A former sergeant in the Rifle Brigade conjured up a vivid picture of the man too poor to make existence bearable with extra food, beer and tobacco:

> . . . When he comes in from his harrassing drill, he is often seen to sit cheerless and melancholy in the corner of his room, brooding over his poor and pennyless condition. The poor fellow. . . often takes it into his head to desert.[35]

It is likely that older recruits would be better able to defend themselves against unscrupulous pay sergeants who tried to take away their pay in 'stoppages'.

Bullying was probably another major factor. Sir Charles Napier, writing in 1837, inveighed against resort to harsh physical punishments in peacetime, on the grounds that 'some commanding officers added petty tyrannical acts of various kinds that were likely enough to drive good men into mutiny and desertion.[36] Extra duties or punishments were meted out at the discretion of sergeants and officers. Members of the ranks could suffer terribly at the hands of vindictive superiors. This type of abuse, hard to control, was not eradicated by the various army reforms. Archibald Forbes, war correspondent and journalist on military affairs, dealt with the problem in one of a series of sketches about army life. *A Deserter's Story* was allegedly based on truth but was written in the first person 'for greater directness and realism'. The hero is a Yorkshire youth who has settled happily into the army. Forbes represents him as the ideal soldier – steady but ambitious, attending regimental school with a view to promotion. His promising career is blighted when an enemy is promoted to corporal and commences 'a regular system of annoyance and oppression'.[37] The vindictive corporal

causes the hero to be flogged and jailed until, goaded into fury, he attacks his oppressor and deserts. Forbes view portrays him as justified:

> Now, my object in penning these rough lines is this. Don't when you see a poor devil marched past you with the darbies on and a file of men with fixed bayonets on either side of him – don't, I say, always shrug your shoulders and say, 'There goes a Queen's hard bargain.' If you were to get at the root of the truth, you might find that at least a proportion had been baited to ruin by the tyranny of noncommissioned officers.[38]

This attribution of blame to a fellow soldier is a recurrent theme in literary representations, reflective of an interest in the psychology and private lives of soldiers. Forbes's short stories are forerunners of Kipling's later accounts of soldiers in India.

In light literature as in official commentaries soldiers are discussed as though they were eternally fixed in the profession after enlistment. It is clear from other sources that some members of the working classes who joined the ranks regarded the army as a temporary means of escape from straitened circumstances. Joining up often meant moving, free of charge, to another district where work was available or better paid. 'Of the sixteen men who deserted from the 36th Depot in August 1840, some were thought to be engaged in harvest work in the neighbouring counties.'[39] If necessary, a man would rejoin under another name when winter set in. The pattern of desertions changed with an overseas posting. It was noted that many desertions took place in the furlough prior to sailing. Fear of disease and prolonged separation from family made overseas service unpopular. It is not known how many men used the Army to get a free passage to a new life overseas. '. . .others desert from regiments in North America from that cause [boredom] and the inducements held out by the Americans of land and independence'.[40] The brief details outlined above suggest the complexity of motivation. Some writers were interested in showing that aspects of military life could be responsible and, as in Forbes's short story, the deserter was represented as a victim of oppression in the period prior to about 1875. The strategy of making the deserter an object of compassion effectively displaced him from the position of anti-establishment threat. Disaffected soldiers, trained in the use of weapons and other military techniques, were a potentially dangerous element in civil unrest Forbes's represents one of a range of strategies for 'defusing' or minimising that sense of anxiety.

There were only nine deserter pictures at the Royal Academy in the nineteenth century. Unlike recruitment pictures their occurrence, prior to 1870, does not tie in with surges of military activity. After the Army Reform Act of 1870, when desertion was increasingly con-

structed as a crime, the genre comparatively declines and only recurs at times of military interest.[41]

All the deserter pictures discussed here show the culprit in the context of his domestic life. There are, however, subtle shifts in emphasis and meaning within this relationship. In the period before the Crimea 'home' was the deserter's refuge but not the *reason* for his crime. Until the soldier was transformed into a respectable working-class hero·in popular bourgeois mythology, it was not necessary to offer extenuating circumstances for desertion. Or, because the army had such low status in some sections of the ruling class, especially radical and liberal circles, desertion did not require exculpation. Moreover pictorial conventions established in the eighteenth century made the genre familiar and unproblematic.

George Moreland's famous and influential series of four paintings, *The Deserter* (1789), showed a country lad being intoxicated and entrapped by unscrupulous recruiting sergeants. The subsequent pictures depict the lad, as a deserter, hiding under his wife's bed, being recaptured; the third is a touching parting from his wife and baby; the last is a happy scene in which he is pardoned by a kindly general. Despite the element of comedy the sympathy of the viewer is aroused. This is undoubtedly because of the unscrupulous way the deserter was trepanned in the first place. In the early nineteenth century deserter pictures drew upon the familiarity of such images and could be read in much the same way.

A critic writing of Redgrave's now lost work *The Deserter's Home* (1847), noted that it succeeded in arousing sympathy despite the criminal nature of desertion. The critic located the focus of the picture, and therefore presumably the sympathy, as the family: '. . . the consternation into which a family is thrown by the arrival of soldiers in search of their relative. . . who has taken refuge among them'.[42] Concern for the feelings of the family is rooted in the mythology of the simple rural cottage as the fount of moral rectitude, untarnished by the vices of the city. The deserter's motives are not mentioned. It may be that Redgrave's audience would have assumed that a decent country boy would wish to escape from the brutal conditions of the army, or that soldiers were 'black sheep' prone to commit such offences. There are no other contemporary writings to clarify this point. In any case, the drama of the picture was offloaded on to the family's responses, avoiding any need to debate the morals of the case.

One of the few 'deserter pictures' exhibited at the RA which has been traced was Hugh Collins's *In close Pursuit of a Deserter: the 42nd Highlanders.* [43] Redgrave's picture must have been similar. Collins

shows a number of soldiers searching a cottage for a deserter. An elderly woman wearing peasant costume is gesturing denial of his where-abouts. Her back is to the viewer so that her interlocutor, a fine High-lander, is facing outwards. Two other soldiers are seen entering other rooms. Hidden behind a chair and his mother's skirts is the deserter, also in Highland uniform. He peers out to exchange anxious glances with his wife, kneeling by a cradle attending to their baby.

The painting is intensely dramatic because of this silent communi-cation between the deserter and his wife. It is possible that a garment in the cradle is his shirt, suggesting that the soldiers will discover him. Since there were no reviews of the work, it is difficult to reconstruct the ways in which it might have been read. The most heroic figures are the Highland soldiers. Their manly stance suggests that they should be read as partaking of the mythology of the heroic Highland soldier. It was mentioned in chapter seven that these regiments had special glamour as romantic warriors in the Scottish revival. The figure of the deserter is crouched in a pose usually indicative of cowardice. The mitigating circumstances are his beautiful wife and child, and the elderly mother who boldly defends him.

Between the 1847 picture by Redgrave and the 1868 work by Collins a shift of meaning seems to have taken place. The new construction of the army as a noble and patriotic institution forced the criminal aspect into greater relief. The searching soldiers in Moreland's pictures are neutral figures, in Collin's work they are the embodiment of man-hood. The deserter is an unworthy character. Post-Crimean/Reform era treatment of desertion had to accommodate the new mythology of the soldiers as hero – the deserter must be shown as delinquent in some way or as driven by reasons which overrode military law.

The deserter in T. W. Marshall's *Absent without Leave* was pre-sented as having made his choice for 'natural' reasons. This canvas, also now lost, was accompanied by a long passage, purportedly a quo-tation from a private letter, the author and date of which is not cited:

> Our circle has been much interested in the case of a young soldier who is to be tried for desertion. . , he received a letter from his sister informing him of the dangerous illness of his mother and earnestly begged for leave to visit her, which his commanding officer sternly refused him. *Unable to resist the calls of filial love*, he decamped in the night and made his way over many miles to his *rural* home. He was, of course, soon followed and brought back as a deserter.[44]

Like the 'steady' Yorkshire lad in Forbes's story the desertion takes place because of the inhumanity of a superior officer. The deserter in Marshall's picture has acted in accordance with 'natural law' only

when military law is too rigidly enforced. Showing the deserter as moved by familial emotion not only obviates the need to consider desertion a crime, but locates the deserter in a safe environment, the rural home. The blame is shifted on to the 'stern' officer, who acts partially and against the laws of 'natural' instinct. In genre paintings the figure of the mother is often used as a foil for the harshness of war. A reference may be made here to Campbell's poem, of 1809, in which a British tar attempts to escape from a Napoleonic gaol to see his old, blind, sick mother. The mention of this extenuating circumstance makes the fierce emperor relent and the sailor is set free.[45] This type of sentiment is clearly international and universal – the love and reverence of the resolute, warlike soldier for the gentle, yielding mother. In contrasting 'opposite' natures – the stronger voluntarily bowing to the weaker – the notion obviously derives from nineteenth century notions of chivalry. Intermixed is the ideology of the perfection of the family and especially its heart, the mother. The officer who refuses the soldier permission to visit his dying mother is opposing important ruling-class ideologies and is thus himself 'guilty'. His guilt does not reflect on the army. It is not to be inferred that the army is an inhumane institution, since only one person within it has abused his power. This Academic painting raises the issue of desertion but handles it in such a way as to avoid extending the discussion beyond the realm of the personal. The neat equation between cause and effect disposes of the problem.

Henshall's *A Deserter* (1881) is unique in removing the subject from both the rural and the domestic setting. A recaptured man escorted by two guards is depicted in a railway carriage. A young woman, dressed in dark, possibly mourning, clothes weeps by his side. Our reading of the picture is confused by the figures of the guards, who seem neither pleasant nor unpleasant but detached. The only critic to review the painting when it was first exhibited found it difficult to place in any familiar context:

> The fourth gallery [at the RA exhibition] is singularly devoid of interest. Mr J. H. Henshall's *Deserter* representing the culprit being taken back to his regiment, his sweetheart vainly trying to comfort him, is carefully drawn and painted but *fails in striking the right note*; perhaps the best thing in the picture is the care with which one of the guards is lighting his pipe – a little piece of nature cleverly expressed.[46]

The military offence of desertion was applicable only to the ranks. Millais's *The Peace Concluded* is unique among Academy representations in its attack on officers who shunned their duties during the Crimean war. William Holman Hunt explained the motivation behind the original form of the painting:

During the war it had become a scandal that several officers with family influence had managed to get leave to return on 'urgent private affairs'; Millais had felt with others the gracelessness of this practice when such liberty could not be afforded to the simple soldier and he undertook a picture to illustrate the luxurious nature of these 'private affairs'.[47]

In undertaking the subject Millais was responding to Holman Hunt's lead in painting 'modern-life' pictures of contemporary social themes. Hunt's *The Awakening Conscience*, exhibited at the RA in 1854, had depicted a 'fallen woman', ruined by a rich young gentleman. Millais's anti-hero was also from the upper classes, a group certainly under attack by the middle classes as dissolute and corrupt. Millais and Holman Hunt were both from this respectable bourgeois background and, more important, both had concerned themselves with radical political movements such as Chartism. Millais's attack was part of a broader assault on the 'attitudes, life style and competence of the officer corps. . . voiced increasingly as the war proved unexpectedly protracted and as the sufferings of the troops became all too apparent'.[48] Millais depicted his officer in a comfortable parlour 'being caressed by his wife, and their infant children were themselves the substitutes of the laurels which he ought to be gathering'.[49] In its original form the painting was meant to show the man as having fled from the discomfort of war on a slender pretext. The irony lay in the man's air of comfortable relaxation.

The painting did not appear in this form at the Royal Academy. According to Holman Hunt, the conclusion of the war made its anti-officer sentiment inappropriate. 'The call for satire on carpet heroes was out of date, the painter adroitly adapted his work to the changing circumstances. . .'[50] The cowardly villain was turned into a wounded hero, forced by ill health to return from the front.

A Crimean officer, returned home, is reading the news of peace in the Times. One of his two little girls has brought out her Noah's Ark, and is displaying the animals emblematic of the warring powers – lion, cock, turkey and arctic bear – concluding the array with the dove bearing the olive branch. The other looks with childish intentness at papa, as though she had hardly got well-acquainted wih him yet.[51]

There is evidence that some contemporary reviewers found the painting difficult to read in its revised form because 'the gentleman on the sofa reminds us of one of Leech's languid swells. . .' The critic was evidently puzzled as to why a figure, closely based on a type lampooned by the *Punch* cartoonist, should be represented in such a positive manner:

We are told that the picture was originally intended to be entitled 'Urgent

Private Affairs' and if intended as a satire upon military imbecility, there may have been more point in the original conception than appears in the work as now finished.[52]

Millais's reasons for making so vital a change were stated by Hunt to have been that the conclusion of the war made the satire out of date. The remark implies that, once peace was declared, all adverse criticism of the Crimean leadership ceased. Such was patently not the case, since the lobby for the abolition of purchase continued to fuel itself on the misconduct of the war for the next fifteen years. However, after peace negotiations had begun in February 1856 powerful parties withdrew their support from the anti-officer campaign, fearing that too radical reforms would result from the agitation. The McNeill and Tullock Commission published its report in January 1856, criticising certain important officers in the Crimea, among them, Lords Raglan and Cardigan. Palmerston, the Prime Minister, was caught between the censure of the Commons and the powerful defence of the officers from the House of Lords, the army and the Queen. The Crown's attitude towards the conduct of senior officers in the Crimea had changed considerably once it was clear that the allies were free from the danger of defeat. The Queen, who had been 'deeply concerned' at the suffering of the troops, now regarded organised attacks on the army as likely to endanger the traditional nature of that institution and her personal control over it. Since it was chiefly radical members of parliament who led the attack, the Queen feared the reform of the army as an undermining of the *status quo*. Under pressure from the Crown, Lord Palmerston arranged a commission of inquiry, which effectively absolved everyone from blame.[53] Such was the political climate in which Millais worked to finish his Academy entry in 1856. It is clear that the moment for exhibiting a satirical attack on the army officer had passed. His adroit adaptation of the picture demonstrates his ability to gauge the sentiment of his upper and middle-class audience, a facility that was to bring him financial and social success.

The image of the 'deserter' underwent important changes in meaning in the period 1840-80. At the same time elements of the genre altered very little. The difference in reading and meaning was based on contemporary ideologies of the army as an institution.

Notes

1 The statistical basis of these and all other figures in this book is to be found in J. W. M. Hichberger, 'Military Themes in British Painting, 1815-1914', Ph. D. thesis, University of London, 1985.
2 Spiers, p. 56.
3 Allan Cunningham, *The Life of Sir David Wilkie, RA*, 1843, I, p. 69.
4 J. F. C. Harrison, *Society and Politics in England, 1780-1960*, New York, 1965, p. 119.
5 E. Halévy, *A History of the British People in 1815*, trans. E. I. Watkin, 1947, I, p. 109.
6 E. Longford, *Wellington: the Years of the Sword*, 1967, p. 321.
7 Henry Marshall, *On the Enlisting, Discharging and Pensioning of Soldiers etc.*, 1839, p. 10.
8 E. P. Thompson, *The Making of the English Working Class*, 1963, p. 88.
9 S. Maccoby, *English Radicalism, 1786-1832*, 1955, p. 313.
10 Spiers, p. 42.
11 Bristol City Art Gallery, *The Bristol School of Artists*, 1973, p. 28.
12 Charles Swain, *Memoir of Henry Liverseege*, 1835, p. 10.
13 Brian Bond, 'Recruiting the Victorian army', *Victorian Studies*, V, p. 333.
14 Skelley, pp. 21-9.
15 Spiers, p. 49.
16 H. Wyndham, *The Queen's Service*, 1899, pp. 6-7.
17 Sarah Robinson, *The Soldier's Friend*, 1913, p. 144.
18 Spiers, p. 48.
19 John Barrell, 'The private comedy of Thomas Rowlandson', *Art History*, Vol. 6, No. 4, p. 423.
20 Raymond Williams, *The Country and the City*, 1973, p. 220.
21 Spiers, p. 30.
22 Marshall, p. 8.
23 Spiers, p. 48.
24 L. S. Amery, *The Problems of the Army*, 1903, p. 185.
25 Spiers, p. 48.
26 E. Butler, *From Sketchbook and Diary*, 1909, p. 185.
27 *Evicted*, exhibited at the Royal Academy in 1890, was based on the Irish question.
28 *Times*, 12 May 1879, p. 5.
29 Meynell, p. 10.
30 E. Butler, 1909, p. 17.
31 Spiers, p. 43.
32 Bond, p. 334.
33 Fortescue, 1899, p. 53.
34 Cunliffe, p. 113.
35 Robert MacDonald, *A Personal Narrative of Military travel in Turkey and Persia*, 1859, pp. 14-15.
36 C. J. Napier, *Remarks*, etc., p. 126.
37 Archibald Forbes, *Soldering and Scribbling*, 1872, p. 120.
38 *Ibid.*, p. 134.
39 Cunliffe, p. 114.
40 *United Service Magazine*, No. 375, 1860, I. p. 272.
41 See Hichberger thesis, 1985.
42 *Athenaeum*, 22 May 1847, p. 552.
43 Smith Institute, Stirling, (Royal Academy 1868).
44 Royal Academy Catalogue, 1872, No. 900.
45 Thomas Campbell, *Napoleon and the Sailor*, 1808.
46 *Times*, 6 June 1891, p. 4.
47 W. Holman Hunt, *Pre-Raphaelitism and the Pre-Raphaelite Brotherhood*, 1905, II, p. 105.
48 Spiers, p. 100.
49 Holman Hunt, II, p. 105.

50 *Loc. cit.*
51 William M. Rossetti, *Fine Art, Chiefly Contemporary*, 1867, p. 217.
52 *Critic*, 15 May, 1856, p. 252.
53 Spiers, pp. 113-18.

CHAPTER NINE

Representations of the veteran

At the close of the Napoleonic wars in 1814, and a year later, after Waterloo, large numbers of soldiers were discharged and returned to Britain. There was little state provision for the care of veterans. A soldier who was wounded or disabled by military service was discharged:

> ... with, if he were fortunate a permanent pension and consigned in theory to the care of relatives or friends. The size of the award depended on the nature and extent of his afflictions. The inadequacies of Army pensions and the fact that after several years military service many had no friends or relatives upon whom to depend led them to destitution or the workhouse.[1]

The able-bodied ex-soldier rarely had any trade which would help him find employment in civilian life:

> If they were fortunate, they were employed by the Government or by hotels and hospitals as caretakers and porters; certain industries, notably the chemical, also employed soldiers because they laid stress on habits of punctuality and unquestioning obedience. But the majority of former soldiers drifted down into the ranks of casual labour.[2]

The presence of this rootless group of fighting men, who did not for the most part return to their previous homes, was a source of real anxiety to members of the ruling class.

> When peace was made with France and a large portion of our army disbanded, everybody expressed their opinion that there would be a vast number of robberies committed and it was well known that old arms for the defence of houses such as blunderbusses etc. sold at a comparatively high price in London as a consequence of the apprehension.[3]

Social disturbances in the form of demonstrations and riots had been common during the wars, mostly in protest against high food prices. Government feared that working-class unrest would become more violent and effective with the help of discharged soldiers. It was noted that a large number of ex-soldiers and sailors were present at a radical meeting at Coldbath Fields in December 1816 at which some

speakers urged revolution. As well as the veterans, some serving members of the forces were at the meeting. One optimistic radical leader believed that 'The army was on the edge of mutiny, not only because of the grievances of the soldiers but also because of general sympathy with the people.' One group from this meeting marched to the Tower of London, where they urged the soldiers to mutiny and hand over the arsenal. The attempt at revolution failed but the incident demonstrated to the authorities that disaffected soldiers, serving or retired, were potentially dangerous. There were already in existence laws designed to prevent the political subversion of soldiers. In 1803 a kind of hysteria had broken out when it was alleged that there was a radical organisation within the army conspiring to sieze power. One Colonel Despard and six guardsmen were executed. The Crown stated that 'no fewer than 300 soldiers in the third Battalion of the Guards and thirty or forty in the first Battalion were involved.[4]

A Select Commission on Mendicancy was set up to inquire into the large numbers of ex-servicemen begging on the streets of London. In its report, published in 1816, the commission concentrated on the criminal actions of certain Chelsea out-pensioners who were beggars despite drawing a pension.[5] No remark was made about the much larger numbers of unpensioned soldiers who had no alternative but to beg. The tone of the report was reproachful of the lack of gratitude among the Chelsea out-pensioners and included, by implication, those who had no cause to feel grateful. The commissioners seem to have been typical of ruling-class commentators who dwelt on the minority of pensioners at Chelsea to the exclusion of the less fortunate majority. Artists who painted veterans for Academy pictures in the nineteenth century followed the lead of civil and military authorities in giving the Chelsea Hospital pensioners undue prominence. Of the forty veteran paintings shown at the Academy in 1815-1914 eighteen specifically refer to Chelsea pensioners or those at the Irish sister institution, Kilmainham. It is estimated that the number of ex-soldiers never fell below 50,000 in the nineteenth century, whereas the number of Chelsea pensioners never exceeded 500, including out-pensioners.[6]

The Royal Military Hospital at Chelsea had been founded in 1681 by order of Charles II. It was popularly believed to have been instigated by the King's mistress, Nell Gwynne. The tale of her warm heart being moved by the plight of destitute soldiers remained popular, despite the efforts of nineteenth-century historians to discredit it. This romantic story is symptomatic of the hospital's happy image. It was regarded with complacency; its picturesque customs and costumes were popular subjects for writers and painters. Since the hospital, funded by the

[*141*]

government, provided home, support and security for 500 ex-soldiers it could be seen that the state was mindful of its obligation to its ex-soldiers. A larger body of about 1,500 out-pensioners received money but did not live in the institution. Disquiet concerning the political activities of ex-soldiers did not extend to Chelsea pensioners. They were regarded as completely integrated into the State, happy recipients of charity. Only those with an unblemished record, usually noncommissioned officers, were admitted, a fact which, with the average age of sixty-five, ensured that few of radical bent became Chelsea inmates. Furthermore the remote location of the place ensured that they were removed from the political contagion of the City and Westminster.

In the first three decades after Waterloo Chelsea pensioners became symbolic of the 'deserving poor' who received just treatment from the nation. By 1839 Chelsea Hospital had become a tourist attraction, with the pensioners living exhibits in the military museum. In his guide to the hospital the chaplain, G. R. Gleig, recommended a visit on Wednesday or Friday:

> It rarely happens that, out of a body of five hundred invalids, one or two are not committed every week to the dust and Wednesday and Friday being here canonical days for interments you may chance to be present at the ceremony.[7]

The burial ceremony was warmly recommended as an experience both touching and picturesque:

> Of levity during the performance of any portion of divine service, I have never observed among soldiers a tittle. On the contrary their manner is always subdued and respectful – such as becomes men who are not unaware that with them 'life is indeed in the midst of death' . . . Examine the countenances of these men minutely; and as they stand uncovered, there is ample opportunity of doing so.[8]

Gleig believes all soldiers to have this 'subdued and respectful' demeanour. The Chelsea pensioner is the ideal soldier and is frequently seen as representative of all soldiers.

David Wilkie's painting of *Chelsea Pensioners receiving the London Gazette Extraordinary of Thursday June 22nd 1815, announcing the Battle of Waterloo* (RA, 1822) was one of the most popular ever exhibited at the RA, requiring a barrier to protect it from the thronging crowds.[9] No doubt interest was stimulated in part by the fact that it had been commissioned by the Duke of Wellington from the famous Wilkie:

> When it was known that Wilkie was engaged on a picture for the Duke of Wellington of a military nature, great was the stir in the ranks of the

army and likewise in society. The current of a *heady fight* was in the fancy of some, while others believed he would choose the *field after the battle* was fought and show the mangled relics of war. . . But no one guessed that out of the wooden legs, mutilated arms and the pension lists of old Chelsea, he was about to evoke a picture which the heart of the nation would accept as a remembrance of Waterloo, a battle which had filled the eyes of Britain with mingled gladness and tears.[10]

The stages of the evolution of Wilkie's picture are recorded in Cunningham's biography, using the artist's letter and journals. It is clear that the initial commission from the duke, in 1816, stipulated that the subject was to show *British Soldiers regaling at Chelsea.* The duke evidently expected one of Wilkie's Dutch-influenced genre pictures of peasants merry-making. Wilkie was deeply admired by his contemporaries as the 'English Teniers', an artist whose work was already in the duke's collection. When he went to Chelsea to research material for the picture he recorded his interest in the pensioners there.[11] It is possible that his idea of linking them with the news of Waterloo was derived from an earlier work by the well known Bristol artist, Edward Bird.[12] Wilkie's innovation was to reinforce the link between a contemporary victory and old soldiers and to connect both with the institution at Chelsea. The result elevated a genre subject to history painting by relating the great events of history to the lives of historically insignificant individuals. Kenneth Bendiner has suggested that Wilkie's approach 'related world events to the experience of the average man and suggests a coming to terms with mass society; it gives a hint of the force of nationalism in which 'the people' take on a singular importance.'[13] Bendiner has conflated the pictorial representation of lower-class men with the notion that it was they, 'the people', whose actions and emotions led to the growth of the mythology of patriotism. It seems that Wilkie's representation of 'the people' partakes of the mythology of working-class patriotism and is important in reasserting it in a reassuringly believable way. Wellington's selection of Chelsea veterans was crucial in focusing on a group who were 'known' to be patriotic and loyal. Wilkie's picture effectively exploited that 'knowledge' and reinforced it.

Wilkie's journals reveal that the duke wanted the artist to represent the veterans as youthful and healthy. When asked to choose between two sketches the duke:

> . . . preferred the one with the youthful figures; but as Mr Long remonstrated against the old fellows being taken out, the Duke agreed that the man reading should be a pensioner, besides some others in the picture. He wished that the piper might be put in, also the man with the

wooden leg; but he objected to the man with the ophthalmia.[14]

Wellington was clearly unwilling for distressing reminders of war to mar his painting. Wilkie published, in the RA catalogue, a guide to the military careers of all the principal figures in the painting, enumerating their former regiments and campaigns. 'These ranged from the pensioner reading the Gazette, who had served at Quebec under Wolfe; to the black bandsman who had fought against the French Republic. . .'[15] The Chelsea pensioners in the painting, then, were invoked as an expert audience who would authenticate Waterloo as a great event. This was particularly important, since after Waterloo Wellington's political enemies claimed that his achievements had been exaggerated.

Despite the reference to Chelsea pensioners in the title of the picture, only seven of the sixty-odd figures are obviously elderly or invalid, the only inmates of the hospital. The scene is outside an inn and most of the figures are young. The most prominent is a young soldier, tossing his baby in the air at the good news. Youth and beauty are also represented by two young women. Wilkie has counteracted any sense of waste or despair in the elderly by filling the picture with youthful happiness. The central group of the soldiers, including the veterans, is broken up with lively effect, by the variety of pictorial types and bright costumes.

When the picture was exhibited in 1822 it was highly acclaimed. The large scale (6ft x 7ft), the reference to Waterloo and the status of the owner all precluded its treatment as a genre painting. The Committee of Arrangement, the Academicians in charge of hanging, placed the picture where it would have maximum effect as an assertion of national triumph, 'with Jackson's portrait of the Duke of York on one side and Lawrence's portrait of the Duke of Wellington on the other'.[16] Situated between portraits of the commander-in-chief and the commander in the field, Wilkie's genre painting became a political statement. It asserted the 'natural' joy felt by all respectable working-class people at a great victory.

The image of the Chelsea pensioner was enhanced during the Chartist demonstrations of 1843-48.

> Chelsea out-pensioners were employed extensively during the early years of the Chartist disturbances. Initially they were used in a civil capacity as special constables for street patrols and for dispersing meetings.[17]

Although the out-pensioners were not inmates they were identified with them in the public mind. By the Enrolled Pensioners Act of 1843 the government sought to make more effective use of the out-pensioners by forging them into an auxilliary military force:

Under the Act, pensioners would be compulsorily enrolled in local uniformed corps, armed with muskets and bayonets and acting under military discipline when called together to assist the civil power. There was provision for assembling for eight days, training and inspection and members of the corps were liable to fines or forfeiture of pension if they lost or damaged their arms or equipment.[18]

The impact upon the public image of the Chelsea pensioners was probably greater than as a deterrent to the Chartists. The utilisation of the pensioners for the defence of the State in the 1840s further cemented the bond between the hospital and the government view of 'the national interest'.

Hubert Herkomer's *The Last Muster* was exhibited at the RA in 1875. It represents the pensioners attending a service in the hospital chapel: one of them has just died and his friend is noticing his passing. Herkomer's oil painting, like Luke Fildes's *Casuals*, appeared originally as a drawing in the weekly paper *The Graphic*. [19] His visualisation of the pensioners was not original. Some thirty years earlier Gleig had recommended watching them as an amusement:

The benches which occupy the body of the place are then crowded with old soldiers whose grave but not austere countenances, lighted up from time to time by a display of deep devotional feeling, seemed to me to present to the eye of the painter subjects too inviting to be overlooked. How decent, how much more than decent, is the deportment of these worn-out warriors![20]

In equating religious observance with moral rectitude Gleig was echoing a belief dear to his ruling-class peers; the worship of God helped to make the poor content with their lot. Much anxiety was felt in the mid-nineteenth century about the inability of the Church to cope with the new urban populations. Religious worship was seen as a safeguard against radicalism, as well as against immorality and lawlessness. The depiction of Chelsea pensioners at prayer satisfied the desire to see the urban poor as God-fearing and humble. In a letter to American relatives Herkomer expressed his pleasure at the sight of ex-soldiers being 're-claimed' by religion.

It is a grand sight to see these venerable old warriors under the influence of divine service. They have been loose (most of their lives), and now coming near their end a certain fear comes over them and they eagerly listen to the Gospel.[21]

Herkomer's painting was planned in 1871 during a crisis in Chelsea's history. Despite the increase in soldiers eligible the numbers of applicants had fallen. In 1870 it was feared that Chelsea and Kilmainham would be forced to close. The institutions' unpopularity was due to

their 'restrictive military regimes'. The requisite obedience and defer-
ence to authority which had been retained in the army and the Hospital
no longer pertained in the civilian world. Ex-soldiers were increasingly
reluctant to live by military rules in their old age, and prepared to suffer
for their independence. Ironically the only class of soldier accepted by
Chelsea was least likely to require 'financial help. Their habits of
sobriety, self-discipline and 'steadiness' enabled them to save for their
old age. The first report of the Commission on the Royal Hospitals,
published in 1870, drew attention to the threat to the survival of the
institutions. Chelsea took on added lustre as an endangered species.[22]

Herkomer's representation of the pensioners captures the wealth of
nostalgic sentiment which surrounded the institution. His view of
them was 'heroic' – in the life-size scale of the figures and in the nobil-
ity of their faces. This treatment was derived from French realism and
was common to a group of artists painting in England after about 1865-
70. Sympathetic portrayal of the poor was by no means as radical as it
had been in France, but part of a liberal and humanitarian philosophy
which regarded them as worthy of serious and sympathetic study.

In its title and subject *The Last Muster* may perhaps have been
designed as a pendent or 'sequel' to the 'picture of the year' in the
previous Academy summer exhibition. Elizabeth Thompson's *Calling
the Roll after an Engagement, Crimea*, nicknamed *The Roll Call*, had
sympathetically depicted the emotions of ordinary soldiers after a
bloody battle. *The Last Muster* showed a group of veterans wearing
medals from the Crimean war of twenty years earlier. It provided re-
assurance that Thompson's heroes had received proper treatment from
the state and were cared for in retirement. The painting represents
pious and prosperous old age rewarded. Blackburn, in his Academy
notes, viewed this fortunate retirement as 'the last act of the drama of
war'.[23]

The theme was also applied to ex-soldiers with no obvious connec-
tion with Chelsea. This type of painting, however, does not seem to
have emerged until after the Crimean war. From then on there were
many more representations of soldiers and, by extension, veterans, in
domestic situations. Their popularity with artists undoubtedly lay in
the opportunity they offered to contrast physical types and age groups
– the decayed strength of the veteran with the youth and beauty of his
daughter or granddaughter. Sometimes a male child was included in
the painting. Thomas Faed's *New Wars to an old Soldier* (RA, 1862)
was typical;

> A veteran of the war in Egypt, striken with the peculiar evil of that luck-
> less campaign, ophthalmia, sits in a chair, withered and worn, his eyes

shrunk deep in the face yet all their companion features playing in earnest attention, while a young woman, his daughter or daughter-in-law, reads from a newspaper the story of the Indian Mutiny and the deeds of the regiment to which he belonged when he was young, strong and capable of war.[24]

An *Athenaeum* review of H. S. Marks's *The Ornithologist* suggests that this picture was meant to be taken as a domestic scene of a veteran officer. There do not seem to have been any other examples. Army officers often became famous as scientific explorers; many were inquisitive and imaginative, and used their overseas tours of duty to undertake archaeological excavations, botanical surveys, zoological collections or anthropological studies. Marks's picture showed:

> . . . the interior of a private museum of stuffed birds with cases arranged above, and stuffed specimens in ranks on the floor. The owner, an old military officer, is standing on a pair of steps and superintending the arrangement of his stuffed favourites. His servant, another old soldier – the characterisation of this figure is happy – attends with a big flamingo and a stork in his charge. The humour of this picture is obvious enough to those who examine it. . .[25]

Marks depicted the ex-officer as an eccentric, enabling him to show a member of the ruling classes in a humorous light: an eccentric is safely outside the norm. It is interesting that the class harmony always insisted upon by ruling-class commentators is revealed here in the relation between officer and servant. It implies that it was natural for the relations of master and servant to continue in retirement.

Post-Crimean representations of veterans away from the Chelsea Hospital were for the most part very positive, showing the old soldier enjoying domestic prosperity and happiness. It is clear that this domestic setting was a piece of bourgeois mythology. As far as is known, no paintings of non-Chelsea veterans were shown at the RA until after the Crimean war. This should not be taken to indicate that they were not a visible element of society. Rather, the belief that they were a latent threat removed them from the repertoire of desirable subjects.

As has been shown earlier, in the aftermath of the Crimean war, with the Volunteer movement, the common soldier had become a humble hero rather than a social outcast in bourgeois mythology. It was at this point that the veteran 'forced to beg' re-entered the Academy exhibition. A considerable mythology had existed in eighteenth-century literature and painting on the subject of the 'poor soldier', i.e. the veteran, the most memorable example being Goldsmith's 'broken soldier' from *The Deserted Village* (1770).

Luke Fildes's *Applicants for Admission to a Casual Ward* (RA, 1874)

was one of the earliest revivals of the veteran as victim of injustice. This oil painting was a reworked version of a drawing which Fildes had engraved for *The Graphic*. When the engraving appeared, in the first issue of December 1869, it was entitled 'Homeless and Hungry'.[26] In this version there was no soldier. In the later oil painting the veteran in a worn red coat supports himself on a crutch, in the queue of destitute people outside the 'casual ward'. Contemporary critics found the portrayal extremely moving, agreeing that the figures waiting for relief were drawn from every type of the needy – the deserving poor to the thriftless, fraudulent and lazy. The only specific reference to the soldier in contemporary reviews set him firmly in the category of the fraudulent, describing him as a 'professional beggar'.[27] The critic did not explain whether he was fraudulent in pretending to be a soldier or in pretending to be in need. His absence from the first version is not explained by Fildes's biographer, his son V. F. Fildes. It would seem that Fildes intended his veteran to be taken as a genuine case of hardship. On the wall behind him is a poster; 'Royal Artillery: Wanted: Smart Young Men'. Juxtaposed with the forlorn figure of the crippled veteran, it can only be interpreted as ironic.

The comment is of interest, however, since it echoes several other mid-nineteenth-century sources who argued that no veteran needed to be outcast. In *London Labour and London Poor* Henry Mayhew described begging veterans in such terms as to imply that few deserved much help or sympathy:

> Soldier beggars may be divided into three classes; those who really have been soldiers and are reduced to mendicancy, those who have been ejected from the army for misconduct, and those with whom the military dress and bearings are pure assumptions. The first or *soldier proper* has all the evidence of drill and barrack life about him; the eye that always 'fronts' the person he addresses; the spare habit; high cheekbones, regulation whisker, stiff chin and deeply marked line from ear to ear. He carries his discharge paper about him and when he has been wounded or seen service is modest and retiring as to the incidents of an engagement except as regards the deeds of his own company and in conversations speaks more of the personal qualities of his officers and comrades than of their feats of valour. Try him which way you will, he will never confess that he has killed a man.[28]

Mayhew's image is bizarrely circumscribed – he must be modest, deferential, thin and ill informed! If the beggar does not exhibit those qualities he must be either a 'bad' soldier, dismissed from the ranks, or a 'false' one pretending to be a soldier to assist his begging. Mayhew's classification effectively disposed of any guilt that might have been felt at the sight of an old soldier begging in the street. Mayhew goes

on to explain that a 'soldier proper' will work hard but 'if my readers would enquire why a man so ready to work should not be able to obtain employment he will receive the answer that universally applies to all questions of hardship among the humbler classes – the vice of the discharged soldier is intemperance'.[29] He clearly cannot admit that any veteran might be forced to beg by inability to obtain work, nor does he accept that 'true' soldiers were other than virtuous and hard-working.

After the Cardwell reforms it seemed that the destitute veteran problem would soon disappear. Short-term enlistment meant that the average age on leaving would be much lower and the ex-soldier would go into the reserve and take up a civilian trade. During the six years in the reserve he was paid a small retaining fee in return for which he was required to be available for training and of course respond to the call to arms in a national emergency. It was found that ex-soldiers who were in reserve were at a disadvantage in the job market. The veteran who did succeed in finding work would be likely to receive a lower wage than average.[30] A few employers of the 'time-expired' rationalised this by claiming that as tax-payers they had already contributed. The Rev. E. J. Hardy remarked in 1891 that this was widespread 'owing to the dishonesty and want of patriotism of employers of labour'.[31] When the job market contracted former soldiers were among the first to be dismissed. They were generally unskilled, always the most vulnerable class of worker, but employers resented their absences on training. General Sir Garnet Wolseley claimed that the problem was exaggerated by idlers:

> You meet a tramp on his travels. He is badly clothed, perhaps footsore. He pulls our his parchment certificate to show you he belongs to the Army Reserve. He does not really want settled employment and would not keep it if it were promised for him; but to excite your pity he tells you that it is because he is liable to military service that he cannot obtain work.[32]

The blustering tone and the lack of supporting evidence suggest that Wolseley felt a deep anxiety over the matter of indigent veterans. Like Mayhew, he was evidently unwilling to believe that a substantial proportion of the 30,000 veterans who left the army each year were unable to find work. Wolseley was commander-in-chief at the time.

The sole attempt to alleviate the plight of unemployed veterans in the post-Cardwell era was a result of private initiative. The National Association for the Employment of ex-soldiers was founded in 1885 by a group of retired officers. The N.A.E.S. was desperately needed; by 1914 it was the largest employment agency in the country, with 110

branches.[33]

Despite hopes that the veteran problem would disappear, and attempts to deny its existance, the begging soldier was as familiar a sight in 1880 as in 1840. What had changed profoundly was the attitude of sections of the ruling class towards the problem. In academic art this shift in ideology was manifested by a large increase in veteran paintings. The number of such subjects at the RA was higher in the five-year period immediately prior to the foundation to the N.A.E.S. than at any other time in the century 1815-1915.[34] A climate of concerned debate was reflected and inflated by the interest of artists. Thomas Faed's *From Hand to Mouth* not only partook of this social concern but provided a noble image of the destitute veteran. Faed was careful to establish his ex-soldier in the category of the deserving poor by subtitling the picture 'He was one of the few who would not beg'. This was to avoid the inference that the man accepted charity from choice rather than necessity. Faed's hero has taken to playing a musical instrument for money. The *Athenaeum* reviewer took a favourable view of him as 'a once stalwart man, now reduced and growing old and compelled to practice music in the streets. . .'.[35]

Faed's picture shows a dramatic scene in a chandler's shop, when an impoverished ex-soldier finds that he has not enough money to pay for his meagre groceries. The desperate situation is emphasised by the sad looks of his two beautiful children. His son holds the leash of a performing monkey and a musical pipe, while the little girl, weak with hunger or illness, has fallen asleep on a basket. Their poverty is contrasted with the opulence of the other family in the shop. A splendidly dressed lady is seated while making her purchases. The luxury of her life is indicated by a black page boy and a pet dog. Her purchases on the counter are all non-essentials – toys, a book and a vase – while the soldier's are the bare essentials. Contemporary reviewers were unable to agree on the outcome of the drama, which rested on the response of the shopkeeper.

> The Chandler studies the man's face while preparing to take back the goods; his looks, although indicating suspicion are not without the possibilities of compassion.[36]

Another reviewer felt differently: '. . . a fat grocer's counter, where there is obviously no disposition to bate a penny'.[37] This interpretation would seem to be supported by internal evidence. Faed has two women behind the counter. One is carrying a too-heavy basket on her head, the other, of similar age and appearance, perhaps her sister, is gazing sadly out of the window. She is clutching a piece of fabric, perhaps

indicating that she works as a seamstress. This class of worker was the focus of social concern in the mid-nineteenth centry and was frequently represented sympathetically.[38] The seamstress, like the veteran, was a symbol of hardship due to injust treatment. We are perhaps to infer that the grocer's harsh behaviour towards his overworked daughters will be echoed in his treatment of the needy veteran. Faed's soldier bears considerable resemblance to Mayhew's 'soldier proper', that is, he is simply an older version of the idealised Victorian soldier. The most striking aspect of Faed's veteran is his humble demeanour. There is no suggestion of anger or resentment in his manner, and the sense of social harmony is reinforced by the domestication implied by the two children. In no sense, then, is he a threat to the *status quo.* The painting is an appeal for sympathy based on a contemporary ideology of the state's duty towards its heroic servants. Without such sympathy the paintings would have shown a fraud trying to get away without paying.

The theme of the veteran, like that of the deserter, underwent considerable changes during the course of the century. In the early years the veteran was so feared that his appearance in academic art could only be tolerated in the sweetened form of a Chelsea pensioner. The transition in ideology towards the army and common soldiers was crucial in allowing new forms to emerge after the Crimean war.

The Volunteer Movement

> . . . until lately, the soldier has never been permanently popular in England, what ever might be the feelings towards him in moments of great national danger. . . It was the creation of the Volunteer Force which first gave the British soldier any good and permanent social position. That force so well represents all classes that its respect for the army of which it was modelled, and by whose members it was drilled and trained, has caused the soldier to be now regarded every where with general interest.[39]

Military commentators writing in the last decades of the century were unanimous that the change which had taken place in civil-military relations after 1860 could be attributed to the Volunteer movement. Wolseley believed that the participation of civilians in the military sphere generated respect for the army. It might be argued that the middle classes' enthusiasm for the Volunteer force was a manifestation of the same feeling that 'popularised' the army. Whatever the actual relation between the Volunteers and the improved image of the regular army, contemporary experts attributed the change to the Volunteers.

The force was founded in 1859, as a result of agitation about the

threat of invasion from France. Invasion scares had been frequent during the preceding fifteen years. Developments in technology, especially the application of steam power to troopships, were recognised as threatening the nation's safety. The English Channel, always regarded as a protective barrier, could now be crossed swiftly and an army landed in any weather. The army's commitments were so extensive that over half its regulars were abroad at any one time. The dangers of leaving the country 'undefended' were constantly bewailed in the press.[40] Various solutions were mooted, notably a revival of the militia, which had a long history. A scheme suggested by the Duke of Wellimgton in 1845 would have provided for a part-time force of 150,000 paid men, with a ballot as an option for raising 'volunteers'. In essence the militia was a multi-class organisation although based on a feudal structure whereas the Volunteer corps that had existed during the Napoleonic wars had been totally middle-class in membership. The few Volunteer corps that had survived into the post-Waterloo era continued as social and sporting clubs.[41] In times of civil crisis, such as the Chartist riots, the Volunteer corps petitioned government to allow them to reform to defend the nation from dissidents. The Volunteer force, founded in 1859, was almost exclusively middle-class in the early years and represented a challenge to upper-class and aristocratic domination as the militia had not. The Volunteers must be seen as another indication of the growing confidence and political influence of the professional and commercial middle classes.

In the first months after the government's endorsement of the plan to raise a Volunteer force, in May 1859, there was comparative apathy. Despite public meetings to foster interest there was scant support. Certain groups, notably the Quakers, voiced opposition. There was also an attack from the Liberal opposition in Parliament, who objected to the class bias built into the structure of the Volunteer force. Since every recruit was expected to provide his own uniform, the working-class volunteer was a rarity.[42] The government was also felt to be using the force to distract the very middle classes who were agitating for far-reaching social and political reforms. Among radical groups it was feared that the force constituted the army of the middle class, to suppress working-class agitation.[43] This element of class conflict is crucial to understanding the Volunteer force and the timing of its representation in Academy art. From 1859-1867 middle and upper-class domination of the movement was complete. Popular support was fostered by powerful organs of the media such as *The Times*, the *Illustrated London News* and *The Graphic*. Great claims were made about the social significance of the movement, which was seen as apolitical. In a letter

to *The Times* Lord Elcho praised the social cohesion being brought about by the Volunteer force:

> . . . in this country different classes of society have few opportunities of meeting and volunteering presents this opportunity, and enables them to meet together and unite shoulder to shoulder. All, indeed, who have taken an active part in this movement will bear witness to the social good arising from it. . .[44]

Far from fostering social 'togetherness' the early Volunteer forces resembled middle-class sporting clubs, with a number of corps established specifically for the 'artisans'. In 1862 a Royal Commission produced interesting data in the social composition of the force. Although there was much more working-class participation in the north of England and Scotland than in the south-east (where most Academy artists lived and worked), a breakdown by trade indicates that they were mainly skilled workers or small tradesmen rather than the lowest class of unskilled labourers.[45] The most threatening social class was not reached at all by the 'healing' effects of the Volunteer force.

In 1863 the government passed an Act providing grants to cover the cost of uniforms for working-class men, as well as cash incentives to attend drill and rifle practice. This tacitly discredited Volunteer claims to trans-class membership and showed that more working-class involvement was conceived to be urgently needed. Middle-class commentators, for the most part, found this acceptable. Not only would it help class relations but it would make working men 'less idle and dissipated and more respectful to authority' and foster such desirable traits as 'discipline, cleanliness, order, punctuality and promptitude and obedience. . .'.[46] Thus the middle class-view of the Volunteers evolved into seeing it as a form of social control, as diverting energy away from enjoyment and possible radicalism into healthy patriotic activities under middle-class supervision. One representation of the Volunteer force exhibited at the RA in 1861 depicts a working-class patriot. It is evident from the only contemporary review of the picture (in the *Art Journal*) that the critic is unsure how to take it. The main figure in *The Hero of the Day* is working-class and therefore would usually be comic, but the nature of the picture suggests a more elevated meaning. Only about half the review can be quoted here:

> Mr Barwell. . . has produced a most literal rendering of what may be a popular, but which is withal rather a vulgar, vigorous embodiment of a present every-day scene. *The Hero of the Day* is one of those patriotic volunteers whose military ardour the weather seems to take every opportunity of attempting to damp. . . The hero, who is no doubt a coster-monger from the quality of animal and style of vehicle on which his

[*153*]

family is returning from witnessing his success, evidently carries home his prize as proud of his military superiority as the first Napoleon or Wellington would have been of conquering a kingdom. . . the wife and children, one of whom carries the prize (for marksmanship), are evidently as proud of their father as he is of his own exploits. In this respect the story is well told. There can be no objection to the satisfaction, any more than to the general arrangement of the picture. . .[47]

The first part of the review of this now lost picture is spent in establishing it as Pre-Raphaelite in style and its subject as of Ruskin's 'true historical style', that is, 'a literal rendering. ., of a present everyday scene'.[48] The critic is evidently at a loss to know whether the volunteer should be regarded as a contemporary hero, a representative of the age, or as a comical cockney. This kind of ambivalence about working-class participation was widespread.

Many of the pictures exhibited at the Royal Academy were portraits of friends or clients in the uniform of Volunteers. Four or five such works were exhibited in 1860-61, reflecting the enthusiasm for the Volunteers in artistic circles. To an artist who was involved with the force, much amusement might be derived from painting a friend grappling with unfamiliar weapons and drill. An untraced work by the Scottish artist, John Ballantyne, may well have been of this type. Ballantyne and his brother, the novelist R. M. Ballantyne, joined the movement in its earliest stages. They were made ensigns (the lowest rank of officer) in the Edinburgh Royal Volunteers in autumn 1859. Both were reported to be enthusiastic in their support. Ballantyne's picture *The Volunteer Movement in the Studio: 'Shoulder Arms'* appeared at the RA in May 1860 – the first depiction of the social movement which was engrossing middle and upper-class attention.[49]

Another Scottish artist, John Faed, depicted middle-class enthusiasm. *A Wappenschaw* partook of the nationalist mythology which was constructed around the movement. Faed subtitled his picture *Scottish Volunteers half-a-century ago,* and stressed further the parallel between the Napoleonic era and his own by appending this revealing passage:

> Frequent musters of the people for sports and pastimes were appointed by authority; at these Wappenschaws, as they were termed, the shooting matches were of the greatest importance and each crown vassal was required to appear with such a muster of men as he was bound to make by his fief.[50]

Faed's quotation (the source is unknown) stresses the continuity of the Volunteers and implies their feudal organisation. At the time when the picture was being painted it was noted that land and factory owners

were encouraging their dependent employees to 'volunteer'. The corps were officered and financed by the employers themselves on lines very similar to the feudal wappenschaw system. This kind of structure seems to have been particularly common in Scotland. In Kincardinshire an artillary battery consisted entirely of fishermen who were clothed and commanded by their landlord.[51] The Volunteers were used by wealthy Scots to create a romantic revival of the clan system, drawing on the mythology of their military tradition.

In England an historical link between the Volunteer force and the men who fought at Agincourt was sometimes claimed. It was based on the fact that the bowmen of Agincourt were thought to have been 'yeomen', small landowners – the medieval equivalent of the Victorian bourgeoisie. Agincourt was a particularly apposite reference, since it was fear of the French which had triggered the establishment of the Volunteers. In an article, 'Volunteering past and present', John Martineau drew 'an analogy between the longbow and the rifle.[52] Tennyson, the poet laureate, had already stressed the great tradition of home defence in his memorable poem *Britons—Guard your Own*. It had been written in response to Louis Napoleon's *coup d'état*, which was feared to presage another era of Bonapartist aggression.

> We were the best of marksmen long ago.
> We won old battles with our strength, the bow.
> Now practise, yeomen,
> Like those bowmen,
> Till your balls fly as their true shafts have flown.
> Yeomen, guard your own.

There were ten paintings exhibited at the Royal Academy whose titles specifically referred to the Volunteer movement. They included a few portraits and a picture by Webster showing children playing volunteers. All were exhibited between 1860 and 1871, indeed only Webster was shown after 1867. The numbers of recruits to the force and its activities continued to expand from 1860 until the Boer war in 1899. Why then given its continuing growth, did Academic representations suddenly cease? It might have been due to the decline of middle-class commitment. A number of aristocratic and professional men continued to command corps, but after about 1867 the middle-class volunteer disappeared from the ranks. The *Volunteer Service Gazette* remarked in 1877 that the middle classes had just 'melted away... the gradual reduction in numbers of the regiments composed of the highest class of men was owing entirely to the *spontaneous extinction of the enthusiasm* which had led these men to join'.[54] One reason may have been disillusionment. *The Times*, which had ardently supported the

Volunteers, cooled rapidly after 1867 when they demanded a higher grant from the government. On 25 December 1869 *The Times* complained of the 'very slow advance' of the Volunteer force towards organisation and 'definitively determined principles'.[55] By the end of its first decade it had become obvious that the force would never be permitted to play anything more than a ceremonial role. The army was rigorously opposed to any extention of its powers. All the predictions about its social and military influence failed to come to fruition. Most important, the invasion scare had passed and the drilling seemed pointless to those with better things to do. The defection of the middle class further strained the goodwill of employers:

> Employers no longer had faith that drill and shooting improved their men, but were instead conscious of the time off that the Volunteers in their employ demanded.[56]

So little is known about the circumstances surrounding the genesis of the paintings that it is only possible to speculate that the middle-class defection was the cause of their sudden cessation. The artists were linked to the middle classes both by class and financial dependence. If a proportion of middle class volunteers grew bored or disillusioned, then some artists would be among them. The hanging committee might reject pictures which seemed to have commonplace, overworked themes. A number of the pictures seem to have been close to the spirit of *Punch* cartoons, which delighted in the ineptitude of the civilian soldiers. This kind of humour must have quickly lost its bite as the Volunteers grew more professional. The most potential reason for the disappearance of Volunteers from painting was that the movement increasingly became appropriated by the working classes under middle-class officers and in a sense differed little from the regular army.

This significance of the Volunteer movement for representations of the military was not limited to the period 1859-67. The consequences of the change in ideology which it embodied was to be discernible until the end of the century.

Notes

1 Skelley, p. 52.
2 G. Stedman Jones, *Outcast London*, 1971, p. 79.
3 C. J. Napier, p. 126.
4 Thompson, p. 693.
5 J. Hichberger, 'The myth of the patriotic veteran in British art, 1815-1880', *Patriotism*, ed. Raphael Samuel, 1987.
6 Anon, *Handbook for Visitors to Chelsea Hospital*, 1885. p. 15.

7 G. R. Gleig, *Chelsea Hospital and its Traditions*, 1839, p. 23.
8 *Ibid.*, p. 337.
9 London, Arts Council of Great Britain, *Great Victorian Painting*, 1978, p. 7.
10 Cunningham, II, p. 13.
11 Cunningham, II, p. 18.
12 Wolverhampton City Art Gallery, 'Edward Bird, 1772-1819', 1982, p. 13.
13 K. Bendiner, 'Wilkie in Turkey', *Art Bulletin*, LXIII, No. 2, pp. 259-77.
14 Cunningham, II, p. 18.
15 *Loc. cit.*
16 Cunningham, II, p. 69.
17 Spiers, p. 85.
18 F. C. Mather, *Public Order in the Age of the Chartists*, 1959, p. 151.
19 L. V. Fildes, *Luke Fildes, R.A.: a Victorian Painter*, 1968, p. 13.
20 Gleig, p. 334.
21 J. Saxon-Mills, *Life and Letters of Sir Hubert Herkomer*, 1923, p. 87.
22 Skelley, p. 205.
23 H. Blackburn, *Academy Notes*, 1875, p. 45.
24 *Athenaeum*, No. 1801, 3 May 1862, p. 680.
25 *Athenaeum*, No. 2375, 3 May 1880, p. 659.
26 Fildes, p. 13.
27 *Illustrated London News*, 9 May 1874, p. 4.
28 H. Mayhew, *London Labour and the London Poor*, IV, 1860-61, p. 417.
29 *Loc. cit.*
30 E. J. Hardy, 'Time-expired men', *Good Words*, 1891, p. 16.
32 T. H. Ward, p. 213.
33 Spiers, p. 27.
34 This statistical evidence was compiled in the doctoral thesis by this author, 'Military Themes in British Painting, 1815-1914', University of London, 1985, see Graph A.
35 *Athenaeum*, No. 2742, 15 May 1880, p. 637.
36 *Loc. cit.*
37 *Times*, 6 May 1860, p. 10.
38 L. Errington, 'Social and Religious Themes in English Art 1840-60', Ph. D. Courtauld Institute of Art, 1976.
39 Garnet Wolseley, 'The standing armies of Great Britain', *The Armies of Today*, 1893, p. 63.
40 Spiers, p. 165.
41 Cunningham, p. 5.
42 *Ibid.*, p. 26.
43 *Ibid.*, p. 28.
44 *Times*, 15 August 1860, p. 8.
45 Cunningham, p. 5.
46 *Ibid.*, pp. 28-9.
47 *Art Journal*, 1861, p. 195.
48 *Loc. cit.*
49 E. Quayle, *Ballantyne the Brave*, 1967, p. 133.
50 Royal Academy Catalogue, 1866.
51 Cunningham, p. 21.
52 *Macmillan's*, Vol. 2, 1860, pp. 394-403.
53 Alfred, Lord Tennyson, *Britons, Guard your Own*, 1859.
54 Cunningham, p. 42.
55 *Ibid.*, p. 88.
56 *Ibid.*, p. 78.
42 *Ibid.*, p. 26.
43 *Ibid.*, p. 28.
44 *Times*, 15 August 1860, p. 8.
45 Cunningham, p. 5.
46 *Ibid.*, pp. 28-9.
47 *Art Journal*, 1861, p. 195.

[*157*]

G

48 *Loc. cit.*
49 E. Quayle, *Ballantyne the Brave*, 1967, p. 133.
50 Royal Academy Catalogue, 1866.
51 Cunningham, p. 21.
52 *Macmillan's*, Vol. 2, 1860, pp. 394-403.
53 Alfred, Lord Tennyson, *Britons, Guard your Own*, 1859.
54 Cunningham, p. 42.
55 *Ibid.*, p. 88.
56 *Ibid.*, p. 78.

CHAPTER TEN

Domestic depictions of the soldier

This chapter will consider the meeting point between the civilian and military worlds. The numbers of domestic military genre paintings are comparatively large.[1] It is not possible to detail them all, nor would it be profitable to do so, since there is often remarkable similarity between them and a frequent repetition of motifs. It will be argued that despite this appearance of continuity in the types of genre paintings exhibited at the R.A. over the century, the genres were crucially modified and the ways in which they were read dramatically changed.

The pictures will be considered according to theme. This is not to say that they fall unproblematically into distinct categories. There is considerable overlap and, of course, each carries resonances of meaning for the others. A painting such as J. Noel Paton's *Home* carries a range of meanings: about the nature of man as warrior, of woman as the homemaker who merely waits, about the reverence of the strong for the gentle or weak, about the domestic nature of the British soldier, the domestic respectability of the working classes, and many more. The meanings operate at different levels and are interwoven in a series of complex relationships. It is intended here to separate out some of those meanings and to suggest the ways in which they can be considered in relation to ideologies of the army held by the ruling class.

An examination of the representation of the military and civilians in Academy painting in the nineteenth century again reveals a marked difference between works produced either side of the dividing era 1854-c.1865. As we have seen, the ideological construction of the soldier in the ranks was transformed in this period from that of potentially dangerous wastrel to that of patriotic warrior. Academic images both reflected and were instrumental in shaping new views of the soldier. The relation of the military to the domestic sphere is clearly crucial in this process, since the home, with its surrounding meanings of marriage, bridled and legitimised sexuality, and the organised reproduction of children, was one of the principal hallmarks of the morally

regenerate in mid-Victorian middle-class ideology.

In the pre-Crimean period there were few representations of soldiers as domestic beings. There were scenes of young men selfishly leaving home to enlist, and spent veterans returning, but none which showed soldiers as family men. This is in harmony with the evidence about the experience of soldiers at this time. Military structures and indeed policy were dedicated to the preservation of a rootless, unmarried private soldier. In the pre-Crimean Army it was virtually impossible for a soldier to retain any links with home or community. The length of service, twenty-one years, and the social disgrace attached to enlistment, made it unlikely that close family ties could be maintained. On enlisting a soldier had to swear that he was not married, and the law which held soldiers not responsible for a wife married before enlistment made the army a refuge for those fleeing domestic ties. Once in the service only six men in a hundred were permitted to marry, and then by permission of the commanding officer. These few wives were allowed because they could perform useful domestic functions and act as servants to the officers' wives. There was no restriction on the marriage of officers.

Many men formed liaisons without official sanction, and were married 'off the strength'. Military regulations virtually ordered the soldiers to abandon their women and children. No provision was made for their welfare, and low pay made it impossible for any but the most thrifty to support a wife.[2] Many such women were abandoned when the regiment moved on, because they could not afford to follow it and, to survive, had either to form new relationships or to support themselves by whatever means they could. The instability of most soldiers' sexual lives was interpreted by the middle-class authorities as a result of their 'natural' immorality and their women designated prostitutes.

A commentator in a contemporary jounal makes it clear that the army was keen to shake off these 'ties', whatever the cost:

> Perhaps, even now, it would be difficult to persuade Parliament to forbid by law the marriage of soldiers [i.e. make it a criminal offence rather than a military misdemeanour]... but if no man can henceforth be engaged for more than ten years, we see no reason why the existing rules of the service on this point should not be rigidly enforced... let no woman be acknowledged in a corps who has married a soldier contrary to the will of the C.O. let no aid in money or otherwise be offered her to follow her husband and if she do make her way to his head-quarters, let nobody connected with the regiment notice her. Such language may sound harsh in the ears who do not know the extent of the evil which a soldier brings upon himself and upon the partner of his folly by marrying without leave, but they that do know this will perfectly understand

that there is mercy in our sternness. . .[3]

This determination to free soldiers from unsanctioned marriages, then, tacitly supported the formation of 'deviant' sexual relationships. The work of Walkowitz on the Contagious Diseases Acts of the 1860s has shown that there was a continuous acceptance of prostitution in barrack districts as 'inevitable'.[4] Jeffrey Weeks has shown that homosexual relations, although officially disapproved of, were suppressed only when they occurred between men of different ranks, which was perceived as threatening to 'tear asunder the carefully maintained hierarchy'.[5] The authorities were concerned to keep the men as economically independent units, living in barracks, whatever the affront to conventional moralities. In the post-Crimean era civilian groups pressed the government and the army to domesticate soldiers into the respectable institution of marriage, perceiving that 'immorality' was an inevitable result of army policy.

The connection of soldiers with 'loose women' was construed very differently in ruling-class ideology in the pre-Crimean period. The contemporary mythologies of prostitution and female sexuality saw an unbridgeable gulf between the 'honest woman' and the whore. Since the financial imperative of prostitution for women on low wages was often discounted, commentators chose to believe that women 'fell' into the life only after being seduced. The profile of the typical prostitute constructed by contemporary authorities was a 'virtuous' serving maid or farm girl led from the path of virtue by a stranger. Having forsaken virtue the girl would inevitably 'fall' into prostitution and be eternally cut off from the respectable society of her family and friends. Once on the 'downward path' she could not return to virtue but was doomed to degradation and death, usually by suicide. William Tait, an Edinburgh surgeon and the author of *Magdalenism* (1840), was in no doubt as to who was to blame.

> Soldiers are more frequently guilty of the crime of seduction than any other class of the community. The short period which they are quartered in any station, the distance that intervenes between the quarters, and the dissolute and idle life which they follow – renders them dangerous enemies to the female portion of the population. It is difficult to say whether the officer or the private is most deserving of censure. . .[6]

The common soldier and the officer both fell into the category of 'immoral seducer' since the former belonged to the unrespectable section of the working class and the latter was a representative of the wicked aristocracy. The theme of sexual morality as class differentiator will be reverted to below. Bourgeois attacks on the aristocracy's right to rule centred on their reputedly profligate and licentious habits. 'Wild

young aristocrats' were blamed for many sexual crimes and the army officer, as an aristocrat and a soldier, was a popular target of disapproval:

> Whenever a female in the middle or higher walks of life had been seduced, it has generally been found to be by a military officer and it is a notorious fact that no private soldier who has any respect for the virtue of his daughter, dare allow her to follow the regiment on account of the licentious conduct of his superiors.[7]

This mythology had a very useful dual function of accounting for prostitution and providing a scapegoat. The causal link between soldiers and prostitutes was seen to be 'proved' by the proverbial allure of the red coat.

In the period 1815-60 a few paintings were exhibited at the RA which drew upon and enriched the myth of the seductive soldier. A short story by Washington Irving provided a source for a number of pictures. *The Pride of the Village* (1820) was undoubtedly popular because of the way in which it raised a titillating and credible subject in a morally acceptable fashion.[8] Six artists between 1830 and 1839 exhibited works based on the story: F. Howard, *Pride of the Village* (1831); W. E. West, *Pride of the Village* (1831); F. Howard, *Pride of the Village going to Church* (1833); J. C. Horsley, *The Pride of the Village* (1839); and J. P. Knight *The Broken Heart* (1839). In Irving's story the narrator witnesses the moving funeral of a village maiden. He is told that she has died from a broken heart, having fallen in love with an officer who would not marry her but proposed that she live with him. The maiden, as innocent as she was beautiful, 'was at first at a loss to comprehend his meaning. When at last the nature of the proposal flashed upon her pure mind, the effect was withering'.[9] She is profoundly shocked by the immoral proposal and although she loves him, refuses him. His regiment is ordered away from the village:

> She had beheld from her window the march of the departing troops. She had seen her faithless lover borne off, as if in triumph, amidst the sound of drum and trumpet and the pomp of arms. She strained a last aching gaze after him, as the morning sun glittered about his figure and his plume waved in the breeze.[10]

After his departure the deserted maiden withers from grief. The number of artists who painted versions of the story suggests not only its popularity but that it contained elements particularly attractive to genre painters. Part of its attraction lay in the opportunity it offered to depict an ideal beauty of physical and spiritual perfection. Moreover it contained the spice of sexual danger. In several of the paintings discussed below, an encounter between a virgin and a soldier is shown to

be dangerous. In paintings based on the Irving story the sexual danger is implicit but disposed of in an anodyne way. The end of the story, when the maiden dies for love is dramatically effective, drawing upon ancient mythologies of female love as spiritual and constant and of male love as base and transient. Iriving's story and, by extension, the paintings based on it, reinforced a number of beliefs about soldiers and their sexual behaviour.

The inconstant and immoral lover is described by Irving as having been evilly influenced by the licentious talk of the officers' mess:

> . . . his passion was mingled with feelings of a coarser nature. He had begun the connection in levity, for he had often heard his brother officers boast of their village conquests and thought some triumph of the kind necessary to his reputation as a man of spirit.[11]

The words serve to extend the lover's immorality and cruelty to army officers as a group, and introduces a class element, since 'village conquests' are implicitly less important than others. The description of the maid's feelings discounts the influence of the proverbial attractiveness of soldiers and yet reinforces it. At the same time Irving elevates her love above the norm:

> The gallant figure of her youthful admirer and the splendour of his military attire might at first have charmed her eye; but it was not these that had captivated her heart.[12]

J. C. Horsley's *Pride of the Village* was more widely reviewed than the other paintings derived from Irving's story but, even so, received only cursory attention. The longest review in the newly founded *Art Union Journal* had no difficulty in referring the picture to its literary source. 'The dying maiden leans on the shoulder of her sad mother. Her face is exquisitely painted; it tells the mournful story of her life. . .'[13] Horsley selected a poignant episode from the short story, after the maiden had been abandoned. Despite the efforts of her parents to solace her with readings from the Bible she can only sit and gaze sadly out of the window through which she has last seen her soldier.

The critic of the *Athenaeum* compared Horsley's painting favourably with a version of the same passage by J. P. Knight, whose *The Broken Heart* was in the same Academy exhibition:

> All the ghastliness of death is to be found in Mr Knight's composition, but without that graceful and delicate veil which the American [author] has thrown over it. The forsaken girl is sitting alone, propped in her chair, warmly wrapped, though on a summer's day (in Mr Horsley's picture she is leaning against her mother's shoulder) with quiet despair and death in every trait of her wan countenance.[14]

It is interesting that although the critic found Knight's version

indelicatly deathly he took issue with the degree of 'refinement' in Horsley's picture. Horsley's young woman was depicted as very 'ladylike', with the thin, pale, elegant features which were signifiers of high social class in nineteenth-century culture. Irving defined the maiden's class precisely in his story. 'Her father had once been an opulent farmer but was reduced in circumstances. This was an only child, and brought up entirely at home, in the simplicity of rural life.'[15] The *Athenaeum* critic was clearly more interested in reading the picture as the consequences of an attempted seduction of an 'honest peasant' girl rather than a reduced bourgeoise.

The Pride of the Village was undoubtedly lent much of its effect by the well known dangers of soldiers for the opposite sex. Thomas Webster exhibited a painting on this theme at the Academy in 1837. *Returning from the Fair* showed an elderly couple returning to their rural cottage. They freeze with horror on seeing a dragoon's helmet outside the door. Through an open window a dashing moustachioed soldier can be seen flirting with a blushing young girl. The expression of fear on the grandfather's face indicates the danger in which she stands. The strong reaction from her protectors removes the picture from the level of rural comedy to that of domestic drama. The picture was shown without any explanation, indicating that the virgin-soldier drama was well enough known not to need elaboration. There were no reviews, suggesting that it was neither a shocking image nor an unusual one.

In the paintings discussed above, exhibited at the RA before 1854, women are shown to be in moral danger when courted by soldiers. Such flirtation pictures constitute only a fraction of soldier-civilian scenes in this period, most of which show soldiers leaving home to enlist or as deserters. In the period after the Crimean war such scenes of 'moral danger' disappeared from the walls of the RA. From the mid-1850s the image of the 'common soldier' underwent a transformation in ruling-class mythology. The men who had fought in the ranks in the Crimean were increasingly constructed as 'heroic' and 'patriotic' by the upper middle class. These heroic patriots were increasingly depicted as respectable husbands and fathers. This emphasis on the sexual morality of the soldier was an attempt to annex him for the respectable working class from the unregenerate poor.[16] After the Crimean war middle class interest in regulating all aspects of soldiers' lives was manifested in a series of official inquiries and Royal Commissions. Florence Nightingale and Sidney Herbert were among the most powerful advocates of sanitary reform for barracks, improved medical provision, educational facilities and better provision for soldiers' wives. The role of women was a subject of much debate among

social reformers. It is impossible to do more here than to summarise a few areas of concern which were examined at this time. Trustram has shown that there was pressure to provide 'on the strength' wives and children with separate quarters. There was also pressure on the army to permit a larger number of men to marry. The post-war ideology was in direct conflict with that of the army; it sought to make 'the regiment a home', rather than an association of bachelors.[17] It was believed that the presence of 'decent', i.e. married, women would have an ennobling effect on the men and make them better soldiers.

The publicity surrounding campaigns for repeal of the Contagious Diseases Acts drew one aspect of soldiers' sexuality into the consciousness of the middle classes. The Acts had been passed in 1864 and 1866 to combat venereal disease, the cause of frequent absenteeism. They sanctioned the detainment and examination of women believed to be prostitutes.[18] The surrounding publicity showed the extent to which soldiers failed to conform to the stereotype of the respectable working-class husband and father. Representations of soldiers and women at the RA in the post-Crimean era could not therefore allow any ambiguity surrounding the relation of a soldier to a woman for fear of being thought to allude to prostitution. The strategies which emerged for disposing of the problem was either to place the protagonists in an obviously domestic setting or to situate them in an earlier, more 'innocent' era.

The latter was developed in the 1870s and appeared at the RA until the end of the century. Such flirtation scenes were set in the late eighteenth century or, more frequently, the Regency period. As Marian Orr has shown, the 'rediscovery' of Jane Austen was fundamental to the late nineteenth-century view of her period. The predominant characteristics of the Regency were believed to have been 'gentility, propriety and morality'.[19] We have already seen that in the late nineteenth century the day of Napoleon and Wellington was considered a 'Golden Age' of social social order and British supremacy. Orr has argued that some sections of the late Victorian ruling class were nostalgic for the moral certainties which they believed had obtained then. 'Regency genre has one characteristic which is not found equally in every form of period genre – the inevitability of marriage.'[20]

Frank Dadd's *Gold Lace has a Charm for the Fair* (RA, 1880) is an example of a scene which if not situated in this 'innocent' period might have been read as sexually ambiguous. It depicts two handsome, smartly dressed officers parading down a rural street. They are watched and admired by three giggling young ladies. The costume is that of the Regency period and the whole picture could serve as an illustration for

Pride and Prejudice (1813). Dadd's picture was ignored by reviewers, but a writer on a similar artist of Regency genre scenes, John Haynes-Williams, emphasised the 'innocence' of the era. It is interesting to note the reiteration of the word 'blameless' as the author describes one of Haynes-Williams's works.

> . . . the appropriate background of some scene of blameless coquetry, of charming love-making. . . where. . . the hero of romance is blameless and young. . . and where the heroine. . . may blamelessly and naively accept the joys of a first fascination.[21]

By far the largest number of soldier-civilian scenes were located in a domestic environment. It has been claimed that this emphasis on the home life of soldiers drew upon the ideologies of the dominant class which consecrated 'the home' as the fount of respectability, harmony and social order. 'The home' was of course, the basis of another sacred institution, 'the family'. The perfect organisation and harmony between sexes and classes in the ideal home was a microcosm of the perfectly ordered society.

> During the first half of the nineteenth century the domestic ideal and its attendant images became a vital organising factor in the development of the middle-classness, and in the differentiated class identity. It became indeed an expression of class confidence, both against the immoral aristocracy and against the masses, apparently denied the joys of family life and prone to sexual immodesty and vice. . .[22]

In tune with the increasingly pervasive bourgeois ideology, domestic representations of the soldier occupied a higher percentage of images in the post-Crimean era. Further, pictorial types that had existed before the 'domestication' of the soldier were reworked in those terms. For example, the genre depicting citizens receiving military news had been current since the early nineteenth century. David Wilkie's *Chelsea Pensioners*, etc. (1822) had been a vehicle for intimating working-class patriotism. Although the 'war news' genre was still found as late as the 1880s emphasis had shifted to the private reception of military news. The domestic became the filter through which military triumphs were viewed. It must be stressed that this domestic 'angle' for the genre was not new in the 1860s but it was at this time that it became the dominant form.

John Faed's *After the Victory* (1873) made ironic play on the national joy at a military success and the private sorrow felt by those bereaved in its achievement. Like the majority of such paintings, Faed's was set in a rural cottage. As has been shown above, the 'ideal' soldier was always shown as emerging from the country rather than the city. Faed, as a Scottish artist, suggested to one reviewer Burns's lines:

When wild war's deadly blast was blown,
And gentle peace returning,
Wi' mony a sweet babe fatherless
And mony a widow mourning.[23]

The painting represents three generations: the mother, wife and baby. There is no sign of a male to provide for them in place of the soldier whose death has just been announced in a letter. It inevitably raises the question of how a family might survive without support. The role of the small toddler is crucial in this and similar pictures as the unknowing victim. Here the child is shown trying to comfort its mother for a loss it cannot yet comprehend. The broad range of meanings of children in military pictures will be discussed below. Faed's picture is unusual in extending the grief to a parent as well as the soldier's wife and children. It is this which develops the tragedy beyond the realm of the purely emotional to the economic disaster. V. Prinsep's *News from the War* (1871) and R. Collinson's *Hopes and Fears* (1861) also show women reading letters bearing news of their husbands with a child by their side. The fate of a fatherless child was believed to be so grim as to arouse the pity of the Academy audience.

The pictures discussed above were all images of working-class families. Frederick Goodall's *A Letter from Papa* (1855) is a rare example of an officer's family. Its appearance must be related to the Crimean war, then at its height. As has been shown above, the war was the cause of conflict between the aristocracy and the upper middle class. Goodall's paintings of a lady and her three daughters creates an image of the ideal bourgeois home – perfect except for the absence of the father, who, even so, is present through the medium of his letter which they are reading. One strand of the upper middle-class claim to power was moral superiority. The sexual escapades of an aristocratic colonel Lord Cardigan received censorious attention in the press. His and other cases were used to imply that a disorderly sexual life made a man unfit to command a regiment. Goodall's representation of the absent officer's home must be read in terms of this assertion of the upper middle classes' 'right to rule' the army. The mother of the family is a model of female virtue; composed, patient, modest and beautiful. Her children are gathered piously about her, to listen to the letter from papa. The overriding impressions are of harmony and discipline. The hero is the absent officer, but his character is articulated through his absence; he has deprived himself of this domestic heaven to do his duty by his country. It was argued earlier that representations of army wives were crucial in articulating ideas not only about the soldier's family but about himself, his social behaviour and his moral qualities.

[*167*]

The most common depictions of army wives were in a genre often nicknamed after the popular marching song 'The girl I left behind me'; showing women waving farewell to their men on their way to war.

Henry Nelson O'Neil's *Eastward Ho!* is a familiar example of the genre which enjoyed enormous popularity when it was shown at the RA in 1858. It was exhibited during the wave of alarm over the Indian Mutiny. The artist was believed to have been 'inspired' to paint the picture by the sight of wives, sweethearts, parents and children crowding around a troopship to say farewell to their men, bound for the front. The criticisms of the painting take it for granted that it is a 'truthful delineation. . . which speaks to the heart'.[24] The *Athenaeum* critic, the most eulogistic of reviewers, was delighted with the way 'The classes of life, the ages and the stations of the leave-takers are admirably expressed and contrasted'.[25] It does not appear that there are more than two social 'stations' represented in the painting – the 'respectable' working-class soldiers and their families and possibly an upper middle-class group in the top left-hand corner. O'Neil's painting portrays the family life of the soldiers as coherent, respectable and prosperous. All the figures are dressed in reasonably smart clothes: none are ragged or shoeless. The reviewer picked out one woman as 'a soldier's wife, a poor woman, but decent enough. . .'[26] She is shown clasping the hand of a sergeant. The sergeant occupied an especially secure position in ruling-class mythology, since, as a noncommissioned officer, he was the most reliable, intelligent and above all respectable working-class soldier. The sergeant and his wife would have been instantly recognisable as respectable members of their class.

The critis from *The Times* discussed O'Neil's picture in a long review with Paton's Indian Mutiny picture *In Memoriam*, Egg's *Past and Present* and Frith's *Derby Day*:

> The mingled horror and elevation of Mr Noel Paton's *In Memoriam* quite yield in attractiveness [popularity at the exhibition] to the familiar interest of Epsom racecourse, the gangway of the transport ship, and the London drawing-room and the dark arch of the Adelphi.[27]

The reviewer remarked on the painful nature of Egg's story of a wife's fall from virtue:

> In Mr O'Neil's picture the element of pain is more delicately blended. Hope and aspiration are busy among these departing soldiers, and if mothers and wives, and sister and sweethearts, go down the side sorrowing, it is a sorrow in which there is no despair, and *no stain of sin and frailty*.[28]

Eastward Ho! drew upon a number of established motifs from other genres, giving it a familiarity which established its 'truthfulness'. One

of the stock characters of military genre painting was the Chelsea pensioner. In O'Neil's picture the veteran is half-way up the steps, passing something to a young soldier. O'Neil is drawing upon and extending the mythology of the patriotic old soldier into the patriotic working-class military family. It will be argued below that the need for a continuous imput of recruits gave value to the concept of 'a military family', a family which remained loyal to the service and provided soldiers from each generation. The Chelsea pensioner was recognised by the reviewer as a patriot, '. . . pushing upward, roughly and self-concentrated, against the downward crowd, in order to shake the medal on his breast at his son, and shout to him to earn a shiner like it and not to disgrace his old father. . .'[29]

The emotional tone is optimistic despite the sadness of family partings. The painting is dominated by bright green and red and the composition is dynamic. O'Neil had banished a sense of tragedy which might have been felt at the embarkation of troops for seven years' service overseas. Most reviewers expressed a sense of the commonplaceness of the scene, playing down the grief in noting the reaction of the boatman, who has, presumably, seen it all before. Since the painting was primarily aimed at showing the willing patriotism of soldiers going to the rescue of the British in India, a display of too great sorrow might have been inappropriate. O'Neil had to maintain a delicate balance between the sense of 'aspiration' and the degree of sorrow which would suggest that the soldiers were leaving domestic happiness behind.

A critic, reviewing the Royal Academy exhibition in 1880, made it plain that the genre was still current and relevant but too frequently reworked:

> Mr F. Holl's *Ordered to the Front* (366) [is] an illustration of a terribly hackneyed subject which has been treated with exceptional success by Mr Holl, as indeed it has been by Mr. C. Green in *The Girl I Left Behind Me* (1072). Mr Holl's picture tells its story very well. Every incident and element in the design is hackneyed and even commonplace, and not a feature nor an idea is expressed which we have not seen painted a dozen times before. Still Mr Holl has done his work so well that hardly any portion of his design fails to move us, while the widow and her son will surely touch most spectators. The artist is successful because he has conveyed sincerely, yet simply, the unaffected and genuine pathos of those ideas which have long ago become common property, and has imparted to their expression a tenderness, which, although sometimes sentimental, is frequently profound.[30]

The six soldiers in Holl's *Ordered to the Front* are from a Highland regiment, wearing kilt and busby. One is holding the hand of a sorrowful-looking woman. Her dress is modest but not ragged. There are two

pretty small girls whose relation to the other groups is not clear, but who add liveliness. Another Highlander is staring down at his wife and baby. The final group is of a soldier with a very elderly woman, evidently his mother, her head bent with grief; he gazes at her compassionately. Her black dress indicates that she is a widow who will be alone on his departure. A reviewer found Holl's painting 'thoroughly dignified and serious'.[31] But another warned that it was 'bordering on the melodramatic'.[32] It is hard to see in what sense the painting is melodramatic – the figures have very restrained poses and facial expressions. All the Highland soldiers are idealised: tall, broad-chested, with fine moustaches and handsome faces. Their posture is upright and their mien dignified. Their women's faces suggest suffering rather than anguished protest.

Both O'Neil and Holl painted 'sequels' for exhibition the following year. One reviewer considered O'Neil's move unwise: 'there is a general impression, often, as we believe here, untrue, that in companion pictures, number two is painted because number one was painted, – to match, to suit the engraver's purpose'.[33] Reviewers were unaninous in finding *Home again, 1858* (1859) less successful than *Eastward Ho!*, revealing the theme of returning soldiers as more problematic than departing ones. The critic of the *Art Journal* referred to a 'burly sergeant' evidently wounded in India: 'he looks, indeed, more like one who is suffering from gout, the result of ease and rich living, than an invalid wounded, as well as sick, who is destined for Chelsea'.[34] The assumption that the state would care for its wounded is obviously disposing of the social problem. Critics writing on other 'home from the war' paintings sometimes found themselves facing the issue of the fate of veterans. Most of the criticism directed at *Home again*, in this review, is about the issue.

> 'Home Again' is not true. The sick and wounded soldier is sent home like a piece of live lumber and duly draughted to the depot or the hospital. His return is generally unknown until after his arrival; and the crowding down of relatives and friends to greet him on the landing, is too generally a myth. . . broken health and penury, to be endured in obscurity, are all that remain. In a word, the sentiment of 'Eastward Ho!' was heroic, elevating; and that in the 'Home Again' is depressing.[35]

The review is remarkable in attacking a painting on the criterion of truth; the painting is not 'true' because it idealises an event, and it is undesirable even so because it conjures up 'depressing' ideas. A reviewer of J. Noel Paton's *Home!* also related an image of the returning soldier to the treatment of veterans: '. . . poor fellow, he deserves the best pension the board can give him. Adieu, mon caporal. You will

have to be honoured in old age and fight your battle over again with your children's children.'[36]

In the mid to late 1850s then, reviewers read these 'home from the war' paintings in terms of contemporary debates over pensions, military hospitals and the reception of heroes. O'Neil's and Paton's pictures represent the two conventions of 'home' paintings which were to recur constantly to the end of the century. O'Neil's is the public return – bands and crowds waiting with the families to receive the homecoming troops. Paton's represents the private return of the soldier to his home. In terms of the reviews they received, the 'private' scenes were more popular. In the passage quoted above, from the *Art Journal* of 1859, the painting was related to another familiar domestic military genre – the old soldier recounting his adventures to his grandchildren. The effect of both pictorial types was to locate the soldier in a domestic milieu, with all surrounding concepts of respectability it implied. No domestic settings of returning soldiers were exhibited in the aftermath of the Waterloo campaign; the concepts of family and home were less powerful signifiers of conformity than in 1856. At that date it was not so desirable to construct a respectable private soldier in the national mythology. It should not be assumed that the ideology of the 'respectable domesticated soldier' represented the only ruling-class view of the ranks. There was a lingering fear of the military mob. In the same year that Paton successfully exhibited *Home!* Viscount Hardinge's speech at the Academy banquet expressed this fear. As General Commander in Chief of the Army Hardinge responded to the toast, 'The army,' by reassuring his listeners, artists and socially and politically prominent leaders that:

> It is also due to my fellow countrymen that I should express my conviction that on their return home these gallant troops will exhibit that *respect for authority, that submission to the laws of the country and that loyalty to their Sovereign* which have long distinguished the British soldier.[37]

Paton's picture sprang from the ideology which submerged this very real fear under the reassurance that family and home would maintain returning soldiers in a state of 'submission'. Such representations as Paton's provided the audience with 'proof' of the mythology. No reviewers levelled a charge of inauthenticity at the *private* homecoming pictures.

Representations of officers going to war are interior scenes more often than at dockside or station. It must be assumed that since middle-class women belonged to the domestic sphere it would have been undesirable for them to be seen in a public street. These images of farewell

work in a way very similar to the Goodall picture, articulating notions of duty and sacrifice by revealing the heaven of home that is forsaken for the hell of war. Such representations also operate by differentiating between the sexes' attitudes to war. Millais's *The Black Brunswicker*, although slightly out of period, being set in the Napoleonic era, is a classic example of a drawing-room parting between a lady and an officer. Her gesture suggests that she is trying to prevent him leaving but his face is resolute with determination to do his duty. The audience would have been aware that the Brunswickers were extremely brave on that day but sustained extensive casualties. Perhaps we are meant to believe that the woman with 'female instinct' has a premonition of her lover's fate. More specifically, Millais is drawing upon contemporary ideologies of gender difference which assigned women to home, family and the personal sphere and men to public concerns such as politics and war. His heroine therefore acts in a way which is understandable and natural but in the superior, male view limited and self-ish. 'The *Black Brunswicker* . . . regards the lady with a look of sad determination, and pain that she should not value, as he does the call of duty. . .'[38] This division of feeling was maintained in all but one representation of middle-class 'off to the war' pictures. It was not until 1899, during the Boer war that a painting appeared which showed the woman as positively encouraging her man to leave for the Front. J. H. F. Bacon's *Ordered South* (1900) depicted a handsome, khaki-clad officer being handed his pith helmet by his beautiful young wife. Her 'unnatural' response is called for by the necessity to show that even those who would not welcome war could perceive it as essential. In 1914-18 this supposed gender difference was used effectively in recruiting. If Woman, known to be antithetical to war, conceded the need to fight, then the war was transformed into something more truly national.

The female role was often represented in academic art as supportive of the male warrior, as the inspiration of bravery. Chivalric notions, appropriated by sections of the ruling class, pervaded this area of ideology and reinforced gender roles. N. J. Crowley's *The Eve of the Battle* (1849) showed a lady praying for her husband's safety. Since the female was spiritual rather than active her contribution was limited to religious intercession. A missing painting by J. Morgan, *The Battle Field* (1855), established woman as inspiration of courage: 'He charged the friendly priest to tell her/Her mem'ry had nerved his arm.'[39]

Ruling-class ideologies of 'womanhood' and the suitable subject matter of academic art excluded the representation of those lower-class women who had traditionally gone to war as camp followers. Class

culture set them apart as 'immoral' and thus unmentionable. 'Popular culture', i.e. working-class forms such as songs and broadsheets, not infrequently constructed these women as heroines. In academic art no working-class women were represented as battlefront heroines. In only a few wars in the nineteenth century were 'ladies' involved in the conflict: in the Waterloo campaign and in the Indian 'Mutiny'. What is celebrated in representations of this kind of 'heroism' is not the act but the fact it was performed by a 'lady'. The interest lay in the contrast between what these heroines did and what was conceived as 'natural' for them to do. The capacities and temperaments of lower-class women were felt to be so radically different from those of ladies that the normal experiences of a camp follower were deemed extraordinary when suffered by a 'lady'.

The Waterloo campaign was one of the few occasions upon which ladies were closely involved in war in the nineteenth century. During the Hundred Days the British army moved to Brussels, to await battle. The campaign was treated as a social event by many members of the aristocracy, who moved to Belgium for a holiday near the front. As the Napoleonic forces pushed forward, many of them fled, but some, notably the wives and families of officers, stayed to await the outcome. Samuel Drummond's *The Field of Waterloo* was inspired by an account of feminine bravery. All that is known of this now lost picture is the lengthy descriptive passage with which it was exhibited at the RA in 1835:

> Repeated accounts of the victory having reached Brussels without any tidings of the General, her husband, Mrs – at midnight, set out accompanied by a female friend, to the field of battle. At daylight in the morning she found him amongst the killed and wounded, still bleeding; they tore off their garments, bound up his wounds and carried him off to a cottage.[40]

The wife's bravery in setting off to look for her husband at midnight was clearly prodigious. Further, the women sacrificed their garments for bandages. Such actions could only be interesting and 'newsworthy' at a time when the prevailing view of 'ladies' was that they were emotionally weak and physically frail. It should be noted that the only unusual aspect of the lady's behaviour was the decision to go to the battlefield in search of her husband. The nature of her role, that of nurse to the sick or wounded, was within a traditional sphere of female activity. The relief of pain or distress were believed to be particularly suited to the talents of ladies, since they called upon 'feminine' attributes of patience, gentleness and sympathy. All the paintings of female heroism near the action of battle conform to two stereotypes of femininity; woman as support of man or as the victim of male aggression.

[*173*]

Only when the woman depicted is not British is she allowed to display any independent initiative or courage.[41]

J. D. Luard's *Nearing Home* (1858) also shows an officer's wife nursing her wounded husband. The scene is 'on board one of the P & O company's steamers'. An officer, presumed by one critic to have been wounded in India, is lying on deck, attended by his wife. A small sailor boy has announced the sighting of the English coast, and the 'other ranks' crowd to gaze at the white cliffs. Contemporary critics devoted most attention to the appearance and demeanour of the wife, 'an amiable, sedulous, lady-like creature'.[42] The reviewer from the *Athenaeum* described the principal figures with great attention to details:

> . . . the chief passenger is an officer of distinction, – still, languid and listless, with Indian wounds. . . The officer's wife, with care and watching, bends towards him to see what quickening of the heart-beats the news will cause, or rather perhaps, so anxious to watch each flush of colour or each growing paleness, as to hardly care herself for the news – glad though it be.[43]

The officer's illness has brought about a reversal of the power roles in their relationship, but it is in no way disruptive of contemporary stereotypes of the female role, since she is strong only to nurture him back to health. A reviewer interpreted the officer as 'quite a Regent St Bayard, – he looks so gravely resolved on honour till he dies, such a quiet chivalrous resolve pervades his features'.[44] It was possible for a woman to act usefully and bravely in relation to war and warriors without stepping beyond the parameters assigned to the female. The Sepoy Revolt in 1857 was uniquely a British campaign in which women and children could not be sent away from the sphere of confrontation. One of the greatest sources of outrage was that white 'ladies' were in the power of black soldiers. A number of appalling atrocities were committed by the Sepoys, the most infamous being the massacre at Cawnpore, where women and children were brutally murdered. In the year after the massacre J. Noel Paton exhibited *In Memoriam*, (1858) showing the final minutes before the slaughter. The picture was probably the most contentious exhibited at the Academy during the century, and is of great interest in providing the focus for a number of contemporary debates about the conventions of art:

> More of the charnel-house! Ay, and in passages which curdle the blood with vain, indignant horror and make one wish that the pen of history could for once be plunged in Lethe. . . The subject is too revolting for further description. The picture is one which ought not to have been hung, and in justice to the hanging committee, we believe that it was not done so without considerable compunction and hesitation.[45]

[174]

Despite the painful nature of the subject, the picture was in many ways a gratifying representation of the moral, spiritual and physical perfection of British ladies. It was also, therefore, a comment on the superiority of the British over their Indian enemies. *The Times* reviewer was delighted with the work, notwithstanding the 'horror' of the subject. 'Nothing in the exhibition shows truer feeling of the end and aim of art than this picture, full in every part of expression, care and refinement.'[46] Paton's composition was derived from Renaissance models, and was reminiscent of Christian martyrdom scenes. In its debt to the grand manner and in its relation to the 'important' subject of contemporary imperial wars the picture was firmly in the tradition of High Art representations of saints. The principal figure was a lady, turning her eyes to heaven in prayer. Paton inscribed on the picture frame, 'in quaint old letters with illuminated initials, words of Divine consolation from Scripture', the lines from the 23rd Psalm, 'Yes, though I walk through the Valley of the Shadow of Death, etc'.[47] One critic accorded the work reverence:

> We will refer first to Mr Noel Paton's *In Memoriam* (417) as one of those sacred subjects before which we stand not to criticise, but to solemnly meditate. We feel it almost a profanation to hang this picture in a show-room, it should have a chapel to itself.[48]

The majority, however, were too upset to admire the way it conveyed 'Christian resignation'. Paton subsequently expunged the 'maddened Sepoys, hot after blood' bursting through the door.[49] In their place he painted Highland soldiers rushing in to rescue the women and children. It was in this form that the picture was engraved. Chesneau, writing in 1885, was scornful of the compromise to 'spare the nerves of his fair and tender-hearted spectators', declaring that in this second form it was a 'pleasant but decidedly commonplace conclusion by which the work is both enfeebled and stunted, all the terror therein is a mere delusion and the drama terminates in the happy and paltry manner of a trashy three-volume novel'.[50] In the context of contemporary constructions of femininity the picture presented irreconcilable ideas. If Paton wished to show his ladies suffering martyrdom with Christian resignation and dignity, then it was dramatically essential to show the instruments of their death, i.e. the Sepoys. Unfortunately, as the storm of criticism showed, the depiction of ladies in the power of black soldiers was deeply offensive. For the wider public Paton decided to sacrifice the martyrdom aspect so as not to disrupt the mythology of white women as inviolable and remote from the male world of war and insurrection.

Finally we turn to representations of children in military paintings.

This topic is, again, very broad and could form the basis of a book in itself. It draws together a number of themes which have run through the book and thus provide a useful conclusion. There is space here to discuss only five out of scores of paintings. Each may be related to an area of contemporary concern regarding war, the army and the state.

Mulready's *The Convalescent from Waterloo* was exhibited in 1822, the same year as Wilkie's *Chelsea Pensioners.* Like Wilkie, Mulready was concerned with the aftermath of war, but in every other sense the paintings were ideologically opposed. Wilkie's picture showed the ex-soldier integrated with society, a happy, tended man, greeting the news of victory with patriotic enthusiasm. Mulready's picture is of the soldier, with his wife and children, recuperating from a war wound. The mood is sombre; the woman is dressed in mourning, perhaps indicating the loss of some other relative in the war. A short distance away their two small boys are locked in a ferocious wrestling match. One contemporary was at a loss to know how this group bore upon the main interest:

> ... the incident of the two children quarrelling, in the foreground, must be considered as totally out of place, since it evidently disturbs and interferes with the kind of interest intended to be called forth by the picture.[51]

The painting seems to treat the aftermath of war as tragic but cannot be regarded as pacifist in the sense of implying that war should or could be avoided. The function of the boys is to remind us of the fundamentally aggressive nature of humanity, which will ensure that wars will inevitably recur. The sadness with which the father contemplates them suggests that he is reflecting upon the inescapable consequences of this tendency.[52]

A more common meaning to be found in representations of soldiers watching children fight or play at war is that children, as innocents, are ignorant of the horrors they mimic. F. D. Hardy's *The Volunteers* (1860) showed a group of six children playing at soldiers, watched by a man in uniform. On one level the painting is to be read as one of Hardy's rural idyll pictures, a typical product of the 'Cranbrooke colony'. Hardy's speciality was scenes in which children ape the occupations and preoccupations of adult life in an amusing way. His military scene works this genre on a more serious level. The children are playing a game the implications of which they are unable to comprehend. They have all the charm of small people seriously trying to be like grown-ups. The soldier is psychologically divided from the other adults, who look on with amusement. He does not smile because he knows the reality of the adult version of their game. Since he is seated,

we are perhaps meant to conclude that he is weakened or wounded.

The title of the painting and the time of its exhibition suggest that Hardy intended it to be read as a comment upon contemporary middle-class enthusiasm for the Volunteer force. This might be interpreted in two ways; that the children have been inspired in their play by the Volunteers or that the Volunteers are themselves playing at real soldiers, and will falter when confronted by the actuality of war. It is certain that criticisms of this kind were levelled at the movement in its early days.[53] One of the few reviews of the picture picked up on the contrast between the beauty of childhood innocence and the ugliness of the 'toys' with which they play. 'A boy, armed with an old birch broom, marches about with the bearskin on his head; his laughing and rosy face showing under the ugly load is pretty and lively.'[54] No reference is made to any further readings of the picture. In these two paintings the soldier functions as one with enlightenment and insight into the 'reality' of war. In both pictures the soldier looking on strikes a chill in the spectator. W. F. Calderon's *A Son of the Empire* (1899) juxtaposes a child playing at soldiers with a group of soldiers executing their duty, to yield a very different meaning. The boy, ragged and dirty, plays at drill with a broom for a rifle as the cavalrymen ride past. They smile with approval which the spectator is invited to share. The boy is imitating them because he admires and wishes to be like them. His reaction is desirable and natural for a 'Son of the Empire'. Calderon's painting should be read as part of the contemporary debate over the health of the nation's children. Reports had shown an alarming percentage of young men as too ill nourished and undersized to come up to the (very low) minimum standards required by the army medical boards.[55] They had drawn attention to the poor standards of nutrition and housing suffered by the urban working class. Considerable anxiety ensued: would the country be able to raise an army of suitable quality and size in time of emergency? Could it be that the nation's fighting qualities were being bred out by the cities?[56] In a period when war seemed likely not only in the empire but in Europe, such fears were urgent and immediate efforts were made to improve nutrition in schools. Calderon's painting must be read in this context. The street urchin is from the very class that would be recruited into the army as an adult, and precisely the type who had been found to be physically unfit to serve. He is, however, robust and healthy-looking, but, more than that, he is full of the right kind of sentiment – patriotic and militaristic. The painting must therefore be read as a reassurance. Sons of the Empire still existed.

Phil Morris's *Sons of the Brave: the Orphan Boys of Soldiers, Royal*

Military Asylum, Chelsea (1880) undoubtedly functioned in a similar way, offering 'evidence' that the army's future material was available. The asylum educated orphans specifically so that they would themselves enter the ranks. The army valued these recruits over all others. A review of Morris's picture linked it to Herkomer's Chelsea pensioner work, *The Last Muster,* as a representation of military patriotism. His language was similar to that used of Herkomer's picture. It was described as having:

> . . . a great deal of realism. Difficulty must always stand in the way of the honest representation of the humbler life in England; type and costume are alike unrefined, the faces being blunt and unfinished, the dress undistinctive of class and therefore vulgar. Mr Morris's picture, nevertheless, has the interest of a true subject.[57]

The painting was hung in a prominent position in Gallery One, a site acknowledging its importance. The critic of the *Art Journal* acclaimed it as a 'brilliant performance';

> We stand in front of the Royal Military Asylum, Chelsea, and from its spacious door we see issuing the brass band of the orphan boys, all clad in full scarlet uniform and preceded by a drum-major, who, staff in hand, has as much military bearing as if he were a six-foot grenadier marching at the head of his regiment.[58]

The boy is seen as amusing but wholly admirable, the embodiment of the military spirit. The lads are watched by the widowed mothers and sisters, and are thus the focus of female admiration. The mood is 'full of life and movement and joyousness'.[59] It is a celebration of the continuity of working-class patriotism; of the military capacity of the English and of the masculine ethos. In the 1880s a number of journals were fostering such a spirit in middle-class boys. These publications, such as G. A. Henty's *The Union Jack* (1880-83) overtly linked childhood games and activities with a career in the army. A similar desire to inculcate religious and moral discipline may be detected in the foundation of paramilitary Christian organisations such as the Boys' Brigade, founded in a working-class district of Glasgow in 1883. Both boys' military imperialist literature and the more distinctly working-class Christian youth movements have been discussed at length elsewhere. It is enough to make the point here that these cultural manifestations not only reflected an interest in the army and endorsed its importance and utility but encouraged boys to enter the service and to become Sons of the Empire as adults.[60]

The final painting in our selection is Frank Holl's *Did you ever kill anybody, father?* (1884). This curious work, essentially a portrait of a beautiful little girl holding a sword, has no obvious narrative theme.

It functions because of the associations it could arouse in its audience. As a child, especially as a beautiful one who would be a woman, the little girl represented the gender and group furthest removed from war and least able to comprehend it. The female sex was the one for whose protection wars were fought, but their natures were seen as antithetical to it. Little girls in military genre paintings have a much smaller range of meanings that their male counterparts. In such works as Hardy' *The Volunteers* the girls are passive spectators, watching with admiration or resentment. The polarisation of sex roles, of course, mirrors the construction of adult gender roles in such paintings as *The Black Brunswicker*. Holl's picture worked these notions of the physical and intellectual separation of women from the masculine province of war:

> ... Mr Holl has contributed a subject picture which is very taking if somewhat melodramatic. It is the nearly life-size figure of the young daughter of a soldier, seated. The father's sabre, partly drawn, lies across her knee, and she is startled by the thought expressed by the title 'Did you ever kill anybody, father?' (No. 67). The notion that a beloved and gentle parent should have slain a fellow creature and shed blood with that sword, which she had never before thought of as a deadly weapon, is finely expressed in the bewildered eyes and parted lips of the girl who trusts her father in every thought.[61]

The painting constructs a glamorous martial past for the father, who is by extension also the male spectator. This is surely a subtle form of flattery which implies that behind every kind and gentle father lies the potential warrior. Only in an age when the soldier was perceived as a moral exemplar for the civilian could such a work have had meaning. The paintings of children fall into two distinct groups, those which regard war as an inevitable evil, in which children will ultimately be implicated, and those which regard them as the military material of the future.

The representation of children in military pictures, then, may be seen to have a variety of forms, and must be read in the context of contemporary notions about childhood and essential human nature, as well as ideologies of the army and war.

Notes

1 See Hichberger, thesis, 1985.
2 Spiers, pp. 45-58.
3 *Quarterly Review*, LXXIX, March 1847, p. 460.
4 Judith Walkowitz, *Prostitution and Victorian Society, etc.*, 1980.
5 Jeffrey Weeks, *Coming Out*, 1977, p. 13.
6 William Tait, *Magdalenism*, 1840, p. 98.
7 *Loc. cit.*
8 Washington Irving, *The Sketchbook of Geoffrey Crayon, Gent.*, 1820, pp. 310-19.

9 *Ibid.*, p. 312.
10 *Ibid.*, p. 314.
11 *Ibid.*, p. 310.
12 *Loc. cit.*
13 *Art Union*, I, 1839, p. 67.
14 *Athenaeum*, May 1839, p. 396.
15 Irving, p. 305.
16 Jeffrey Weeks, *Sex, Politics and Society*, 1981, p. 27.
17 Myna Trustram, *Marriage and the Victorian Army*, 1984.
18 Walkowitz, *passim*.
19 Marrian Orr, 'Regency Themes in late Victorian Painting', unpub. M.Phil., University of London, Courtauld Institute of Art, 1982, p. 2.
20 *Ibid.*, p. 48.
21 Frederick Wedmore, 'John Haynes-Williams', *Art Journal*, 1894, p. 292.
22 Weeks, p. 28.
23 *Athenaeum*, 17 May 1873, p. 635.
24 *Times*, 22 May 1858, p. 9.
25 *Athenaeum*, 8 May 1858, p. 596.
26 *Loc. cit.*
27 *Times*, 22 May 1858, p. 9.
28 *Loc. cit.*
29 *Athenaeum*, 8 May 1858, p. 596.
30 *Athenaeum*, 22 May 1880, p. 668.
31 *Magazine of Art*, 1880, p. 348.
32 *Times*, 6 May 1880, p. 10.
33 *Athenaeum*, 30 April 1859, p. 587.
34 *Art Journal*, 1859, p. 168.
35 *Athenauem*, 30 April 1859, p. 587.
36 *Art Journal*, 1859, p. 168.
37 *Times*, 5 May, p. 5.
38 *Athenaeum*, 5 May 1860, p. 620.
39 Royal Academy Catalogue, 1955.
40 *Ibid.*, 1835.
41 Wilkie's *Woman of Saragossa* and Absolon's *Fuentes de Onor* are depictions of Spanish heroines.
42 *Illustrated London News*, 22 May 1858, p. 518.
43 *Athenaeum*, 8 May 1858, p. 597.
44 *Loc. cit.*
45 *Illustrated London News*, 15 May 1858, p. 498.
46 *Times*, 1 May 1859, p. 5.
47 *Illustrated London News*, 15 May 1858, p. 498.
48 *The Critic*, 15 May 1858, p. 235.
49 *Times*, 1 May 1858, p. 5.
50 E. Chesneau, *The English School of Painting*, 1885, trans. L. N. Etherington, p. 208.
51 *New Monthly Magazine*, 22 June 1822, p. 206.
52 Kathryn M. Heleniak, *William Mulready*, 1980, p. 97.
53 Cunningham, p. 79.
54 *Athenaeum*, 19 May 1860, p. 689.
55 Skelley, p. 27.
56 Frederick Maurice, 'National health – a soldier's study', *Contemporary Review*, LXXXIII, 1903, pp. 41-57.
57 *Magazine of Art*, 1880, p. 348.
58 *Art Journal*, 1880, p. 186.
59 *Loc. cit.*
60 Louis James, 'Tom Brown's imperialist sons', *Victorian Studies*, September 1973, p. 99, and Patrick A. Dunae, 'Boys' literature and the idea of empire', *Victorian Studies*, October 1880, pp. 105-12.
61 Athenaeum, 24 May 1884, p. 667.

BIBLIOGRAPHY

Amery, L. S., *The Problem of the Army*, London, 1903.
The Journal of Mrs Arbuthnot, ed. the Duke of Wellington and Francis Bamford, London, 1959.
Beeton, S. O., *Our Soldiers and the V.C.*, London, 1878.
Bennett, George, *The Concept of the Empire*, London, 1953.
Blackburn, Henry, *Academy Notes*, London, 1875.
Boase, T. S. R., *English Art, 1800-70*, Oxford, 1959.
Bowle, John, *The Imperial Achievement*, London, 1974.
Bratton, J. S., 'Performance and politics', *Popular Drama*, ed. David Bradby, Cambridge, 1980.
Bryant, Arthur, *The Great Duke*, London, 1971.
Butler, Elizabeth, *From Sketchbook and Diary*, London, 1909.
Butler, Elizabeth, *An Autobiography*, London, 1922.
Butler, William, *An Autobiography*, London, 1911.
Carlyle, Thomas, *On Heroes, Hero-Worship, and the Heroic in History*, London, 1841.
Chesney, Kellow, *Crimean War Reader*, London, 1960.
Clayton, Ellen, *English Female Artists*, London, 1876.
Cunningham, Allan, *The Life of Sir David Wilkie R.A.*, 2 vols, London, 1843.
Curtin, P. D., *The Image of Africa*, London, 1964.
Eldridge, C. C., *Victorian Imperialism*, London, 1978.
The Farington Diary, ed. James Greig, 8 vols, London, 1928.
Farr, Dennis, *English Art, 1870-1949*, Oxford, 1976.
Farwell, Byron, *Queen Victoria's Little Wars*, London, 1973.
Fildes, L. V., *Luke Fildes R.A. Victorian Painter*, London, 1978.
Finch, Edith, *Wilfred Scawen Blunt, 1840-1922*, London, 1938.
Fortescue, John, *The Last Post*, Edinburgh, 1934.
Fussell, G. E., *James Ward, R.A.*, London, 1974.
Gernsheim, Helmut and Alison, *Roger Fenton, Photographer of the Crimean War*, London, 1954.
Girouard, Mark, *The Road to Camelot*, New Haven and London, 1981.
Gleig, C. R., *Chelsea Hospital and its Traditions*, London, 1839.
Halévy, E., *A History of the English People in 1815*, trans. E. I. Watkin, London, 1947.
Hallam, A. *Observations of Principles which may regulate the Selection of Paintings in the Palace of Westminster*, London, 1844.
Hanham, J., 'Mid-century Scottish nationalism: romantic and radical', *Ideas and Institutions of Victorian Britain*, ed. Robert Robson, London, 1967.
Harries-Jenkins, Gwyn, *The Army in Victorian Society*, London, 1977.
Harrison, J. F. C., *Society and Politics in England, 1780-1860*, New York, 1965.
Haydon, F. W., *Benjamin Robert Haydon, Correspondences and Table Talk*, London, 1865.
Hibbert, Christopher, *The Great Mutiny*, London, 1978.
Hichberger, Joany, 'The myth of the patriotic veteran in British art, 1815-1880', *Patriotism*, ed. Raphael Samuel, London, 1987.
Hobson, Anthony, *The Art and Life of J. W. Waterhouse, R.A.*, London, 1980.
Hunt, William Holman, *Pre-Raphaelitism and the Pre-Raphaelite Brotherhood*, London, 1905.
Irwin, David, and Francina, *Scottish Painters at Home and Abroad, 1700-1900*, London, 1975.
Jackson, L. C., *The United Service Club and its Founder*, London, 1931.
Johnson, Peter, *Front-line Artists*, London, 1978.
Jones, Gareth Stedman, *Outcast London*, Oxford, 1971.

Kilvert's Diary, ed. W. Plomer, 3 vols, London, 1940.

Kingslake, A. W., *The Invasion of the Crimea*, 8 vols, Edinburgh and London, 1863-87.

Lalumia, Matthew Paul, *Realism and Politics in Victorian Art of the Crimean War*, Ann Arbor, Michigan, 1984.

Leslie, C. R., *A Handbook for young Artists*, London, 1855.

Lorrimer, Douglas A., *Colour, Class and the Victorians*, Leicester, 1978.

Loyd-Lindsay, H., *Memoir of Lord Wantage, V.C., K.C.B.*, London, 1907.

Maas, Jeremy, *Gambart, Prince of the Victorian Art World*, London, 1975.

Marshall, Henry, *On the Enlisting, Discharging and Pensioning of Soldiers, etc.*, Edinburgh, 1859.

MacDonald, Robert, *A Personal Narrative of Military Travel in Turkey and Persia*, Edinburgh, 1839.

Mather, F. C., *Public Order in the Age of the Chartists*, Manchester, 1959.

McCourt, Edward, *Remember Butler!*, London, 1967.

Meynell, Wilfred, *The Life and Work of Lady Butler*, London, 1898.

Millar, Oliver, *Later Georgian pictures in the Collection of H. M. the Queen*, London, 1969.

Milner, Alfred, *England in Egypt*, London, 1892.

Morris, Donald S., *The Washing of the Spears*, New York, 1965.

Pakenham, Thomas, *The Boer War*, London, 1979.

Paston, George, *Benjamin Robert Haydon and his Friends*, London, 1905.

Postle, Martin, *Luke Clennell*, unpub. M.A. report, Courtauld Institute of Art, 1979.

Qualyle, E., *Ballantyne the Brave*, London, 1967.

Redgrave, F. M. *Richard Redgrave, C.B., R.A.*, London, 1874.

Robertson, David. *Sir Charles Eastlake and the Victorian Art World*, Princeton, 1967.

Robinson, Sarah, *The Soldier's Friend*, London, 1913.

Rossetti, William Michael, *Fine Art, Chiefly Contemporary*, London, 1867.

Saxon-Mills, J. *Life and Letters of Sir Hubert Herkomer*, London, 1923.

Skelley, Alan Ramsey, *The Victorian Army at Home*, London and Montreal, 1977.

Smith, T., *Recollections of the British Institution*, London, 1860.

Spiers, Edward, *The Army and Society, 1815-1914*, London, 1980.

Storey, G. A., *Sketches from Memory*, London, 1899.

Strachan, Hew, *The Reform of the British Army, 1830-54*, Manchester, 1984.

Swain, Charles, *A Memoir of Henry Liverseege*, Manchester, 1835.

Thompson, E. P., *The Making of the English Working Class*, Harmondsworth, 1963 edition.

Trevor-Roper, H.,'The Highland tradition of Scotland', *The Invention of Tradition*, ed. E. Hobsbawn and T. Ranger, Cambridge, 1983.

Uwins, S., *Memoir of T. Uwins, R.A.*, London, 1858.

Villiers, Frederick, *Peaceful Personalities and Warriors Bold*, London and New York, 1907.

Walkowitz, Judith, *Prostitution and Victorian Society*, London, 1980.

Weeks, Jeffery, *Sex, Politics and Society*, London, 1981.

Wilkinson-Latham, *From our Special Correspondent*, London, 1979.

Woodville, Richard Caton, *Random Recollections*, London, 1914.

Wyndham, H., *The Queen's Service*, London, 1899.

Articles

Anderson, Olive, 'The growth of Christian militarism in mid-Victorian Britain', *English Historical Review*, January 1971, pp. 42-9.

Bachrach, A. G. H., 'The field of Waterloo and beyond', *Turner Studies*, Vol. 1: 2, pp. 14-26.

Barrell, John, 'The private comedy of Thomas Rowlandson', *Victorian Studies*, Vol. 6: 4, pp. 423-32.

Bond, Brian, 'Recruiting the Victorian army', *Victorian Studies*, Vol. V, 1962, pp. 331-8.

Carmen, W. Y., 'The Battle of Waterloo, by Denis Dighton', *Journal of the Society for Army Historical Research*, 1965, pp. 55-8.

BIBLIOGRAPHY

Cunningham, Hugh, 'The language of patriotism, 1750-1914', *History Workshop Journal*, Vol. 12, 1981, pp. 8-33.

Fullerton, Peter, 'Patronage and pedagogy: the British Institution in the early nineteenth century', *Art History*, Vol. 5: 1. pp. 59-72.

Hardy, E. J., 'Time-expired men', *Good Words*, 1891, pp. 16-18.

Hichberger, Joany, 'Democratising glory: the Victoria Cross series of Louis Desanges', *Oxford Art Journal*, Vol. 7: 2, pp. 47-56.

Hichberger, Joany, 'Captain Jones, Royal Academy', *Turner Studies*, Vol. 3, pp. 21-8.

Pointon, Marcia, 'From the midst of warfare and its incidents to the Peaceful Scenes of Home', *Journal of European Studies*, Vol. XI, 1981.

Yarrington, Alison, 'Nelson the citizen hero: state and public patronage in monumental sculpture 1805-18', *Art History*, Vol 6: 3, pp. 315-29.

INDEX

INDEX